THE ROME OF ALEXANDER VII

OTHER BOOKS BY RICHARD KRAUTHEIMER

Corpus of the Early Christian Basilicas in Rome
Lorenzo Ghiberti
Early Christian and Byzantine Architecture
Collected Essays
Ghiberti's Bronze Doors
Rome: Profile of a City, 312-1308

PRINCETON UNIVERSITY PRESS PRINCETON, NEW JERSEY

THE ROME OF
ALEXANDER VII,
1655-1667

Richard Krautheimer

Copyright © 1985 by Princeton University Press

Published by Princeton University Press, 41 William Street, Princeton, New Jersey 08540
In the United Kingdom: Princeton University Press, Guildford, Surrey

All Rights Reserved

Library of Congress Cataloging in Publication Data will be found on the last printed page
of this book

ISBN 0-691-04032-X

This book has been composed in Linotron Trump text and Sabon display type

Clothbound editions of Princeton University Press books are printed on acid-free paper,
and binding materials are chosen for strength and durability

Printed in the United States of America by Princeton University Press, Princeton, New Jersey

Contents

List of Illustrations

NOTE: Falda, unless otherwise remarked, refers to G. B. Falda, *Nuovo Teatro*, Rome, 1665 and 1667

ABBREVIATIONS: BH Bibliotheca Hertziana, Rome
GFN Gabinetto Fotografico Nazionale, Rome

Preface

THE PRESENT book, while smaller and covering a span of time much shorter and considerably later than that dealt with in my previous volume *Rome: Profile of a City* (Princeton, 1981), nonetheless is closely linked to its predecessor. It deals with the same subject, Rome, albeit picking up the threads at a point nearly four hundred years from where the former volume ended. It approaches the theme from the same angle, the growth of and the changes in the urban fabric, its expanse, its streets and squares, its churches, palaces and ordinary housing. It views the transmutation of the cityscape and the planning of new thoroughfares, *piazze* and monumental buildings and their distribution over the map of Rome as born from and reflecting the practical, political and social realities and ideologies of the time and the ambitions and aims of the man behind that vision of a New Rome, Alexander VII, assisted primarily by Bernini. And it has been researched and written with the same aim of finding out how that city came about which the author for sixty years had known—and not known. In a way, then, the present book is part of a third volume of *Rome: Profile of a City, 1560-1700*; a volume which together with a second volume, covering the intervening years, 1300-1560, I would have written, were I twenty-five years younger. To start that enterprise now would be foolhardy.

None of the great building popes from Julius II to Urban VIII, not even Sixtus V, changed the face and the image of Rome as much as Alexander. His are Piazza S. Pietro, Piazza Colonna, Piazza del Popolo; his S. Maria della Pace and its square, his S. Maria in Campitelli and Piazza del Pantheon; his finally dozens of projects to change the urban fabric, a few carried out, some started, the majority left undone due to lack of time and funds. More important still, his as I see it, is the new image of Rome: no longer that of a great political capital; but, while still the See of the pope, a great city both ancient and modern, a focus to attract the educated of all nations and of all faiths. Unimaginable to him, he yet planted the seed whence grew the Rome of the tourists gathered from the Far East and the Far West and the Ultima Thule.

No wonder, then, that Alexander's figure and his work has attracted me for a long time. I have dealt with him in seminars and lecture courses, have investigated details of his urban planning in a number of papers which will be quoted at their proper time and have sketched the main lines of his activities in a limited edition: *Roma Alessandrina:*

The Remapping of Rome under Alexander VII, 1655-1667 (The Agnes Rindge Claflin Endowment), Vassar College, Poughkeepsie, New York, 1982.

My warm thanks for the inestimable help in completing the present book go to the Bibliotheca Hertziana, the Vatican Library and Archive, to the Archivio di Stato in Rome and to their staffs, always willing and ready to help. Special thanks are due to Dr. Eva Stahn, in charge of the splendid collection of Rome photographs in the Bibliotheca Hertziana, who generously gave her time and knowledge to my search for illustrative material; to Eric Frank and Derek Moore who at various times assisted me tracking down and copying out archival material; to the photographers of the Bibliotheca Hertziana, Mrs. Gaby Fichera and Mr. Franz Schlechter to whom a great number of the illustrations are due; to Mary V. Bartman who produced a letter-perfect manuscript; and to Marilyn Campbell, editor, and Susan Bishop, designer, of Princeton University Press.

THE ROME OF ALEXANDER VII

Prelude

IN 1665 there appears in Rome a volume of plates, *Il Nuovo Teatro delle fabriche et edificij in prospettiva di Roma moderna sotto il felice pontificato di N.S. Papa Alessandro VII.* Engraved by Giovanni Battista Falda and published by Giovanni Giacomo Rossi, it contains views, *vedute*, of Piazza S. Pietro, of the Scala Regia, of Piazza del Popolo, Piazza Colonna and Piazza della Pace with its church, Piazza della Rotonda with the Pantheon, the Pyramid of Cestius, S. Maria in Via Lata along the Corso, Piazza del Collegio Romano and the Sapienza with the dome of S. Ivo as seen from Piazza S. Eustachio (figs. 1, 2, 3); thirty-three engravings all told, not counting the title and dedication pages. Short captions point out Alexander's interventions—new constructions, restorations, buildings finished and decorated inside, streets widened, straightened and graded, squares enlarged—these foremost. All through the volume, indeed, it is the squares and the streets that the draughtsman focuses on wherever possible. Churches, palaces, houses and old Roman buildings stand on the rim of these squares, or along the flight of a street, integrated with them. Where they rise on the edge of town, like St. Peter's Square or the Pyramid of Cestius, they link up with the surrounding hills and trees. Modelled in light and shade and presented in wide vistas, *in prospettiva* as the title page promises, Falda's plates give a picture full of life of the "modern Rome" created by the structures and buildings—*fabriche et edificij*—laid out and created by Pope Alexander VII. The dedication to the pope's brother, Don Mario Chigi, further explains the publisher's aim. Some, it says, have maintained that "Rome could no longer be seen in the very midst of Rome"—meaning that the grandeur of Rome, ancient Rome, was gone. These *vedute*, on the contrary, were to show Rome risen again by new splendours to her glory of old; structures and ancient monuments, erected or rediscovered: all were the immortal works of the piety and munificence of Alexander.

The first book, apparently a great success—the edition must have been large, judging by the many surviving copies—was followed two years later by a *secondo libro* of but seventeen plates with only fifteen views: a few sights in Rome, completed by 1667—Piazza del Pantheon, two plates of Piazza della Minerva, the façade of the palace on Piazza SS. Apostoli; and others outside the city, the churches in Castel Gandolfo, Ariccia and Galloro, and the arsenal in Civitavecchia, all built under Alexander. A third volume dedicated to Clement IX, Alexander's succesor, again called *Nuovo Teatro* but obviously omitting Alexander's

3

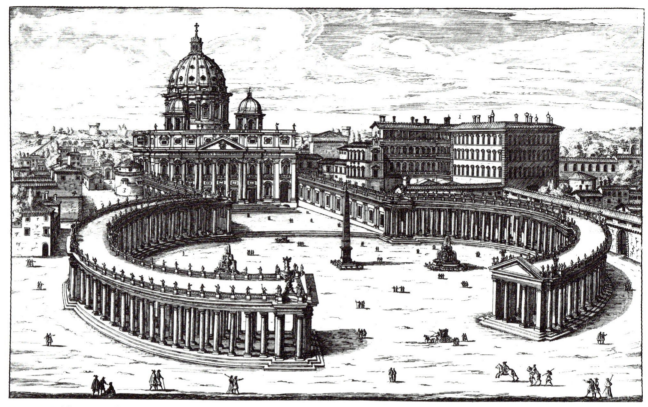

1. G. B. Falda, view of
Piazza S. Pietro as of 1665

name, and subtitled *Le chiese di Roma*, comprises two leftovers from
Alexander's time, Piazza S. Pietro without the *terzo braccio* and S.
Andrea al Quirinale as it was to be completed by 1671; but the other
twenty-six views represent a sampling of sixteenth and seventeenth
century churches in Rome. A fourth volume, engraved by Alessandro
Specchi and published in 1699, was given over to views of Roman
palaces. It still uses the title *Nuovo Teatro*.

Teatro, in fact, is a favourite term used by Alexander and his con-
temporaries to designate grand architectural designs. "Teatro dei portici
attorno a Piazza S. Pietro"; or "quel gran teatro intorno la piazza"; or
"la fabrica del nuovo teatro . . ."; or simply, in a late diary entry of
Alexander's, ". . . piazza del teatro di S. Pietro" occur over and over to
refer to Bernini's colonnades. Similarly, Alexander speaks of the "Teatro
della Pace," meaning the prospect of the church of S. Maria della Pace
jointly with the small five-sided square in front, enveloped as it is by
palatial façades concealing very ordinary houses.

Teatro in sixteenth and seventeenth century usage has many mean-
ings. Primarily it refers, needless to say, to Roman theater buildings as

4

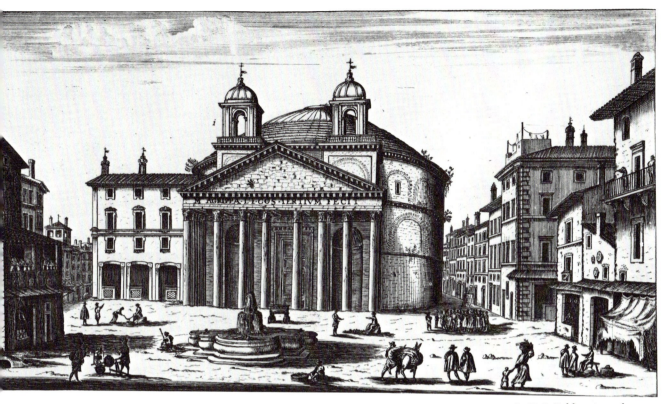

2. G. B. Falda, view of
Piazza del Pantheon as of
1665, before grading

the Renaissance knew them from reading Vitruvius and from looking
at the Theater of Marcellus or also at the Colosseum: huge buildings,
semicircular or, if amphitheaters, round or oval, the seats rising in
multiple steps along the inner curve and facing the stage or else the
arena. Strange as it is, the first *Vocabolario della Crusca* in 1612 refers,
in fact, to an amphitheater in defining the word—"a round building
where spectacles are presented"; and the same explanation is given still
in 1681 in Baldinucci's *Vocabolario Toscano dell'Arte del Disegno*.
However, that contrasts with the usage among architects and theore-
ticians of architecture. To them, ever since Alberti, theaters were sem-
icircular; a definition at which the editors of the *Crusca* seem to arrive
only in 1686—"an edifice where spectacles are performed, semicircular
in plan"; the philologists were apparently lagging. In fact, the meaning
of *teatro* was often restricted to refer to the spectators' area—a niche
filled with seating steps, for instance.

It has been suggested that in Alexander's day the term *teatro* was
applied to Piazza S. Pietro because of its oval shape. As an *ex post facto*
explanation, that appears to have been on the minds of some learned

5

or would-be learned contemporaries—the piazza "being enveloped by a magnificent portico which gives it the shape of a theater this being oval in plan"; just as the huge hemicycles framing fountains and water plays at Villa Mondragone and Villa Aldobrandini at Frascati, the *teatri d'acqua* or simply *teatri*, would call to mind by their shape Roman theaters. But such associative explanations won't work: the porticoes planned to enclose St. Peter's Square were already called a *teatro* at a time when the piazza was still envisaged as rectangular. And surely, there is no oval nor for that matter hemicycle to be associated with the "Teatro della Pace." One wants a broader explanation for the term as used by Alexander and his contemporaries.

After all, *teatro* in the sixteenth and seventeenth centuries did not refer to only the shape of ancient amphitheaters or theaters or to their spectators' area. From the start the term referred to the stage as well. Chantelou, Bernini's Boswell in France, in recounting an anecdote told by the latter, calls the stage *le théâtre*. At the same time *teatro* means not only the stage but what happens on the stage: the action, the performance, the spectacle. It is what Du Bellay, writing in 1558, has in mind:

> . . . Rome est de tout le monde un publique éschafault
> Une scène, un théatre auquel rien ne default
> De ce qui peult tomber ès actions de l'homme
> Icy se void le jeu de la Fortune. . . .

Thence the term was easily transferred from the theatrical to other kinds of action. To Pallavicino, Alexander's biographer—we shall hear of him later on—the celebration of a *Cappella Pontificia*, a mass read by the pope or in his presence, surrounded by the Cardinals' College, is a *teatro* ". . . at which the people enjoy the greatness of the princes and the meekness of the clergy." In short, the celebration or, for that matter, the stage play, is a show worth seeing and meant to be enjoyed. So is the setting in which the action takes place: the choir of the church where mass is celebrated; the square across which the papal cortege moves; the stage set against which the play is performed—they are constituent elements of the *teatro*. The buildings and their membering are part of the action, they become, as it were, actors in the show. Thus it happens that as early as 1611 or thereabouts a counterproject to Maderno's façade of St. Peter's is described as "swinging back in the middle"—the hemicycle of a theater is associated with the plan—"the two *campanili* going together with the small domes, so that they would appear in the shape of a *teatro* to those on that square." The building itself is the main actor and performs the grand show to be admired by the spectators.

6

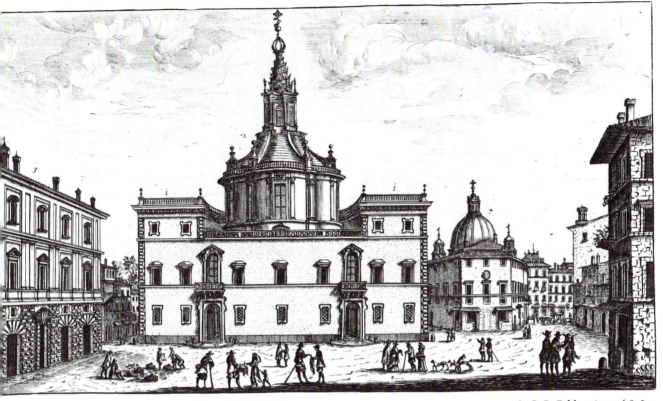

3. G. B. Falda, view of S. Ivo and Sapienza from Piazza S. Eustachio

It is in this context, as a show, that the use of the term *teatro* by Alexander and his contemporaries, Falda foremost, wants to be understood. The *teatro dei portici di S. Pietro*, the *teatro della Pace*, are shows worth seeing. It is such *teatri*, shows or showpieces, with which Rome becomes studded through the building activities of Alexander VII. Concomitantly Falda's *Nuovo Teatro* is the grand "New Show" of the squares (they in the first place), streets and buildings of modern Rome laid out and erected "in the felicitous pontificate of Alexander VII."

1. The Man and His Time

ALEXANDER VII, Fabio Chigi before his election on April 7, 1655, was an attractive man: small and delicate, of indifferent health, with a fine-boned face and intelligent eyes; elegant of manners, speech and mind; a seventeenth century gentleman *comme il faut* (fig.4). Witty and quick—he came after all from Siena—he was well-read and a writer in both prose and poetry, whether Italian or Latin, of not common achievement. His interests ranged widely—". . . si dilettò," he says in his autobiographical notes, "di pitture, di sculture, di medaglie antiche e moderne, di archivii particolarmente, e massimo, per toccare il vero che mascherano gli historici, della città particolare." And so, a dilettante young scholar, he set out to compile lists of the old painters of Siena and to identify their works. Such scholarly interests continued: so when he asked the learned Jesuit Athanasius Kircher to report on an archaeological find made at Tusculum; or when he submitted to Lucas Holstenius, the great Latinist, compositions of his to make sure the Latin was unimpeachable and, quite remarkably, in the epitaph proposed for his ancestor Agostino Chigi, true to sixteenth century Latin form, when after all Agostino had lived. That he spent much time on antiquarian irrelevancies, "whether Achilles' beard was blond or dark . . ." is quite possible.

Alexander's education had been that customary for a cultured gentleman of that time—the classics, philosophy and, since he was preparing for a clerical-administrative career, legal and theological studies. Whether he was as deeply religious as his biographer Pallavicino assures us remains an open question; but he carefully fulfilled his religious duties and edified his contemporaries by the devotion shown in the Corpus Christi procession when he was carried for hours under a baldachin kneeling—if indeed he did—adoring the host. He was decidedly no intellectual, but he liked to surround himself with learned men—Holstenius, the polymath Kircher, Leo Allacci, Greek scholar and early Byzantinist—and provided the tools for their work by purchasing and bringing to Rome, not quite legally, the library of the Dukes of Urbino, an acquisition he greatly prided himself on. More than learned discussions, though, he enjoyed witty, spirited talk—Bernini and the Jesuit Sforza Pallavicino being his favourites. Along with them stood the severe but not unworldly Jesuit General Giovanni Paolo Oliva and the Oratorian Virgilio Spada, who acted, as he had done for Innocent X, as the pope's almoner and general man of affairs and, until his death in 1661, *éminence grise* in Rome on building activities. To be sure, they

8

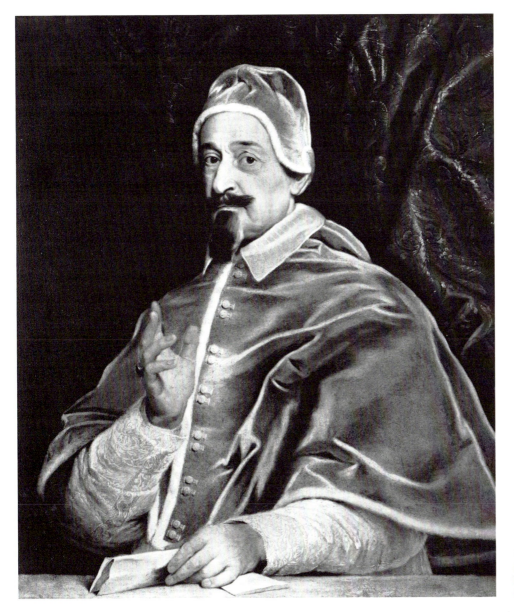

4. G. B. Gaulli, workshop, *Portrait of Alexander VII*; Baltimore, Walters Art Gallery

probably avoided discussing Borromini, Spada's difficult protégé and Alexander's *bête noire*. That he surrounded himself with a bevy of fellow Sienese, some distant or close relatives, was but natural.

Fertile of imagination—too much so at times—Alexander was ever receptive to new ideas and all too easily led on to vast and often chimerical projects. He was vain. He composed dozens of explanatory and self-laudatory inscriptions to be placed all over Rome to record his building activities—they fill half a volume in the Vatican Library, many written in his own hand and, more often than not, in several versions.

9

Like his inscriptions, his coat-of-arms or parts thereof—the oak, the mountains, the star—are to this day seen all over town. Again the medals he had struck record his accomplishments, buildings and otherwise, though buildings foremost—twenty out of twenty-six medals. Vanity, to be sure, but also more importantly a highly developed sense of public relations. It was but self-evident that he would claim among his own buildings such as the façade of S. Andrea della Valle or S. Ivo, started long before but completed under him. In the diary, too, which he kept until a few weeks before his death, he inserted long lists of his achievements, being both self-satisfied and self-reassuring, one suspects. Naturally he was open to flattery. The abate Buti in an unguarded moment confided to Chantelou that the pope had to be treated "like a child who is won over with candy and apples, that is the way to achieve one's aim—big things for small ones." The eulogies composed at his election and throughout his pontificate are legion and sheer boredom to read. The name he chose for himself, Alexander, was meant to allude to the one pope Siena had produced before him, Alexander III Bandinelli, but his courtiers and the pope himself quickly linked it to the Great Alexander—that of antiquity. Pietro da Cortona in a drawing preparatory for an engraving showed the Chigi pope being presented with a building plan by two artists, one presumably Cortona, the other the Greek Deinokrates, pointing to the background where Mount Athos rises, shaped into the figure of the Greek Alexander holding in his outstretched hand a town as projected by Deinokrates (fig. 5). As proud of himself and the place he held, was Alexander of his family—the Croesus of Renaissance Rome, Agostino, was an ancestor, if collateral. He was the more proud of him, one suspects, since only the fame remained of his riches. The Chigi in Siena had occupied a respected but modest place for the past one hundred and fifty years, before Alexander's election. Age nineteen or twenty he compiled a genealogy and history of the Chigi and a biography of Agostino; and ten years later, a young monsignor in Rome, he took care of reclaiming and restoring the two family chapels founded by his ancestor, one at S. Maria del Popolo, the other at S. Maria della Pace.

Alexander, like any pope before him ever since the late fifteenth century, relied for the government of the Church and of the Papal State on his relatives and he strove to enrich them. It has given his pontificate a black name as one of the worst for nepotism. This is true only in part. At the start of his pontificate he tried—honestly, one feels—to cope with the problem, keeping his family away from Rome; letting them come after a year, he tried in consultation with his advisers to limit by law the income allowable for *nipoti*. But the bull proposed to that effect was never issued and in the end the Chigi accumulated as many po-

5 *(facing page)*. Pietro da Cortona, *Deinokrates Shows Alexander VII Mount Athos*; London, British Museum, Dept. of Drawings

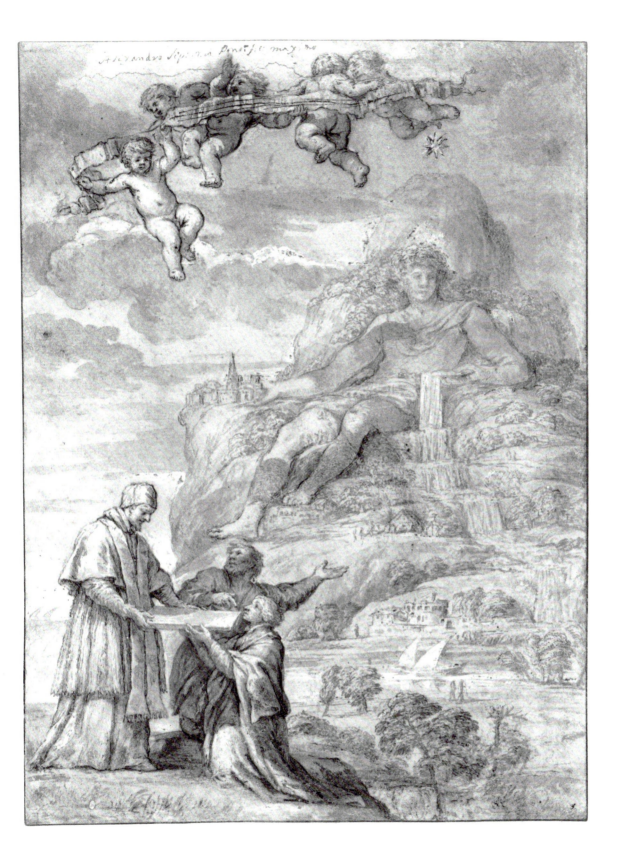

sitions, honours and riches as had the Aldobrandini, the Ludovisi and the Borghese before them. Alexander's brother Don Mario was made Generale di Santa Chiesa, commander-in-chief of the Papal armies. Mario's son, Flavio Chigi, was created Cardinal Nepote, though five years below the canonical age, made secretary of state, and heaped with benefices. To another nephew, Don Agostino, was entrusted the task of linking the Chigi, upstarts from the provinces, to the great Roman clans by marriage to a Borghese, an Aldobrandini granddaughter through her mother Olympia Princess Rossano, and through the latter's second marriage a Pamphili stepdaughter as well. Among the richest heiresses in Rome—she brought her husband a dowry of 200,000 *scudi*, the principality of Farnese and the dukedom of Campagnano—she was also expected to inherit the Borghese fortunes but that prospect went up in smoke when her sickly brother produced an heir. Similarly, other relatives were taken care of. It was nepotism, to be sure, but then, by the mid-seventeenth century, the custom had become institutionalized: governing the Church without relying on and enriching one's relatives was unthinkable, and in fact considered immoral. Moreover—this as an explanation rather than a justification—the Chigi were poor. Alexander himself before his ascendancy had been living almost exclusively on his modest salary. He had practically no choice but to build a power base through and for his family among the Roman factions. Anyhow, nepotism was a fact of life; deplorable perhaps, but not wicked in seventeenth century eyes or a burden on one's conscience. That it became only when the expense ran counter to the needs of the commonweal, as obviously it did under Alexander. What contemporaries blamed him for was apparently that the conflict did not waken his conscience.

Prior to his election, Alexander had spent most of his career in the diplomatic service of the Church; his most important post having been at Cologne, where for five long years he negotiated the Treaty of Westphalia which ended the Thirty Years' War. That treaty was signed at Münster in 1648 over his protest, sealing the defeat of the Church both politically and materially by recognizing for all practical purposes the equal status of the Protestant churches and countries. Alexander never overcame the "trauma of Münster." At the same time he held the highest opinion of the sublime status of the papacy and the homage due to it notwithstanding its defeat, and of his own role as pontiff. He strove to play his part to perfection, being punctilious in performing all ceremonies. Also, as one would expect in a contemporary of Louis XIV, he "surrounded himself with men of high birth." The papacy to him, in the face of all his experience to the contrary, towered both temporally and spiritually over all secular kingdoms. Pope Alexander III was memorable, so Pallavicino explains, "for his fortunate defence

12

of the papal dignity against the major powers and for that reason the Chigi Pope had chosen his name; his having been the one pope in the past to come from Siena was another reason." Torn between this his firm belief, his memories of the defeat suffered by the Church and his unwillingness to recognize the new political realities, his policies, both when secretary of state under Innocent X and as pope, were vacillating. Contemporaries, less than charitable, called him timid and undecided and there is some truth in the accusation that "wanting to have his hand in everything . . . the large number of affairs leads to the majority's waning out before a decision which never takes place." Whether or not he was as lazy as the same pamphlet has it, he seems to have withdrawn increasingly from affairs of state as time went on, ". . . so as to bear the name of pontiff rather than the effectiveness of the pontificate." Also, headstrong as he was, he overrated the political clout of the Church and constantly ran into trouble with the superpowers France and Spain. In particular, constant friction existed with France and her leaders, first Mazarin, then the young and equally self-assured Louis XIV. In the end he left the papacy as a political power weaker than it had been at the beginning of his pontificate.

Of matters financial and economic Alexander appears to have been both innocent and heedless. The situation in the Papal States and in Rome in particular inherited by and increasingly deteriorating under him could hardly have been worse. The Venetian ambassador in 1661, hardheaded businessman that he was, gives an unvarnished picture. The population had dwindled, due in part to the plague that hit the region in 1656. However, the principal reason for the shrinkage was the economic decline which in the whole of Italy and particularly in Rome had begun around 1630. In the city of Rome the number of inhabitants, stabilized from 1645 at around 120,000, dropped from 123,000 to 100,000 between 1655 and 1657 to rise very slowly over the next decade to 110,000; in the diocese of Terni it fell from 10,000 to 7,000 souls. Unemployment, always high, had become chronic. By 1661 the state debt, represented by government loans, *monti*, had reached 39 million *scudi*. At the time of his death it was estimated to have reached the 50 million mark. The "ordinary" revenues from taxes, estimated at below 2 million *scudi* and falling with the population decline, barely covered the interest due on the *monti*. The "extraordinary" revenues from office sales, dispensations and contributions from the Catholic powers, Spain foremost, were irregular and likewise declining. The remedies tried by Alexander were as risky as they were inefficient: raising taxes had its limits and was politically undesirable; reducing interest on the *monti* and redeeming them at par, considerably below their market value, and pocketing the difference, shook the credit system; issuing even more

depreciated *monti* only raised the debt. Restricting expenses apparently never crossed Alexander's mind: neither the donations to the *nipoti* nor other gifts nor building activities were ever curtailed. But catastrophic as it was for the Papal State and the well-being of his subjects, Alexander's financial short-sightedness and unconcern enabled him to give Rome in the course of a mere twelve years a new face and to provide her with a new image.

As a patron of the arts Alexander's figure is strangely ambiguous. For painting he apparently had little feeling. He gave no large commissions and he did not employ any of the leading painters of his day. None of the great fresco decorations in the churches of Rome was commissioned by him and most of the work in the papal palaces and in the Nepote's palace at Piazza SS. Apostoli dates from after his time; so do Gaulli's large fresco cycles in the Gesù and in S. Agnese a Piazza Navona. The only sizable painting decoration undertaken for him, the gallery of the Quirinal Palace, was to be sure designed by Pietro da Cortona—a large-scale architectural frame formed by twin columns placed in niches and supporting broken entablatures; but the paintings framed by that fictitious architecture were entrusted to a team of artists among whom only a few—Mola and the young Maratta—stand out; the majority are not from the top drawer and two are rather inferior—obviously included by Alexander because fellow Sienese. One of them, Raffaele Vanni (his father had been one of Alexander's godparents) was also commissioned to paint the dome of S. Maria del Popolo, but Alexander did not like what he saw. Much in contrast to his contemporary Camillo Pamphili, he built up no collections of paintings or of ancient or modern sculpture. Presumably he did not want to divert funds from activities closer to his heart; and certainly his taste in painting was insecure. He did spend a good deal on objets d'art, on silver and gold plate, on textiles, lace and embroideries as did every seventeenth century gentleman of means. But what really counted to him was architecture and sculpture, the latter primarily when placed in an architectural frame and done by Bernini: his own tomb monument in its niche at St. Peter's; the Cathedra Petri in the apse; the Constantine on the landing of the Scala Regia at the north end of the narthex. And needless to say he loved the portraits, busts or reliefs that Bernini did of him.

Architecture, though, on a large scale, was what Alexander passionately cared for: splendid buildings in an urban context. Just as Cortona had depicted him he viewed himself a new Alexander, a founder of cities.

2. The Urban Substructure: Streets, Coaches, Shopping Centers

WHEN Alexander was elected pope the map of Rome in its essential outline had little changed over the preceding fifty years. The population having stabilized at around 120,000 or somewhat less, the *abitato* did not expand beyond the limits reached by 1630: northeast of the Corso it reached just beyond Piazza Barberini; southeast of Piazza S. Marco—much enlarged around 1900, it has become Piazza Venezia—it had advanced a few streets beyond the Madonna dei Monti; south it still stopped at the Theater of Marcellus (fig. 6). The *disabitato*, to be sure, opened up ever since the sixteenth century by villas and roads, continued to change: large new villas had been laid out and were increased in size and number: Villa Ludovisi since the first twenty years of the century had sprawled all over the south slope of the Pincio adjoining Villa Medici; opposite, on the north slope of the Quirinal, rose Palazzo Barberini, its park extending as far as S. Susanna. On the south slope of the Esquiline, below the huge Villa Montalto-Peretti, begun by Sixtus V before his election and which by 1588 covered the entire crest of the hill, Cardinal Nerli had built a smallish villa. Opposite, on the north slope of the Celian and extending not quite up to the Lateran, the Giustiniani had established themselves in the early seventeenth century. These new villas, in addition to the sixteenth century villas on the Quirinal, the Celian and the Palatine—Villa Mattei and the Orti Farnesiani—were turning the eastern *disabitato* into a zone of private parks in a huge crescent from north to south. That green belt continued across the river onto the slope of the Gianicolo with the Riario and Salviati gardens, not to mention the huge Villa Pamphili outside the walls on the crest of the Gianicolo, laid out and expanded continuously from 1624 to the forties and fifties.

The *abitato* had changed far less. True, new quarters had grown in the course of Rome's sixteenth century expansion on the outskirts in the *rioni* Campo Marzio, Colonna and Monti, laid out in a grid system with straight and comparatively wide streets. But the inner core of the city retained its old narrow, dark and dank streets, winding and crooked, many still unpaved and muddy, filled with refuse and impassable after a rain. There were few squares—Piazza Farnese, Campo dei Fiori, Piazza Navona; but that in 1655 was still a building site for S. Agnese. The others were, for the most part, no more than widenings of streets; these were taken up by market stands and clogged by traffic—mules, litters,

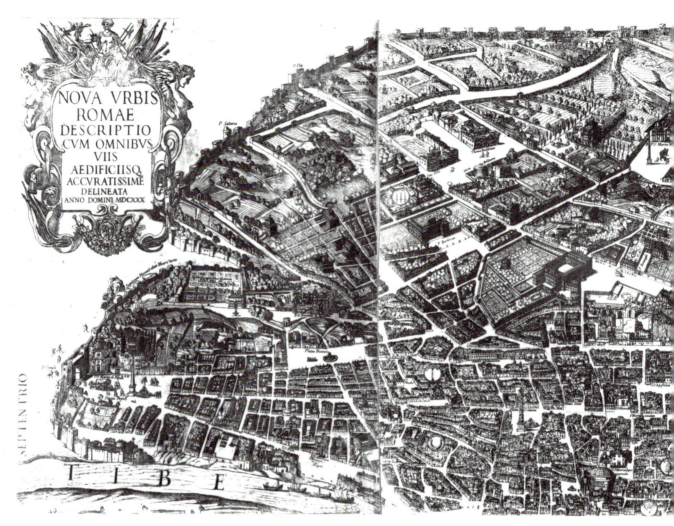

6. G. Schayck, Map of Rome as of 1630, showing *abitato* and *disabitato*, northeastern sector

porters carrying huge burdens, coaches and carts. Houses, in the inner city densely crowded, were unequal in width and height, lining the streets in a disorderly jumble and projecting beyond or retiring behind the streetline. To be sure, palaces and churches had been built in huge numbers throughout the sixteenth and early seventeenth centuries and continued to be built in the thirty years prior to Alexander's reign. But with a few exceptions—the Pamphili Palace and S. Agnese, their church in Piazza Navona, the Barberini Palace on the outskirts—they had been plunked down incongruously between the higgledy-piggledy houses. Their façades were hard to see in the narrow streets, and many remained unfinished for lack of funds or loss of interest on the part of the owners, whether private families or ecclesiastical institutions. It was not the Rome Alexander envisaged as the capital of the Church and as his own.

16

His was to be a new Rome, with the imprint of his personality, a *Roma Alessandrina* (fig. 7). He was not interested in laying out either in the *disabitato* or beyond the walls a huge Chigi villa as the Ludovisi, the Borghese and the Pamphili had done. On the contrary, it was the *abitato*, the built-up old town, that he meant to change. However, tracing new streets or clearing entirely new squares in the overbuilt inner town was not easy. Buying up real estate or indemnifying the owners of houses slated for demolition was costly already by the end of the sixteenth century. It was prohibitively expensive half a century later. Much as Alexander may have regretted it, he could not lay out any major street.

If he could not afford cutting major thoroughfares into that tangled, overbuilt, high-priced web of streets and housing that was the inner town, improving the street system as it existed became a foremost task. A flattering public duly took notice of even minor links opened up and streets straightened. Agnelli's map of 1666 enumerates such modest enterprises as rectifying the short stretch of a street from Piazza S. Apollinare to S. Agostino, opening a parallel street, now Via S. Giovanna d'Arco, or correcting the one from Piazza Capranica to Piazza della Maddalena, now Via delle Colonnelle. Alexander himself did not think it worth the composition of inscriptions for such streets. It was just a job to be done. Nor did he think it anything great to trace a new street on the rim of town: Via Baccina was broken through behind the Madonna dei Monti to link two comparatively recent suburbs, but "it's not worth bearing the pope's name," he notes in his collected inscriptions next to the one proposed for that street.

If new streets could not be cut through the core of the old town, old ones of importance and those much-travelled by people who counted could be improved and squares built over could be cleared. Bettering and keeping up the street system was from the outset much on Alexander's mind and he was proud of what he got done. One of the first actions taken and recorded in his diary was to infuse new blood, hardly three months after his election, into the *Congregazione delle Strade*, the supervisory organ for maintaining and ameliorating the streets, nominating a new chairman, the *presidente delle strade*, a papal appointee—Monsignore Neri Corsini for a number of years—and to have new men elected by the municipality to the executive organ, the *maestri di strade*. Domenico Jacovacci, one of the *maestri* from 1658 until his death in 1662, a man "old in habit but modern in spirit," became a close confidant and a reliable collaborator in the pope's remapping projects. Nor did Alexander spare laudatory inscriptions where he thought them warranted. The approaches to the papal palace on the Quirinal—Monte Cavallo as it was called—his favourite residence, had to be taken

17

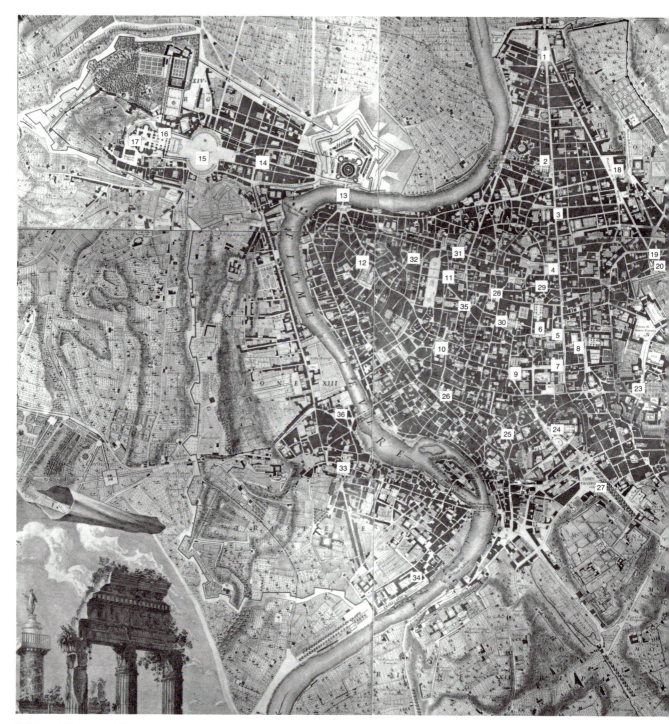

7. Map of Rome, marking
Alexander's street correc-
tions, piazze and buildings

1 Piazza del Popolo.
2 S. Carlo al Corso.
3 Via del Corso.
4 Piazza Colonna.
5 S. Maria in Via Lata.
6 Piazza del Collegio Romano.
7 Piazza Venezia and Via del Gesù (Plebiscito).
8 Palazzo Chigi (Odescalchi) on Piazza SS. Apostoli.
9 Piazza del Gesù.
10 S. Andrea della Valle.

11 Avenue leading to S. Andrea della Valle (project).
12 Piazza di Monte Giordano.
13 Ponte S. Angelo.
14 Avenue leading to Piazza S. Pietro (project).
15 Piazza S. Pietro.
16 Scala Regia.
17 Cathedra Petri.
18 Access to Trinità dei Monti (project).
19 Via Babuino-Due Macelli continued to foot of Quirinal Gardens (project).
20 Stairs and gate to Qurinal Gardens (project).

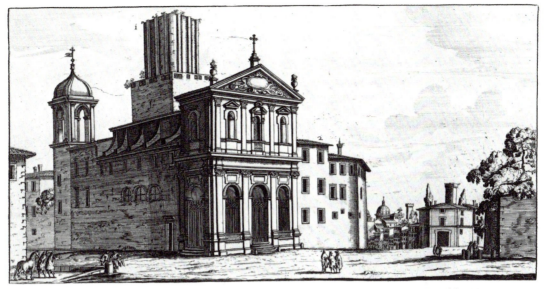

8. G. B. Falda, Piazza
Magnanapoli and approach
from town as of 1665

care of. Via Dataria, which ascends from near the Trevi Fountain, was
graded and the achievement was recorded in an inscription composed
by the pope in several variants: ". . . a road is now where a mountain
was . . ."; "by this great ascent with ease you reach the Quirinal . . .";
". . . graded the arduous slope, softened the approach for the visiting
people . . ."—but to tell the truth it is still quite a climb and coaches
must have had a hard time. The approach to the Quirinal from Piazza
S. Marco, now Venezia, the link to the old town and the route to St.
Peter's, was likewise graded; ascending from the Column of Trajan by
way of the Tre Cannelle and Piazza Magnanapoli it climbed to Piazza
del Quirinale (fig. 8)—Alexander usually travelled it when returning
from an outing in his sedan chair. Even so, it remained steep before
being levelled a hundred years ago when Via XXIV Maggio was dropped
eight meters, inconsiderately leaving the church of S. Silvestro al Quir-
inale high above street level.

Alexander's main concern, however, in the network of Roman streets
centered upon the Corso, the Via Lata, which had run since ancient
times from Porta del Popolo south to what was then Piazza S. Marco,
the narrower predecessor of today's Piazza Venezia. Ever since the fif-
teenth and more so in the second half of the sixteenth and the first half
of the seventeenth centuries the Corso had become the noblest street

21 New wing of Quirinal Palace ("manica lunga").
22 S. Andrea al Quirinale.
23 Approach from Piazza Magnanapoli to Quirinal Palace.
24 S. Rita di Cascia, foot of Capitol.
25 Piazza Campitelli and church.
26 S. Carlo ai Catinari and convent of Barnabites.
27 Forum Romanum with trees.
28 Pantheon.

29 Piazza di Pietra.
30 Piazza della Minerva.
31 Piazza S. Agostino and projected shopping center.
32 Piazza della Pace and church.
33 Piazza S. Maria in Trastevere.
34 Ripa Grande.
35 S. Ivo della Sapienza and Sapienza rear façade.
36 Via S. Dorotea.

19

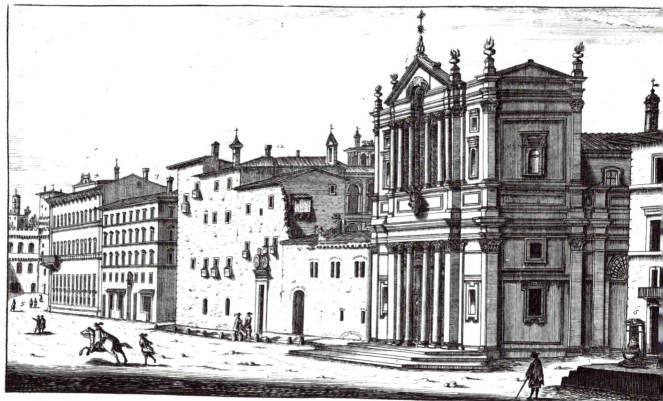

9. G. B. Falda, Palazzo Aldo-
brandini-Santori-Pamphili as
of 1665, adjoining S. Maria
in Via Lata as completed

10. Palazzo del Bufalo as of
ca. 1880

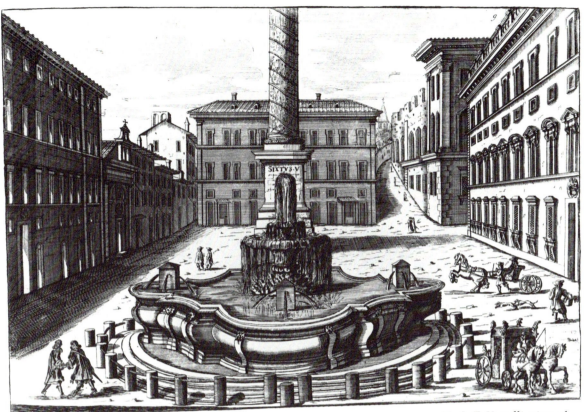

11. G. T. Vergelli, view of
Piazza Colonna and Palazzo
Ludovisi-Montecitorio, *Le
Fontane publiche delle
piazze di Roma moderna*,
Rome, 1690, pl. 9

of Rome, a favourite site for erecting large and at times distinguished
palaces and churches or remodelling old ones. But these structures, by
Alexander's time, were outmoded; others remained unfinished,
crowded in by humble houses. The street looked not so different in
1655 from half a century before. On the south stretch of the street rose
the early sixteenth century palace of Cardinal Santori, incorporating
some older mansions and itself incorporated into an Aldobrandini pal-
ace, mean-looking still in 1665; the whole swallowed up seventy years
later by the sprawling mass of Palazzo Doria-Pamphili (fig. 9). Next to
it stood S. Maria in Via Lata, its interior splendidly refurbished in the
1640's, its façade still naked; across the street S. Marcello al Corso
likewise faced the Corso with a bare front. A hundred meters further
north Palazzo Sciarra was, to be sure, completed, but it was then nearly
half a century old and anything but stylish. So was the Palazzo del
Bufalo at the south corner of Piazza Colonna; although completed only
in 1650, it looked outmoded and, to boot, demeaned by rows of shops
facing Corso and piazza—unacceptable in a modern palace really *da
signori* (fig. 10). Opposite, where the Galleria now sprawls, stood Palazzo
Veralla—a jumble of structures, never finished. On the north corner of

21

12 (*at top*). Anonymous, view of Via del Corso as of 1632, west face looking south from Via delle Convertite (Piazza del Parlamento), showing the Theodoli, Verospi and Aldobrandini-Chigi and Bufalo palaces, the latter two flanking Piazza Colonna; Rome, Collection Marchese Theodoli

13. Anonymous, view of Via del Corso as of 1632, east face, looking south, opposite fig. 12, showing church of the Convertite

the piazza another Aldobrandini palace in 1655 was a mere fragment. Further back on the rise of Montecitorio loomed another far more impressive ruin, Palazzo Ludovisi, begun by Bernini in 1650 and stopped three years later when the prince fell into disgrace and his wife's uncle, Pope Innocent X, had the materials carted off for the construction of S. Agnese in Piazza Navona; it remained a ruin for another fifty years (fig. 11). Next to the Aldobrandini palace on the Corso stood a small house, followed by the elegant Verospi and the Theodoli Palace (fig. 12); but across the street old houses crowded in on the unfinished church of the Convertite (fig. 13). Northward rose Palazzo Rucellai-Ruspoli on the corner of Via Condotti—at least the wing towards the Corso looked presentable—and S. Giacomo degli Incurabili. But all were unfashionable in mid-seventeenth century eyes. In between, there loomed the huge fragment of S. Carlo al Corso—only the nave completed in the rough, lacking chancel, dome and façade. Opposite S. Giacomo degli Incurabili near the upper end of the Corso the church of Gesù e Maria, begun 1633, was equally unfinished. Moreover, in between these half-finished, unfinished and completed but old-fashioned churches and pal-

22

STRADA DE PONTEFICI

STRADA DEL CORSO

14. G. Vasi, Palazzo Ruspoli and Corso looking south, as of 1752, terminated by Capitol

15. Corner of Via del Corso and Via dei Pontefici as of 1656; BAV, Chig., P VII 13, f. 28r

aces stood dense rows of modest houses, some raised to four floors, others low, all mean, interspersed with empty lots (figs. 14, 15).

It was an indecorous sight, incompatible with the concepts of dignity and decorum so prominent in seventeenth century thought. However, Alexander could do little to have unfinished buildings brought quickly to completion. Of the palaces he had the Aldobrandini one on Piazza Colonna bought for his family—it consequently became Palazzo Chigi;

23

but terminating the construction of the huge building took another generation at a cost of many hundred thousand *scudi*. Most owners of unfinished palaces just did not have that kind of money. They either camped comfortably in the parts of the structures completed or they lived in their villas within or beyond the walls, as did the Ludovisi and the Pamphili—and there were bitter complaints about it. The pope tried to exert some pressure on Prince Ludovisi about continuing construction at Montecitorio "showing him from one of the [Quirinal] windows the palace started and telling him it was no good so . . . ," but the prince truthfully pleaded his lack of funds. About the unfinished churches he could bring his influence to bear more strongly: at S. Maria in Via Lata, narthex and façade were started by an obliging canon, Atanasio Ridolfi, a fellow Tuscan and a protégé of Alexander's from way back when he was nuncio at Cologne. When funds ran short half a year before Ridolfi's death, the pope took over and had the work completed over the following two years. Work at S. Carlo al Corso, interrupted for many years, was taken up again late in his pontificate, funded by another of his protégés, but only completed a quarter of a century after the pope's death. Finishing buildings just took a lot of time and money.

What could be done at comparatively small cost was having streets cleared and straightened; an eminently practical task, but more than that. A *chirografo* of Alexander's on August 7, 1660 granted the *maestri di strade* overall authority to straighten, enlarge and clear streets and squares; and to that end to expropriate and demolish houses and palaces, wholly or in part. The decree, moreover, validated *ex post facto* such demolitions undertaken previously, specifically on Piazza Colonna, Piazza del Collegio Romano, Piazza S. Marco-Venezia, along the street from there to the Gesù and along the Corso. There, a Roman triumphal arch, known as the Arco di Portogallo, spanned the Corso just north of Via della Vite, narrowing the freeway to nearly half its width, from 9.6 to 5.5 meters; Alexander had the obstacle removed, if with some qualms (fig. 16). Protruding housefronts all along the street were cut off like so many offending noses: three just above Piazza Colonna opposite Palazzo Aldobrandini-Chigi; others south of the square on either side of the Corso and near Piazza Sciarra. Conversely, houses receding behind the streetline were extended forward, such as that of the pope's court jeweller Moretti at the corner of the Corso and Via dei Pontefici—the whipping post on the sidewalk in front of the old house was moved a block to the north. Modest though such adjustments were, they meant a great deal in Alexander's vision of the renewal of Rome. The tablet he had fixed to the corner of Via della Vite claims that through him "Via Lata the racecourse of the city on festive days"—he is thinking of the Carnival races held there since the fifteenth century, but by using

24

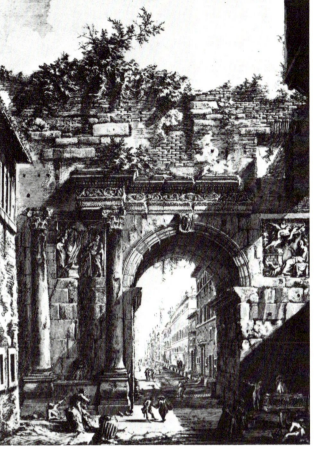

16. G. B. Piranesi, view of
Arco di Portogallo spanning
Corso as of ca. 1650, based
on Israel Silvestre(?)

the ancient term *hippodromum* he projects the custom back to antiq-
uity—"deformed by structures intervening and buildings protruding,
has been freed and straightened for public convenience and beauty." In
another version in his own hand he specifies more precisely yet that
the street "was put out of joint [*denormatam*] by the corners of the
houses pushing forward. . . ." The reference to antiquity and the wider
aims on his mind become more obvious still in yet another variant he
tried out: "The Roman stadium"—again the backward projection in
time—"once athwart and narrowed [*angustam*] by many a structure has
been made straight and august [*augustam*] and returned to royal splen-
dour by Alexander the city's widener [*amplificator*]."

Returning Rome to her "ancient splendour"—and whatever that
meant to his contemporaries it comprised grandeur and decorum—was
no doubt the ultimate aim of Alexander's urban planning. But this final
goal tied up with considerations both practical and esthetic. Straight
streets made for orderliness and they eased traffic conditions. Rome by

25

PROSPETTO DEL PALAZZO PONTIFICIO NEL QVIRINALE DETTO MONTE CAVALLO
Con la solenne comparsa delle sontuose Carrozze dell'Ecc.mo Signor Prencipe Antonio Floriano de Liechtenstein, Prencipe del sacro Romano Imperio, Duca di Tropau, dorff Conte di Rutberg, Signore hereditario in Rumburg, Cavaliere della Chiave d'Oro di sua Maestà Cesarea, e suo Ambasciatore alla sede Apostolica.

17. G. Wouters, Coaches of
Imperial ambassador leaving
Quirinal Palace, 1692

the mid-seventeenth century had run into a traffic problem nearly as bad as today's. Since the 1560's coaches increasingly had been replacing the conveyances previously in use—sedan chairs, litters, saddle horses and mules. Wolfgang Lotz in 1973 published a list of 883 coaches counted in Rome in 1594. By that time, and even more so by the mid-seventeenth century, coaches, like cars today, had become both a convenience and a status symbol. Conversely they had turned into a public nuisance and had created a serious urban problem. Lawyers, doctors, ecclesiastical dignitaries, ambassadors and nobility owed it to themselves to go by coach. They vied with one another in the number and luxury of their carriages, seating up to six, three in a row and drawn on state visits by four, six, or even eight horses (fig. 17). Romans around 1660 may not have gone as far as their descendants did a hundred years later when "the love of shew [being] the charakteristick of an Italian

26

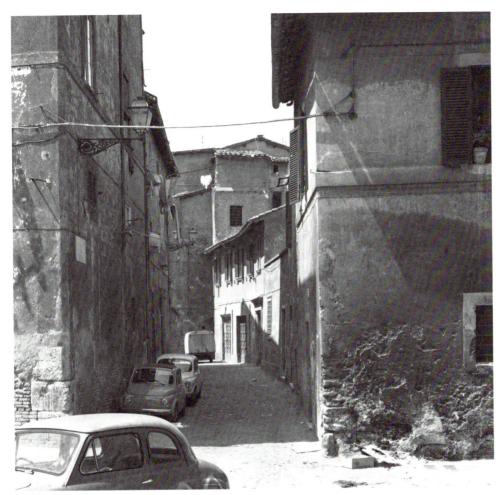

18. Vicolo del Cipresso

. . . a coach and servants seem to be the first object and when they are provided they do as they can for the rest . . .''; but they probably did not remain very far behind in wanting to make *bella figura* on the daily *corso*. Up to a hundred coaches would go to meet an honoured guest, the ambassador from Parma or the one from Malta; and Queen Christina of Sweden, the royal if somewhat embarrassing convert to the Catholic Church, was met by a reception committee headed by two cardinals and accompanied by many coaches, each with six horses, ten belonging to the cardinals and the rest to the other gentlemen.

But the streets of Rome were hard to negotiate even with but two horses (fig. 18) and any luxury coach would have had a hard time passing through the Arco di Portogallo on the Corso or any minor street. Quarrels over precedence, so prominent a point within the seventeenth century social code, were common: horses were unhitched to leave the

19. Warren of streets south
of Via dei Coronari, airview

carriage blocking the street to the opponent's coach, gentlemen drew
swords, *monsignori* were beaten up. Parking was difficult in front of
churches on high feasts, in front of palaces on days of big receptions;
as early as 1607 Maffeo Barberini, later Pope Urban VIII, was occupying
new accommodations because the old Barberini palace in Via dei Giub-
bonari in the inner town had narrow approaches and little space in front
where coaches might park—"angusto d'entrata et ha poco piazza avanti,
onde non ci possono star cocchi." Clearing squares, widening and

28

straightening streets and removing vendors' stalls, bollards and stairs and stoops protruding into squares and streets were a practical and increasingly urgent necessity in remapping Rome (fig. 19).

None of this was easily done. House owners and tenants would object to removing a commodious stoop or rebuilding a staircase so as to do away with outside steps. Tradespeople would resist abandoning a convenient stall projecting from their shop into the street. And they would cry out loudly against having the fronts of their houses cut, rooms halved or turned triangular—and all this so as to have a street straightened, a piazza squared off, traffic conditions improved, public thoroughfares look more decorous or, indeed, the city appear more beautiful. But of course, this was Alexander's ultimate aim; for, as he states, ". . . public squares have been laid out as an embellishment of the city, *per ornamento della Città*, and we want them to be free and cleared of all encumbrances"; and streets as well, obviously.

Long straight streets had been considered both a practical need and an esthetic ideal ever since the urbanization of the Campo Marzio, starting in the first decades of the Cinquecento, and the coterminous tracing of Via Giulia on the southwest rim of the old town, along the Tiber. They had become a hallmark of the expanding map of Rome in the second half of the century: in the new checkerboard quarters from Piazza di Spagna to the Corso; in the Borgo Pio from the Vatican to Castel S. Angelo; and in the conquest of the *disabitato* from Pius IV to Sixtus V running along the crest of the Quirinal and star-shaped from S. Maria Maggiore to the Trinità dei Monti, the Lateran, S. Croce and the Column of Trajan on the edge of the old town. Domenico Fontana near the end of the century had commented on the beauty of the endless streets he had laid out for Sixtus V "as if drawn with a ruler not minding hills and valleys." The ideal was upheld by Alexander VII and his planners. Like the Corso, the two streets perpendicular to its south end across the upper end of Piazza S. Marco-Venezia were regularized so as to form a long vista: the westward street, then Via del Gesù, the first stretch of the main route across the inner town to St. Peter's, and the eastward street, Via Cesare Battisti, then Via S. Romualdo and much narrower, leading to Piazza SS. Apostoli and beyond to the Quirinal Palace. At the corner of the Corso with Via del Gesù (fig. 20), now Via del Plebiscito, the protruding front of a palace was torn down in 1658; on the remaining site the *cavaliere* Francesco d'Aste built the elegant small palace which to this day faces Piazza Venezia. Other offending houses further down the street at the same time had to go, both in the broad first stretch—it had been widened in 1536 to nearly twenty meters, its present width—and in the second tract, narrower, but still over twelve meters wide, almost three meters more than the Corso. At the

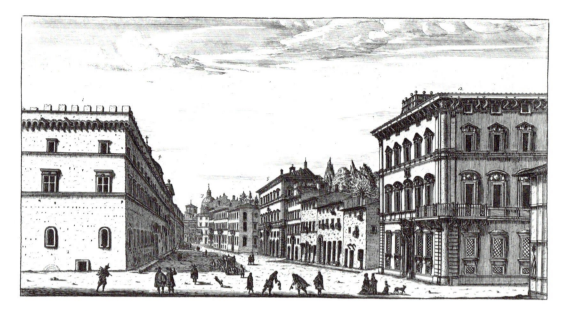

20. G. B. Falda, view of Via del Gesù (Plebiscito) as of 1665, looking west, with Aste and Gottifredi-Grazioli palaces

first corner, halfway down the wide stretch, an offending house was torn down; its site was incorporated into Palazzo Gottifredi, newly built before 1665. Likewise, to the east in Via S. Romualdo—no more than 6.7 meters wide before being swallowed by the vast expanse of today's Via Cesare Battisti—a house out of line was demolished; and now, so the legend of Agnelli's map of 1666 dedicated to Alexander's achievements in beautifying Rome says, "the view has been opened from the Gesù to SS. Apostoli." Similarly Alexander in July 1657 commanded Bernini to clear Via del Babuino ". . . so that from the obelisk on [Piazza del] Popolo one can see the portal of this garden"; the portal being an entrance to the Quirinal gardens which was projected but never executed. Distant vistas down long streets were clearly a major consideration in Alexander's street corrections.

Visibility in a different sense too was a major aim he strove for in his urban planning. The streets and squares that he laid out and marked by inscriptions were those travelled by high-placed visitors to Rome and to his own presence. They were the streets leading to his palace on the Quirinal: Via della Dataria ascending from near to Fontana di Trevi and the Corso; the approaches from Piazza S. Marco-Venezia by way of Piazza SS. Apostoli, where his family had installed itself and Piazza Magnanapoli; and a third—but that remained a dream of Alexander's—Via del Babuino leading straight from the northern city gate, Porta del Popolo, to a grand portal in the wall of the Quirinal gardens. Or they were thoroughfares and squares leading to the core of town— from Piazza del Popolo along the Corso to the Gesù—and across Ponte

30

S. Angelo to the See and grave of St. Peter and to the official residence of his successor, Alexander, in the Vatican Palace. Even a seemingly insignificant street adjustment makes sense within the scheme of street corrections aimed at important visitors. The street leading south from Piazza S. Marco-Venezia towards Macel de' Corvi was widened; it continued down to the Forum and certainly any visitor who counted would want to see that. In Trastevere, the short Via S. Dorotea leading to the Lungara was straightened and widened in the summer of 1658—was Queen Christina of Sweden already negotiating for the sublet of the Palazzo Riario-Corsini on the Lungara? The contract was signed a year

31

22. Shopping center facing
Via della Scrofa

later, but such negotiations often took a year or longer. Still, by and
large, it is his own figure or the fame of his family which is meant to
be glorified by the buildings, streets and squares laid out by Alexander
during the twelve years of his pontificate.

The most serious obstacle to both improved traffic conditions and a
decorous image of the city were the markets all over town. Wherever
a square opened, a street widened or two streets joined, vendors had set
up their stalls: the ragpickers on Piazza di Monte Giordano, the gar-
deners on Piazza Madama, the oil sellers on Piazza Capranica, the book-
sellers on Piazza del Pasquino. On Piazza Navona, amidst its new splen-
dours congregated as of old the storytellers and quacks, the scrap-iron
dealers and second-hand booksellers, and the fruit vendors; also a mar-
ket was held there on Wednesday (fig. 21). Indeed, this list does not
comprise the vegetable dealers, the butchers and fishmongers. They
were to be found all over, even in such prominent locations as Piazza
Sciarra along the Corso, Piazza Colonna, Piazza S. Pietro and nearby
Piazza Rusticucci. But they had their largest market on Piazza del Pan-
theon-Piazza della Rotonda. To remove them from so prestigious a site
was Alexander's aim ever since 1658. But there was strong resistance,
and transferring them, as finally was done, to the nearby Piazza di Pietra
meant clearing only one square in exchange for cluttering up another,
albeit of minor importance. Hence in 1662 the *Congregazione delle
Strade* recommended removing from all streets and squares of the entire
city "all booths and stands of butchers, fishmongers and vegetable deal-
ers . . ."; from Piazza della Rotonda in the first place, but also from the
square in front of the Cancelleria, from Piazza Giudea and Piazza di
Ponte, even from Campo dei Fiori where the grain- and haymarket had

32

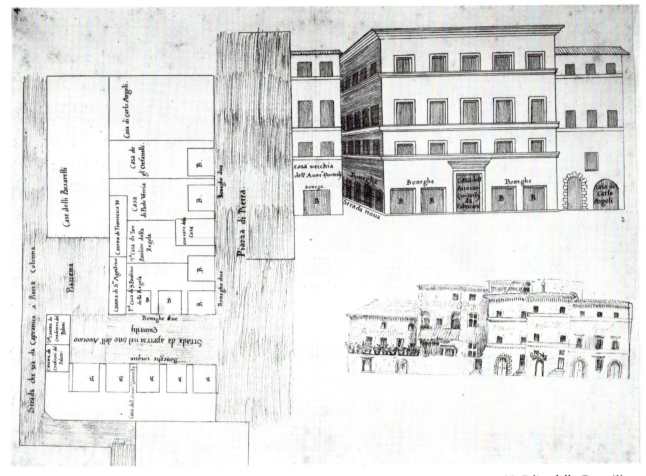

23. Felice della Greca (?),
shopping center planned for
Piazza di Pietra; BAV, Chig.,
P VII 13, f. 44

been held forever. Only Piazza Navona, set aside in 1467 for the market of *alimentari*, was exempted, if only for market days. Instead, a decree issued in that context ordered all vendors to be moved to a shopping center to be installed in the new wing of the Collegium Germanicum framed by Piazza S. Agostino, Via S. Giovanna d'Arco and Via della Scrofa. Located in the middle of town, *"in meditullio urbis,"* the shops "thus concentrated on one site"—a shopping center—would be "most convenient . . . for servicing this Our City." The *botteghe*, open or walled up, survive to this day (fig. 22). Obviously one such shopping center would not have sufficed, and a second one was planned for Piazza di Pietra; the transfer of the vendors' stalls from Piazza della Rotonda was to be a mere emergency measure. Instead a permanent rearrangement was considered: two houses to be rebuilt were to shelter a total of eleven *botteghe*, lined up along the square, as well as an alley to be newly laid out (fig. 23). Other *botteghe* were to be housed on the ground

33

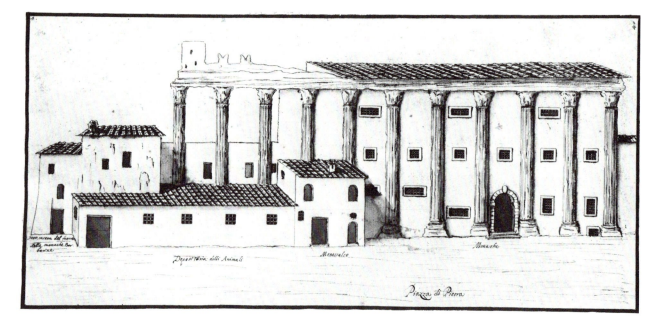

Depostoria dilli Animali Menescalco Monache

Piazza di Pietra

24. Piazza di Pietra, nunnery
built into Temple of Had-
rian; BAV, Chig., P VII 13, f.
43a

floor loggia of the cloister inside the nunnery built into the Temple of
Hadrian (fig. 24). Again, shopping centers were planned at just that time,
in 1661-1662, for Piazza del Popolo. The *veduta* presented to Alexander
shows at the end of the piazza at the very start of Via di Ripetta and
Via del Babuino on either side a large building, the ground floor (fig.
97) taken up by six shops, *botteghe*, surmounted by the customary
mezzanine windows. Clearly they were to be shopping centers, as they
would be needed on a square at the entrance of the city where farmers
would gather to do their shopping after having sold their produce in
town. They still appear on the foundation medal and at least the one
to the left where Via del Babuino starts was built, though in different
shape, in Alexander's time. In the inner town, on the other hand, the
project of creating such shopping centers was utopian in Alexander's
Rome and nothing came of it. Butchers and fishmongers and vegetable
dealers were back on Piazza della Rotonda a few months later; and they
remained on Campo dei Fiori and in other squares and streets as they
do to this day.

Clearing streets and squares, as Alexander planned to do throughout
his reign, had obviously practical aims—to improve communications
and ease traffic problems. At the same time, though, these changes were
directed at removing from sight improprieties, as he would have called
them, and thus providing the decorum and dignity due to Rome, his

34

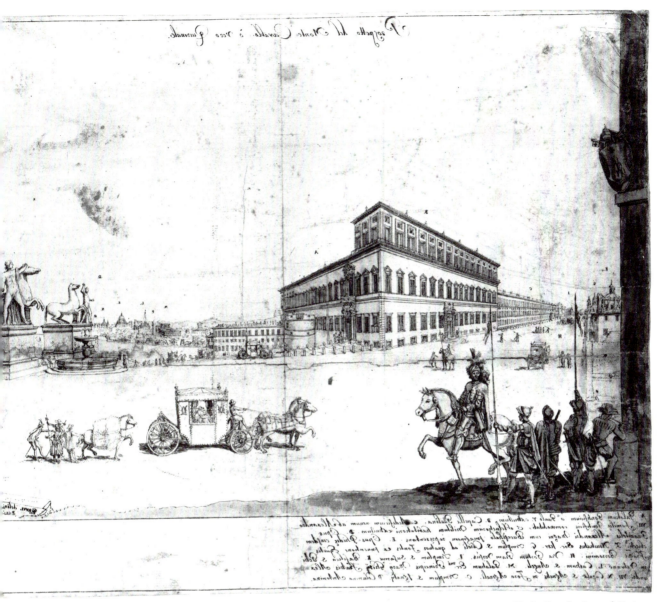

25. L. Cruyl, view of Quirinal Palace and *manica lunga*; The Cleveland Museum of Art, Dudley P. Allen Fund

city. That the approaches leading to the papal palaces where he or members of his family resided were to be prominent above the rest, was but self-evident. Still, intertwined with such aims of practicality and propaganda was another element, rarely mentioned by the contemporaries, but ever present and distinctly envisaged. Long straight streets and regular open squares, clearly outlined, were the basic elements of an ideal of urban beauty by the mid-seventeenth century. The long

35

prospect of a straight street was beautiful in itself. It was more so when
it led up to a grand structure. Likewise a square would be newly laid
out or it would be cleared and reshaped in front of a church or a palace,
whether new or long extant, but given new weight by the changed
approach. Or else, the length of a seemingly endless street is underscored
by an equally endless building to attract by its long perspective the
attention of the approaching onlooker, as does the *manica lunga* (fig.
25), the "long sleeve," the wing added to the Quirinal Palace and ex-
tending monotonously, if not the present 300 meters, so at least half
that length along Strada Pia, now Via Venti Settembre, to house upper
and lower servants, the papal *famiglia*. Streets, buildings and squares,
placed conveniently and conspicuously within the fabric of the city,
are the key elements in the remapping of Rome envisaged by Alexander
"per abbellimento di questa Nostra Città."

3. The Architects: High Baroque and Baroque Cinquecentismo

To TRANSLATE this vision into a reality Pope Alexander had the architects at hand. Bernini stood first: into his late fifties and early sixties by then, the same age as the pope, he was world famous as sculptor, painter, stage designer—in short as the *artista universale* who had fused all the arts, architecture as well, into the *bel composto* of a total work of art. To be sure, his enemies never ceased to point out his lack of architectural training and in consequence thereof, it was said, the failure in 1644 of the *campanili* projected since 1638 for St. Peter's. Certainly it was true that aside from the unfortunate bell towers he had built only, when quite young, the porch and façade of S. Bibiana and later the Chapel of the Three Magi in the Propaganda Fide—it was torn down in 1659 to make room for Borromini's chapel. As it turned out, the opportunities offered by Alexander's projects fired both his architectural imagination and skill and he threw himself with a vengeance into the tasks set by the pope or suggested by him to the pope. Alexander saw him almost daily to chat, to be entertained and to be advised on whatever came along regarding questions in art, from buying antiques to designing Piazza S. Pietro or shifting the Column of Trajan. When in the first months of Alexander's pontificate Bernini was sick, "the pope who greatly loves him sent every day to inquire, to bring presents and to visit him"; and the intimacy grew. Bernini became, in short, a kind of *surintendant des bâtiments et divertissements de Sa Sainté*, the pope's personal sculptor and designer of coaches, medals, ecclesiastical vestments, festival apparatus, stage sets; all this besides holding the posts of Architect of the Papal Palaces, of the Camera Apostolica, of Castel S. Angelo, of St. Peter's, of the Fontana di Trevi—all separately paid—and thus architect *en chef* of nearly all major building tasks during Alexander's pontificate. Indeed, where he was not officially in charge he would more often than not interfere—by a word into the pope's ear or, as he did for both Piazza del Popolo and the façade of S. Andrea della Valle, he would back against the architect in charge a young collaborator of the latter and great admirer of his own work.

The idiom Bernini developed in his architecture during the late fifties and the sixties would seem to have pleased Alexander. Buildings and squares were laid out on a large scale—"princes must build grandly or not at all"; indeed, even small structures must convey an impression of monumentality as do the churches in Ariccia and Castel Gandolfo

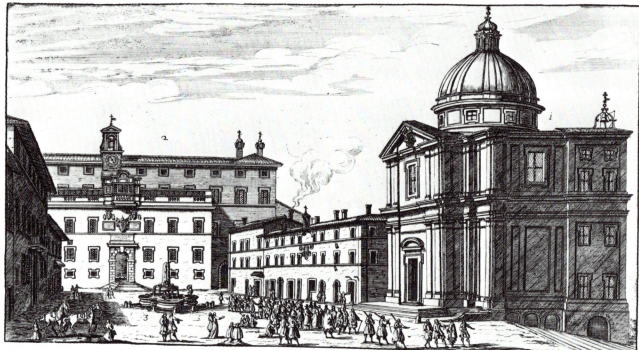

26. G. B. Falda, view of S. Tommaso da Villanova, Castel Gandolfo

27 (*facing page*). Piazza S. Pietro, north colonnade, detail

or S. Andrea al Quirinale. They were clear in plan, and looked at superficially seemed not overly demanding intellectually; the subtleties in planning and detail reveal themselves to the watchful observer while hidden from the casual visitor. The overall design is astonishingly quiet yet powerful. Laid out in clean volumes the building is held in place by orders of pilasters and columns, freestanding or engaged. Ornament is sparse, its forms almost purist, so much so as to arouse occasional criticism. The vocabulary only discreetly deviates from the classical past, as in the use of the colossal order and rustication, but shuns any open breach of the rules ". . . uscir tal volta dalle Regole senza però giammai violarle. . . ." It is, then, a vocabulary derived from Vitruvius as reformulated by Bramante, Peruzzi and Michelangelo and codified by their commentators from Serlio and Vignola to Palladio. This traditional and sedate vocabulary Bernini chooses to carry out his innovative architectural concepts: the sweeping arms of the colonnades at Piazza S. Pietro; the oval shape of S. Andrea al Quirinale, filled with passionate groups of angels surrounding the saint rising with lively colours; or the emphatically simple, clean Greek cross volumes of the church at Castel Gandolfo; or the circular cylinder of Ariccia (fig. 26).

Rather than loosely as "classicism," Bernini's architectural idiom in these years has best been described as a "Baroque Cinquecentismo." It

38

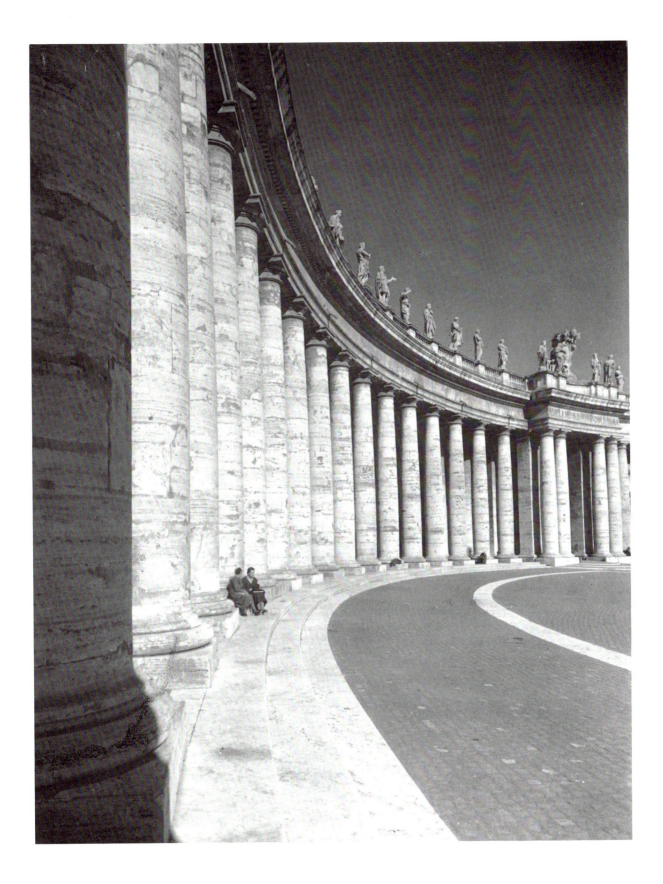

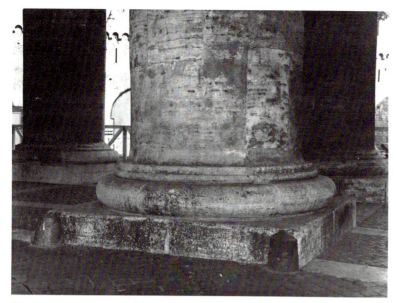

28. Piazza S. Pietro, north
colonnade, base

sharply contrasts with the "High Baroque" architectures designed from
the forties into the sixties by Martino Lunghi the Younger and Carlo
Rainaldi, whose heaped columns, broken gables and figural elements
conceal the volumes and cast deep shadows. That idiom is not foreign
to Bernini. However, he employs his vocabulary strictly in keeping with
the function of the structure and hence respecting the conventions of
decorum so important in seventeenth century thought. As early as the
twenties of the century he divorces serious from festive architecture,
cladding the narthex of S. Bibiana in sober classical, but the baldachin
of St. Peter's in exuberant High Baroque forms. Similarly, in his later
years plain Doric columns mark Piazza S. Pietro, mere forecourt that
it is to church and palace (figs. 27, 28, 29); the long colonnades are of
monumental calmness, entablatures, capitals and bases of emphatic
simplicity. Colossal orders of pilasters ennoble the palace on Piazza SS.
Apostoli and in Paris the planned main façade of the Louvre—a Mi-
chelangelo motif never used by the ancients, as pointed out by Bernini's
assistant; while on the west façade he combined two-storied arcades,
like those of Palazzo Farnese nearly a century and a half before, with a
colossal order of engaged Corinthian columns raised over a delicately
rusticated ground floor. Finally, for the festive Scala Regia he employs
an Ionic colonnade, the capitals festooned, as are Michelangelo's on the
Palazzo dei Conservatori (fig. 57). All is in keeping also with the taste
of Alexander, an educated avant-garde gentleman, brought up on Vitru-
vius and his Cinquecento commentators, and pleased with novelties if
kept within a traditional frame.

40

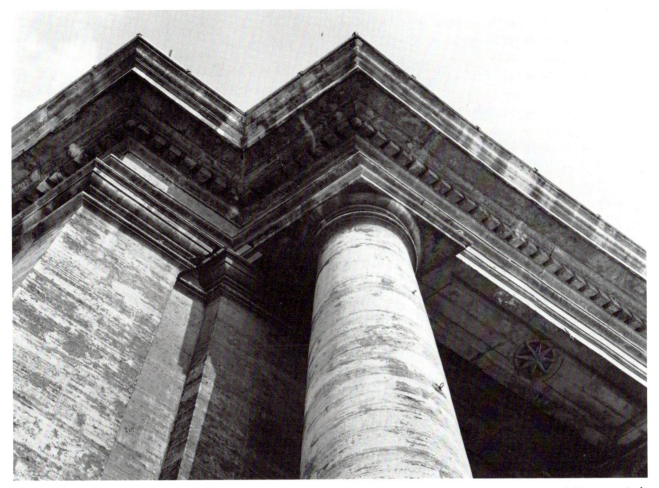

29. Piazza S. Pietro, capital and entablature

Next to Bernini and in many ways his equal, if not on such close terms with Alexander, stood Pietro da Cortona, another exact contemporary: president of the Accademia di S. Luca and hence the official head of the artists active in Rome, he was in the forties and fifties of the century the leading painter of mural and ceiling frescoes on a large scale—at Palazzo Barberini, the Chiesa Nuova and, in Florence, Palazzo Pitti. Contended for between Rome and the Grand Duke of Tuscany, he was equally known as the architect of SS. Luca e Martina on the Forum and of the Sacchetti villa on Monte Mario. Alexander liked him and his company and was amused by the obvious jealousy between him and Bernini and their mutual purloining of ideas—"tell the majordomo Bernini must not see the drawings of Pietro da Cortona and vice versa." After all, it was Cortona who had first designed a palace façade with a colossal order of engaged columns and a coffered vault overlaid by ribs:

41

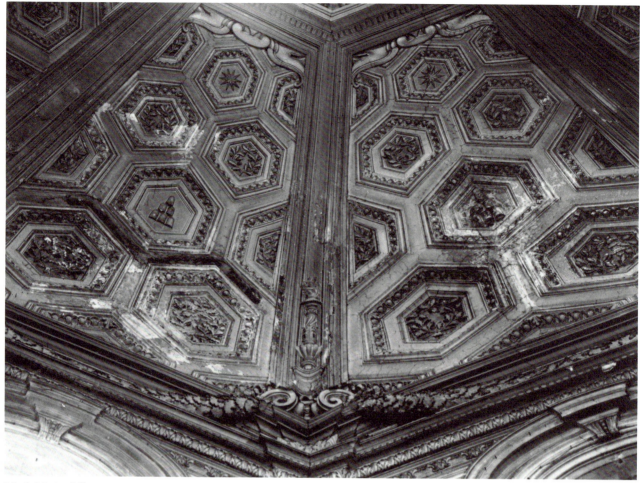

30. S. Maria della Pace,
interior, dome, detail

the one for a palace planned at Piazza Colonna—more on it later—the other at S. Maria della Pace (fig. 30), and long before at SS. Luca e Martina. Both motifs were quickly picked up by Bernini: the colossal order of engaged columns in the Louvre façade, the coffered dome overlaid by ribs at S. Andrea al Quirinale. Bernini, to be sure, soon gained the upper hand in the contest, but Cortona did win four major commissions under Alexander: S. Maria della Pace, the façade of S. Maria in Via Lata, the decoration of the *galleria* in the Quirinal Palace and, near the end of Alexander's and his own life, the completion of apse, chancel and dome of S. Carlo al Corso; all except S. Maria della Pace, at the very start, designed in an idiom monumental and "classical," if not as purist as Bernini's, and apparently appealing to the pope.

Bernini and Cortona, and understandably so, were in a class by themselves in Alexander's esteem. With Carlo Rainaldi he had less contact and it seems little sympathy, notwithstanding the latter's involvement

42

in three major commissions during his pontificate—S. Maria in Campitelli, the façade of S. Andrea della Valle and Piazza del Popolo; also, projects he had prepared for Piazza S. Pietro under the pope's predecessor, Pope Innocent X, were apparently briefly reconsidered by Alexander before Bernini's indeed superior proposal won out. True, of the commissions he received, only that for Piazza del Popolo was outright in Alexander's gift—a consolation prize for having failed to win Piazza S. Pietro? The initiative for building S. Maria in Campitelli had originated as an ex-voto with the municipal authorities, and while Alexander contributed towards expenses and kept an eye on the plans, the patronage remained theirs. Rainaldi, long having been *architetto del Popolo Romano*, was *eo ipso* in charge. Similarly, he had long been the architect of the Theatines at S. Andrea della Valle (fig. 31). The original project for the façade was designed in his customary High Baroque idiom, loaded with columns, broken cornices and gables and marked by deep shadows and highlights. The design, perhaps on Bernini's suggestion, was simplified by his assistant Carlo Fontana, even then much under the impact of Bernini's "Cinquecentesque" concepts. Likewise, on Piazza del Popolo, the twin churches planned by Rainaldi were transposed by Fontana into a design with Berninesque overtones. Once Alexander was dead, Bernini himself with Fontana took over construction of one of the two churches. Bernini just did not like any gods beside himself.

Other architects Alexander apparently did not consider. Felice della Greca he employed as a more elevated kind of foreman to complete Palazzo Aldobrandini for the Chigi family. Nor did a major but conservative architect like Giovanni Antonio De Rossi receive any significant papal commissions—but then he was busy enough building dozens of private palaces. In fact, where palace design is concerned, the picture of Alexander's Rome and that of his immediate successors is largely determined by De Rossi.

From Borromini Alexander shied away. He shared the prejudice against his "Gothic" style, meaning his break from the classical orders and his seemingly arbitrary vocabulary, and explained such deviations by Borromini's coming from Gothic Milan. He also criticized his "needless ornaments"; the angles and projections of a flight of stairs and the lack of "frankness," meaning presumably the sophisticated complexities in his design as against the new Cinquecentismo. But his main reason for avoiding contact was Borromini's difficult personality. He dragged things on no end—time and again Alexander made a note to make him speed up work on the papal memorials in the Lateran; but Borromini, having stopped work already in 1657, quit for good in January 1659. Felice della Greca was appointed to complete what was left to be done, but in April 1660 Alexander altogether cut off the funds. As always

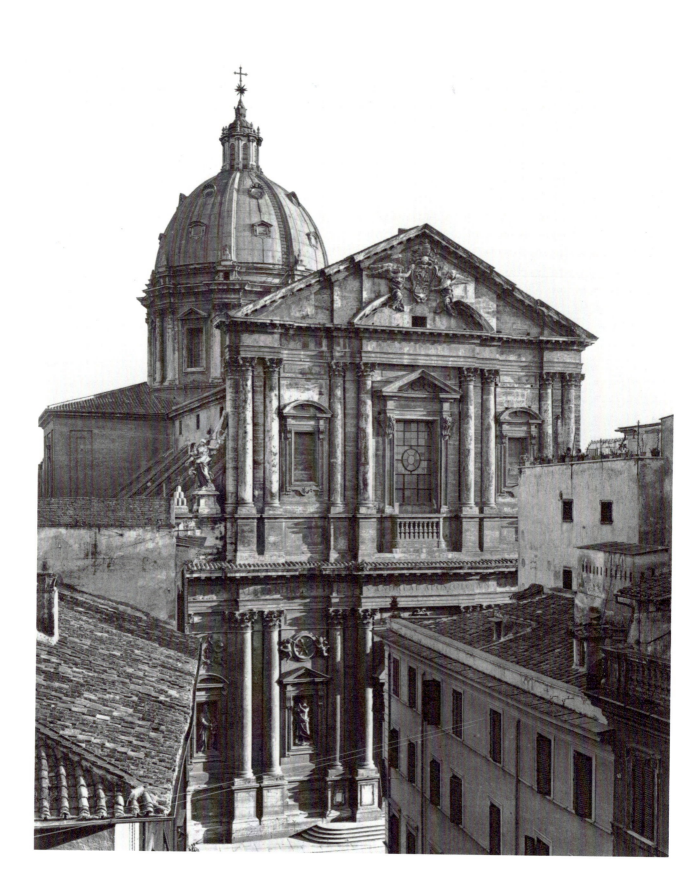

Borromini was unwilling to cooperate with his patrons—"one would have to send the police," Virgilio Spada told Alexander, "to pull from his hands the notes and drawings for S. Giovanni in Laterano"; as always, he underestimated the cost by at least half "though he was not the only one to do so"; he was unwilling to render account—"one can get from him as much information as from an *indio*"; and was generally both touchy and obstreperous. Just when Alexander came to power, Camillo Pamphili had dismissed him from S. Agnese in Piazza Navona for neglecting his duties and having constant friction with his masons—a warning to every future employer—and the pope had to intervene by appointing an arbitration committee.

Obviously Alexander could not avoid Borromini completely; he had been, after all, since 1646 *architetto di S. Giovanni in Laterano* and hence in charge of completing the rebuilding—which meant the papal memorials and the façade. Work on the latter was not discussed under Alexander's pontificate and the silence is telling; the pope evidently had no intention of finding the funds needed for its completion. Work on the papal memorials went on; but Alexander intervened, threatening to have Borromini remove the "Gothic" elements from the memorial of Alexander III "at the top and foot of the columns" (fig. 32). Whatever was meant, Borromini would justifiably take offence. That Alexander did not mind; on the contrary, he loved to needle Borromini by appointing, for instance, another architect to redesign the baldachin of the High Altar of the Lateran and "Borromini is dying from anger." Thus Alexander, without removing Borromini, preferred dealing with him through middlemen: through Virgilio Spada, who long had taken Borromini under his wing and who had been moreover for twenty years *soprintendente* of the *fabrica* of S. Giovanni in Laterano; through Carlo Cartari, professor of jurisprudence and one of the pope's confidants, for the Sapienza, where Borromini had been appointed architect as long before as 1632 by the municipality, they being the patrons of the university. Under Cartari's supervision Borromini decorated the dome of S. Ivo with the Chigi emblems and built and installed, in the northwest wing of the complex, the Biblioteca Alessandrina; also he planned the façade towards Piazza S. Eustachio, different from that actually built after the pope's death, and flanked by three colossal *monti* on either side. Cartari reported regularly to the pope and accompanied him on his occasional visits.

Contact with Borromini, then, Alexander avoided whenever possible. Only when in 1659 the question was aired to reshape Piazza S. Agostino and to build a new half-oval flight of stairs ascending to the church did he, after preliminary discussions between the architect and the pope's majordomo, Monsignor Bandinelli, command four times Borromini's

31 (*facing page*). S. Andrea della Valle, façade as of ca. 1880

45

32. S. Giovanni in Laterano,
memorial of Alexander III

presence, presumably for further explanations of the drawings submitted in several variants upon the pope's request. Once more in 1661 Alexander had himself persuaded by Virgilio Spada to let Borromini design under papal aegis a small building: the new Banco di Santo Spirito on Piazza di Monte Giordano where Spada, governor of the Hospital of Santo Spirito, the bank's mother institution, had charge of operations. But he seems to have done so unwillingly—Spada three times within a month and a half had to submit Borromini's drawings in different versions before the pope signed the *chirografo*, the building permit, and the façade elevation finally accepted was the most reticent and "classical" ever designed by Borromini—had Spada coached him? Nonetheless, the attempt ended in complete disaster. Hardly was Virgilio Spada dead that Alexander forced his heir through sheer blackmail into buying the half-finished building and having it finished at his own expense for his own use. To be sure, as Alexander's emissary pointed out, the cost was eightfold that estimated (supposedly by Virgilio Spada) and Alexander had no funds to spare. But did he not also want to wash his hands of that pain-in-the-neck Borromini now that Virgilio Spada was gone as a buffer?

4. Teatri I: Piazze and Churches

I F I N T H E new Rome envisaged and in large part laid out by Alexander long unencumbered streets were an essential element providing far vistas, so were spacious squares, enveloped or dominated by monumental structures. Public squares, he said at one point, are an ornament to the city, aside from filling a public need in the traffic system of a modern mid-seventeenth century cityscape. Like the long streets— the Corso, the one linking Piazza SS. Apostoli to the Gesù across the upper end of Piazza S. Marco, with their faraway prospects—were *nuovi teatri* intended both to fill very urgent practical needs and to present a grand show to the visitor.

S. Maria della Pace, piazza and church jointly, is the first such showpiece designed and completed by Alexander. The church meant a great deal to the Chigi and to Alexander in particular; the first chapel on the right had been founded by the great Agostino and decorated for him by Raphael; deteriorated and neglected, it had been restored in 1628 by Alexander, then still young Monsignor Fabio Chigi. Now in 1655-56 his was the chance to have the church redesigned and given a decorous festival ambience.

The way he went about it exemplifies the manner in which an architectural project grew under and on him. Planning started on a small scale as a job of restoring and refurbishing rather than anything major. Bernini had his hands full devising Piazza S. Pietro and so Pietro da Cortona was put in charge of the Pace project. An octagon preceded by a short nave with flanking chapels, the church had been built by Sixtus IV and consecrated in 1482, while underway but still long before completion, to the Virgin of Peace; this to commemorate the attainment of "peace and concord"—so a bull of Sixtus IV—after the end of the war in Italy in which the papacy, too, was involved. In 1514 the great Agostino Chigi had purchased and adorned a chapel and Raphael's mural was painted on the nave wall above the entrance arch. It was but natural that Alexander, still in the first year of his reign, would want to see the church restored and embellished, the more so that its dedication to peace coincided with his own—in the end fruitless and humiliating— attempt to negotiate at that time peace between Spain and France. Not by chance does his first diary entry regarding the church in June 1656 try to formulate an inscription intended to celebrate, in words much like those used two hundred years before by Sixtus IV, the conclusion of that peace; a peace still years away.

Work on the church was indeed decided on in 1655 or early in 1656:

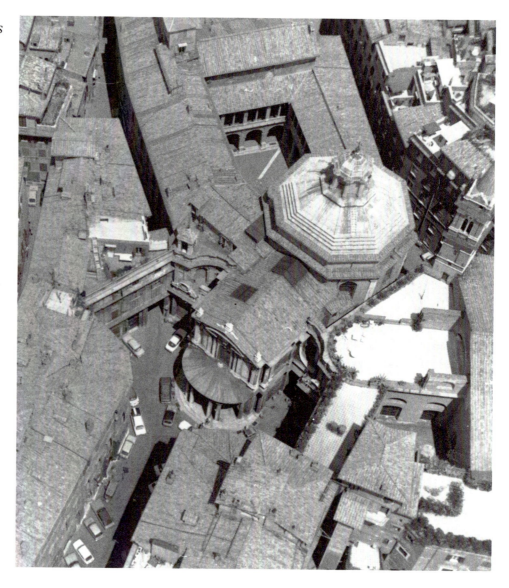

33. S. Maria della Pace, air-
view

the stonecutters were busy since February of that year. But to render
the structure more resplendent and impressive was not easy. It was and
still is located in the heart of the old town, crowded in on all sides (figs.
33, 35). Only Via della Pace, less than seven meters wide, led to the plain
façade, widening funnel-like at the end whence issued on either side of
the church an alley: the one to the left, Vicolo dell'Arco della Pace,
leading to Bramante's cloister; the other squeezed in between the
church and the apse of S. Maria dell'Anima projecting from the com-
pound of the homonymous German hostel to a side entrance of the
octagon. Such narrow approaches, acceptable in fifteenth century Rome,
were no longer so at the time of Alexander. Traffic problems created

34. S. Maria della Pace, first
project, elevation; BAV,
Chig., P VII 9, ff. 45-73

by the increasing number of coaches had to be dealt with and in the
remodelling of S. Maria della Pace their solution was of prime impor-
tance. The church, situated but a few hundred meters from the law
courts, enjoyed the privilege of having mass said after noon when the
courts closed, thus allowing those engaged there since early morning
to attend the services. However, judges, lawyers of repute, indeed, no
one of social standing, could allow himself to be seen except in a coach.
But in front of the church there was no room for approaching or parking.

How to solve this difficulty became a major issue for Alexander and
his advisors; the process by which the solution was arrived at throws
light on the collaboration between him and his architects during the
planning stage, on the speed in arriving at a final decision and on the
growth of a project, far beyond that originally envisaged, in constant
discussions. The first proposals for remodelling the church submitted
to the pope early in June 1656 by Pietro da Cortona were quite modest:
the first a semicircular porch resting on six equidistant Doric columns
plus two flanking the portal (fig. 34); the other, eight paired as today.
Neither solution attacked the traffic problem; early in July, though,
that question was forced on both Cortona and the pope, perhaps brought
up by Alexander himself: coaches, it was clear, could not turn in the
funnel-piazza. Hence an advisor of Alexander's, unknown but obviously
collaborating with Cortona, proposed on July 6 to break through the
houses on the left-hand side of Via della Pace. Coaches then would drive

49

35. S. Maria della Pace, project for approach to square (five-sided piazza sketched in pencil upper right); BAV, Chig., P VII 9, f. 71

in from the next parallel street and leave along Via della Pace; also the gap thus opened would provide a small parking space. A plan of Cortona's illustrates the suggestion (fig. 35). Alexander, it seems, was not enthused and in talking to him Pietro da Cortona, whether spontaneously or well-prepared, sketched in with a few pencil strokes a far grander and needless to say more expensive project. He cut a piece from the Anima buildings to the right in addition to taking over the houses on the left: the five-sided piazza thus outlined embraced the porch of the church and left in front and on either side an area quite a bit larger than the funnel; but it still remained restricted. Indeed, after thinking it over, Alexander on August 19 noted his qualms whether coaches could turn on that piazza—they could only do so by backing up—and whether they could pass through the *vicolo*—Vicolo dell'Arco della Pace obviously. The answer is no.

Nonetheless it was this project elaborated upon in yet another plan of Cortona's on which Alexander fastened; perhaps because that last plan already outlined, and presumably was accompanied by, the proposed elevations both of the grand show façade of the church in three variants and of the palace fronts designed to mask the houses around the five-sided piazza. These elevations submitted to Alexander in the summer or early fall of 1656 presented essentially the façade design of S. Maria della Pace as it now stands (fig. 36). The center, corresponding

50

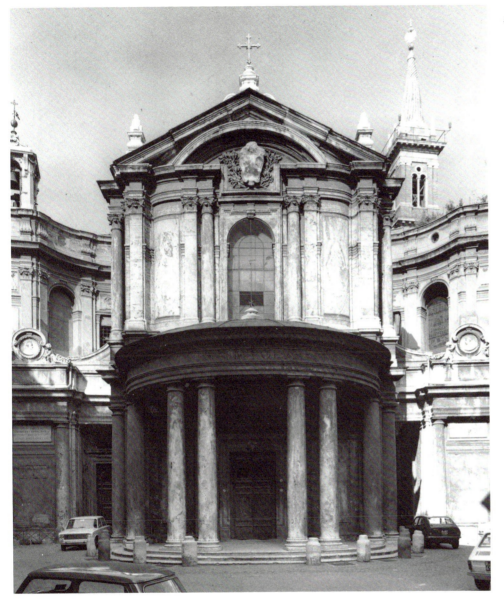

36. S. Maria della Pace,
façade

to the nave façade, softly swerves forward and back; rich in planes, light
and shade and articulated by bundles of composite piers and columns,
it towers over the plain colonnaded porch. This centerpiece is set against
a receding, equally wealthy backdrop, curved convex and concave and
held in place by strong anchors at both corners; the one to the right
effectively concealing the apse of S. Maria dell'Anima across the alley,
that to the left masking the old campanile and supporting Cortona's
steeple. In a distinct counterplay against such abundance the fronts of
the buildings that enclose the piazza are marked by plain Doric and

51

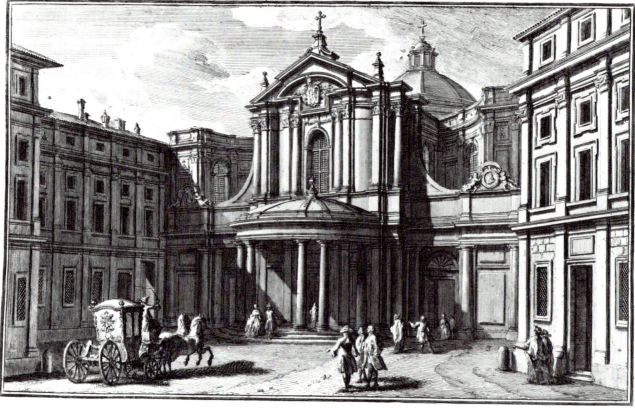

37. G. Vasi, S. Maria della
Pace, church and piazza

Ionic pilasters kept flat, single and paired, in two orders and surmounted
by an attic zone; the whole harking back to High Renaissance palaces—
one thinks of the *palazzi* Maccarani, Ossoli or Massimi (fig. 37).

In the planning stage the collaboration between Alexander, Cortona
and the pope's other advisors—*abbiamo disegnato con*, we have planned
with so and so, he notes time and again in his diary—is as remarkable
as the speed, hardly three months, in which the final project was settled
on. From there the pace slackened. Funds had to be provided; the houses
to be demolished had to be estimated, bought and paid for—in govern-
ment bonds, *luoghi di monte*; stone had to be quarried. All this, much
to Alexander's annoyance, took over a year and work did not start before
the spring of 1657. Nonetheless the façades of the church and the houses
enveloping the square were nearly ready just a few months later, in
August of that year, the *teatro della Pace* clearly being given priority
in construction by an ever-impatient Alexander. Refurbishing the in-
terior of the church started that fall and was more slowly brought to
an end. By December 1659 a thanksgiving service could be held for the
conclusion of peace between France and Spain. But already in June 1659
Alexander had issued a decree accompanied by a drawing intended to

52

protect forever what counted most: any changes whatsoever were forbidden to be made in the buildings enclosing the piazza, whether by raising walls or roofs which would cut off light for the church; nor could any market stalls be set up in the square. The architectural unit, the *teatro*, was to be preserved—a showpiece closed in itself and a key element in what was to become Alexander's remapping of Rome.

To outline Alexander's vision of Rome, projects well-documented but never brought to fruition are as important as those carried through. Piazza Colonna is such a project, envisaged in ever-new forms and never completed. Located off the Corso halfway between Piazza del Popolo and Piazza S. Marco-Venezia, it shelters the Column of Marcus Aurelius, the first great monument of antiquity, not counting the patched-up and unsightly Arco di Portogallo, that a visitor would have encountered travelling down from the northern city gate, Porta del Popolo. But the square was a sore sight when Alexander came to power (fig. 38): bordered by mean structures and unfinished palaces and irregular in shape; the column engulfed by an L-shaped block of old houses; a modest church and a convent patched together by the Barnabites from several houses terminating the piazza; an insane asylum and its church on the left at the back, adjoining the Bufalo Palace with its demeaning shops on the ground floor; the unfinished Aldobrandini Palace to the right; and behind it, off the square, the fragment of the Ludovisi Palace on Montecitorio. Space was limited and coaches could neither approach the palaces to the right, nor could they park. The situation was indecorous, and as early as September 1657 a survey was made of the square, possibly with an eye towards removing the houses which crowded in on the column. Such clearing became more urgent when the Chigi, brother and nephews of Alexander, threw covetous glances at Piazza Colonna, a desirable address. By February 1658 it was rumoured that they were going to buy Palazzo del Bufalo and the insane asylum and turn both into a large palace and that "the Trevi waters were to be brought to Piazza Colonna to feed rich fountains." (The present Trevi Fountain, a quarter of a mile away, was built only nearly a century later; in 1658 there was in Piazza di Trevi but a simple basin, left over from a fountain planned by Bernini in 1641 but later abandoned.)

By the summer of 1658 in fact, steps were initiated by Alexander toward clearing away the houses near the column, while at the same time feelers were extended regarding the purchase by the Chigi, not of the Bufalo, but of the unfinished Aldobrandini Palace. The negotiations dragged on for a year and a half until in September of 1659 the property was sold to the Chigi at a bargain price. Alexander meanwhile waxed more and more impatient about seeing the piazza cleared; but not before February 1659 did the demolition of the houses near the column start.

53

38. Felice della Greca,
Piazza Colonna as of 1656;
BAV, Arch. Chig., III, 1, 159

At that time, though, the pope's appetite had grown and the irregular front of the convent block behind the column, too, was to be cut straight "to square off the piazza"—thus the decree—"for its embellishment and that of Our City." On the suggestion of Monsignor Neri Corsini, *presidente delle strade,* and hence ex officio involved, he ordered, however, four weeks later, the cut into the "Barnabite block" to be moved much further back, thus condemning both convent and church (fig. 39). This brought the new front in line with the corner of the Ludovisi Palace on Montecitorio and made the piazza an almost perfect square. At the same time, however, Alexander and his advisors from the outset were fully aware that both the siting of the Column of Marcus Aurelius and the transfer, long bruited about, of the Trevi waters to Piazza Colonna were an integral part of any project aimed at reorganizing the square. Several solutions appear to have been discussed by those involved. Monsignore Corsini pointed out how the deep cut into the Barnabite property would bring the column to exactly the halfway point of the square's east-west axis, and suggested adding a fountain to the

54

39. Piazza Colonna, successive cuts projected of "Barnabite block"; ASR, Disegni e Mappe, cart. 80, 252

column so as to conceal its off-center siting on the north-south axis—it stands much closer to the south than to the north edge of the square. At another point he speaks of the pope's considering a plan to place the Trevi Fountain on the site of the Barnabite convent. Finally he reports on Alexander's commanding a survey plan of the streets flanking the Barnabite block, presumably with an eye to altering the approaches to the piazza from that side. All three ideas are reflected in projects that survive to this day.

In fact, at the time of these discussions, in the early spring of 1659, Pietro da Cortona came to the fore with an exciting proposal, either spontaneously or on the inspiration of Alexander: to build on the site of the convent block a "fountain palace," thus providing for the needs of the Chigi and at one stroke bringing the Trevi Fountain to Piazza Colonna. The project is preserved in three versions, one marked on the verso in Alexander's own hand "Fontana in Piazza Colonna." In the most impressive variant of the project a huge oval fountain with figures is enveloped and surmounted by a palace; the façade, articulated by a

55

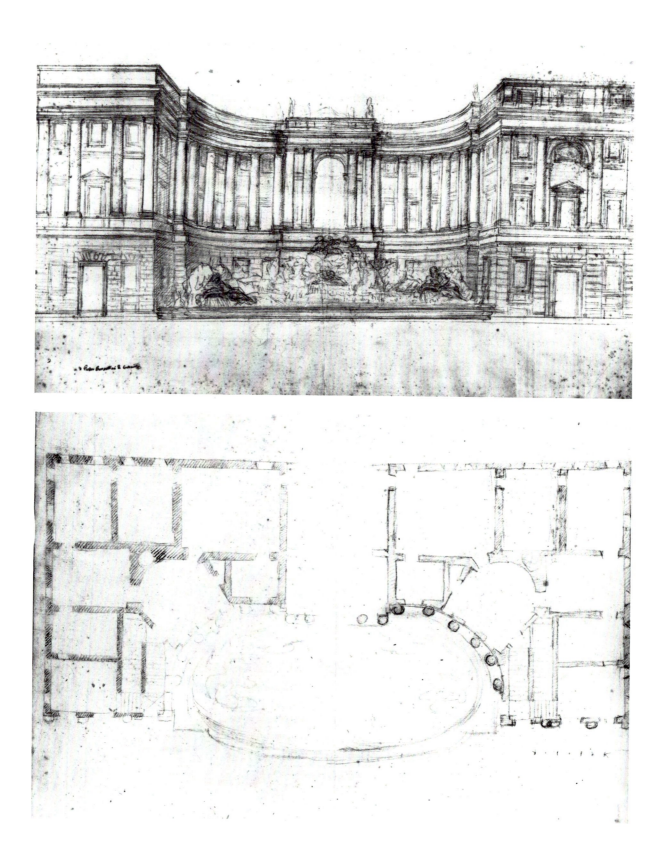

Within the plan, the following labels appear:

Sito da fabricarsi da Ludouisy

Palazzo Lodouisio

Ospedale de Pazzi

Piazza Colonna

Palazzo Chigi

Palazzo del Buffalo

Corso

Corso

Palazzo dell' Heredita Veralla

colossal order of columns and pilasters above a plain rusticated base-ment, curves back in the center to open over the fountain in a triumphal arch flanked by short wings (figs. 40, 41). An ingenious design, if in-commodious to live in, it would have dominated the square on a grand scale. But Alexander's brother and nephew preferred comfortable dull-ness. Nor did they want to wait for a new palace to be built—it would have taken a few years anyhow. Thus in September 1659 they purchased Palazzo Aldobrandini, fragment though it was, moved in quickly and in the course of the next forty years completed it at considerable cost.

The site where Cortona had meant to set up his fountain-cum-palace was given over a few months later in December 1659 to an insignificant structure needed by the Ludovisi to house their *famiglia*, upper and lower servants, the *parvum palatium* Ludovisi (fig. 42). Much altered, it remains to this day, closing Piazza Colonna to the west. But it did have one advantage as against Cortona's project: shorter by far as was stipulated by Alexander in the building permit, it left a wide approach

42. Piazza Colonna, with "parvum palatium," December 1659; ASR, Notai di Acque e Strade, vol. 88 (98), 1660, c. 375

40 (*facing page, at top*). Pietro da Cortona, Piazza Colonna, project for "fountain palace," elevation, 1659; BAV, Chig., P VII 10, f. 11

41 (*facing page, bottom*). Pietro da Cortona, Piazza Colonna, project for "fountain palace," groundplan, 1659; BAV, Chig., P VII 10, f. 10

43. Piazza Colonna, ship fountain using Column of Marcus Aurelius as mast; BAV, Arch. Chig., III, 25058, detail

from Montecitorio; convenient for coaches; it brought also into view the corner of the Ludovisi Palace. Whose was the idea of opening that breach is open to conjecture. Alexander may have had it in mind nearly a year earlier when commanding a plan of the streets on either side of the Barnabite block approaching the square from the west. Whether or not suggested by Bernini, the latter would have taken it up with enthusiasm. It would allow him to merge Piazza Colonna with a piazza of similar size to be laid out on Montecitorio in front of his Ludovisi Palace, once finished. Such a project, indeed, would explain Alexander's willingness to give in to his relatives' pleas and to drop the Cortona project in favour of the new proposal.

Cortona's palace-cum-fountain would have made for a grand prospect to dominate and integrate into a real *teatro* Piazza Colonna, column and all. The new building for the Ludovisi *famiglia* was too modest and too weak for that; and moreover, the project to bring over the Trevi Fountain had gone by the board. Thus, by default, the square became focused on the Column of Marcus Aurelius. Clearing the piazza, however, had rendered evident its position far off center, as foretold by Monsignor Corsini as early as February 1659. To hide that discrepancy and to bring the Trevi waters to the piazza, Corsini had already suggested joining a fountain to the column—whatever kind of fountain he had in mind. The suggestion came to nought. But a few years later, in 1662 perhaps, someone—Bernini, I suspect—with a stroke of genius, revived the idea. On a plan demonstrating the column's eccentric siting he sketched around it in pencil the outline of a boat, placing its bow and poop, respectively, at the same distance from the borders of the square (fig. 43). It was to be a ship fountain with the column as its mast, like the small ones at Frascati and Tivoli, but colossal in size. Inevitably the hasty but sure pencil strokes recall what Bernini in 1665 in Paris told Monsieur de Chantelou: that he had proposed to the pope to move the Column of Trajan to Piazza Colonna as well and to set up both

columns, each in a fountain. And it would have been, he said, the most beautiful square in Rome. It would have been, indeed, and Alexander would have been happy with it. As it was, lack of funds and technical obstacles left him frustrated after having been led from one grand project to the next; so bitterly frustrated indeed that even a few weeks before his death he scribbled a note among projects he meant to complete to "bring the show façade [*mostra*] of the Trevi Fountain to Piazza Colonna."

S. Andrea al Quirinale is another *teatro* of Alexander's, on a small scale, and one of the finest. In a suburban garden zone on the crest of the hill across from the papal palace, the Jesuits long before had established their novitiate in Strada Pia. Their chapel, small and in poor shape, had for years needed replacing, but Innocent X had refused approval of a project of Borromini's—he did not want a large church there facing his windows. Alexander revived the idea by intimating in July 1658 to his confidant, the Jesuit Sforza Pallavicino, that a church on that site might serve the order as well as the palace, the papal chapel there being too small to accommodate his large household now that they were all to live in the long wing, the *manica lunga*, just then under construction; however, he was not going to fund the church. The amount at the disposal of the Jesuits would have sufficed for an adequate but plain church; but since some of the fathers supported by Alexander—or was it the other way around?—wanted a church richly appointed, the Jesuits approached Camillo Pamphili, Pope Innocent's nephew, who indeed was willing to bear most of the expense.

Still Alexander, having at his side Bernini (who from the start was involved), kept control; early in August he sent Bernini to talk to the fathers as if on his own. When three weeks later Bernini brought the plan for a five-sided church—the Jesuits requiring five altars—he ordered him to move it back from the street—"gli riduciamo la Chiesa più indietro"; it would have deprived part of the *manica lunga* of light and air—and to return with another plan as well. This Bernini did, and a fortnight later an oval plan was ready with a chancel and four chapels, thus with the required five altars; still another fortnight later he presented the pope with a *modello*, whether a clay model or a section. Digging for the foundations started two days later; the papal *chirografo* with plan and section was approved and signed at the end of October and the cornerstone was laid on November 3. Camillo Pamphili was and remained even after his death in 1666 the financial angel of the Jesuits and figured as founder of the church, his arms and inscriptions being well in view; but Alexander was in control of the planning—as usual with him it went fast, taking three to four months—and kept a watchful eye on the construction and on the changes made over the

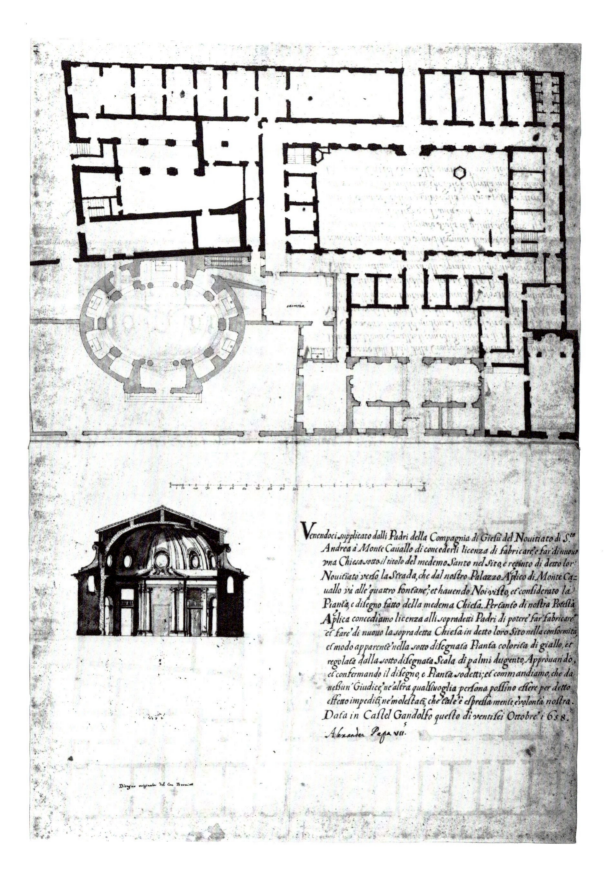

Venendoci supplicato dalli Padri della Compagnia di Giesù del Nouitiato di S.^{to}
Andrea à Monte Cauallo di concederli licenza di fabricare, e far di nuouo
vna Chiesa sotto il titolo del medemo Santo nel Sito, e recinto di detto lor
Nouitiato verso la Strada, che dal nostro Palazzo Aplico di Monte Ca-
uallo va alle quattro fontane; et hauendo Noi visto, et considerato la
Pianta, e disegno fatto della medema Chiesa. Pertanto di nostra Potestà
Aplica concediamo licenza alli sopradetti Padri di potere far fabricare
et fare di nuouo la sopradetta Chiesa in detto loro Sito nella conformità
et modo apparente nella sotto disegnata Pianta colorita di giallo, et
regolata dalla sotto disegnata Scala di palmi dugento, Approuando,
et confermando il disegno, e Pianta sodetti; et commandiamo, che da
nessun Giudice ne altra qualsiuoglia persona possino essere per detto
effetto impediti, ne molestati, che tale è espressamente volontà nostra.
Data in Castel Gandolfo questo di ventisei Ottobre i 658.

Alexander Papa VII.

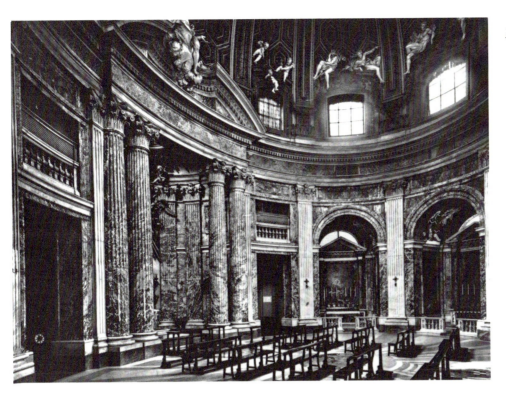

44 (*facing page*). G. L. Bernini, S. Andrea al Quirinale, first project, 1658; BAV, Chig., P VII 13, ff. 40v-41r

45. G. L. Bernini, S. Andrea al Quirinale, interior, 1660ff.

next twelve years as the building was going up—the last ones, to be sure, dating from after Alexander's death.

The church as first planned would have looked different from what is seen today. Pushed back from the street—a suggestion of Alexander's—it stood inside a forecourt with but two doorways in its wall (fig. 44). Hidden from the casual passer-by, it was to start with not meant as a public *teatro*—was that the reason that Alexander left to Camillo Pamphili alone the glory of having built it? The façade, too, was to be quite plain, flanked by twin pilasters in two superimposed orders, presumably Tuscan, and quite low, much as the façade of the church at Castel Gandolfo; the volutes buttressing the dome rose in simple concave curves. The subtlety of the design revealed itself only inside: the paired chapels right and left, the taller main and entrance bays and the intervening low niches for confessionals surmounted by *coretti* for musicians; the articulating pilasters Ionic rather than Corinthian; the dome ribbed and lit by eight *oculi*, though not yet coffered or opened in a lantern; but the walls from the outset were planned to be covered by colourful revetment with precious marble columns flanking the altar- and entrance bays. By 1660 all this was to be changed both inside and outside: the capitals Corinthian rather than Ionic, the altarbay apsed, the confessionals oval instead of rectangular (fig. 45).

61

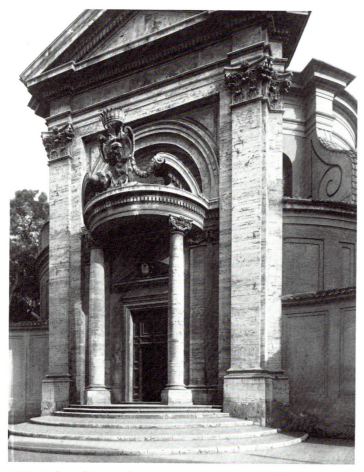

46. S. Andrea al Quirinale,
façade as of ca. 1890

More important, the dome was opened at the apex and surmounted by
a lantern; a similar opening in the apse vault sheds light on the altar,
its painting and a host of angels; and a wealth of sculptural decoration
fills the interior—fishermen and *putti* over the windows, cherub heads
circling the rim of the lantern and fluttering on its walls, Saint Andrew
breaking in glory through the gable above the entrance to the altarbay—
all executed between 1661 and 1665 and designed to dramatize and
activate the interior. Likewise, the outside was dramatized; the volutes
of the drum sweep up in double curves, convex and concave; the façade
is anchored by single colossal Corinthian pilasters, backed up by half
pilasters; and, most important, as an afterthought the façade was linked
by low curved walls to the street, the forecourt wall having been re-
moved (fig. 46). In short, the private, intimate note of the first project
is gone and the church has become a public *teatro*, not quite as dramatic
yet as we see it today—the convex colonnaded porch was added by
Bernini only in 1670, and of the cascade of stairs only the topmost are

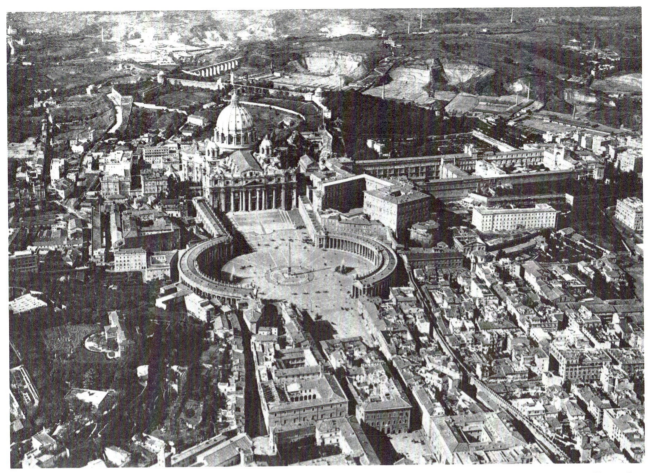

47. G. L. Bernini, Piazza S.
Pietro, airview, as of 1913

his, the majority having been added when Strada Pia was lowered in
the nineteenth century. But the public note and the drama were there
in Alexander's late years—Bernini had turned into a grand show of
Alexander's the church paid for by Don Camillo Pamphili.

Piazza S. Pietro was the most ambitious and to Alexander the most
important of his *teatri*. Planning and execution filled his entire ponti-
ficate and he saw it almost finished; finished, that is, as far as it stands
today—which means that a key element in the design, the *terzo braccio*,
the closing barrier across the wide opening opposite the church, was
never built. Nowadays church and square are dwarfed as they are seen
from afar down the long prospect of Via della Conciliazione, opened in
1938. Till then, one emerged from the narrow streets of the Borgo;
coming from an area at the Tiber bank adjoining Castel S. Angelo and
linked via its forecourt to Ponte S. Angelo, these streets issued on the
east side of St. Peter's square (fig. 47). The one in the middle, the Borgo
Vecchio, was left of the axis of the church; the one to the right, the

63

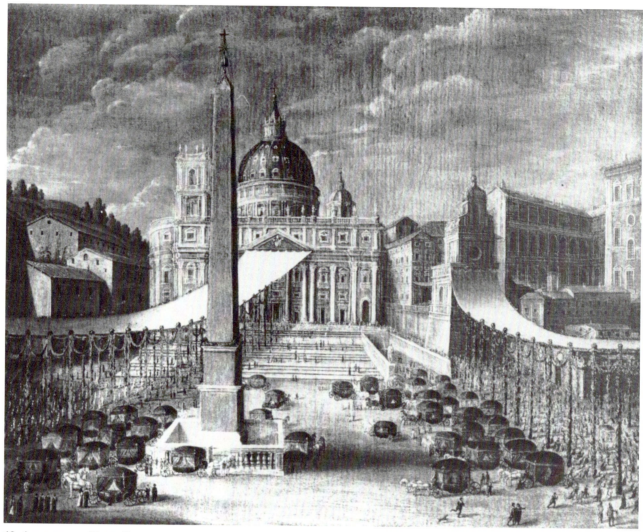

48. Anonymous, Piazza S.
Pietro, ca. 1640; Museo Pa-
lazzo Venezia

Borgo Nuovo, lined up with the entrance to the Vatican Palace, ex-
tending to the right of St. Peter's. The blocks of houses separating Borgo
Vecchio and Borgo Nuovo were known as the *spina*. The piazza itself
was shapeless, the façade of St. Peter's spread broadly and seemingly
much too low across its far end—Bernini's towers, one recalls, having
been a failure. The left, south half of the square was all cluttered up
with small and large buildings, among them the Cesi Palace with its
vast collection of antiques and the palace of the *penitenzieri* and other
canons of St. Peter's. The obelisk set up in 1586 slightly to the right of
the axis of the church—it was to line up with an avenue which was
planned even then to replace the *spina* and the two *borghi*—thus ap-
peared to stand far left on the square. North of the church, a short arm
jutted forth from the palace entrance, terminated by Ferrabosco's clock

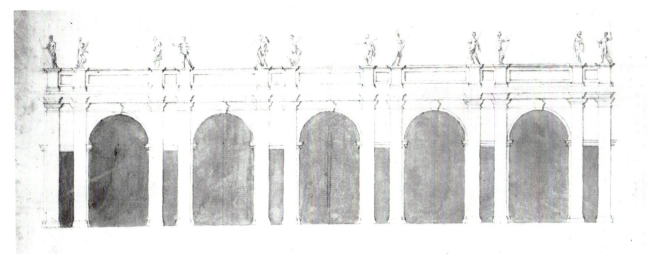

49. Anonymous, Piazza
S. Pietro, project with
arcades; BAV, Chig., H II 22,
f. 94v

tower of 1618; adjoining it, buildings and outbuildings of the palace
limited expansion of the square. On the open area of the piazza no
protection was provided against rain and sun; for greater occasions,
awnings were stretched its length to the entrances of St. Peter's and
the papal palace (fig. 48).

Alexander and Bernini set out to remedy all that and to provide a
dignified approach to the church and to the Vatican Palace on its right.
Planning, begun in the first year of Alexander's reign, as always pro-
ceeded through a number of successive phases in an interplay between
the pope, his architect Gian Lorenzo Bernini, other advisors and hard
opposition voiced in meetings of the Commission of Cardinals charged
with supervising the project. Early proposals abound: one a longish
trapezoid determined by Ferrabosco's obliquely jutting clock tower arm;
another one rectangular; and perhaps a third, circular. Enveloped by
double-storied arcaded porticoes, the upper floors to house the evicted
canons, they strove to combine grandeur and usefulness. But that com-
bination was dropped early in the game and on August 13, 1656 Alex-
ander noted with determination "... the portico without upper floor
but with a balustrade and statues ..." (fig. 49). He was a jump ahead
of the *Congregazione della Fabrica di S. Pietro*, the commission of
cardinals nominally in charge of discussing and approving all work to
do with St. Peter's. That commission six days later discussed the project
with two-storied arcades, obsolete in Alexander's mind. The commis-
sion objected, but he remained firm. He also backed Bernini's next
proposal early in the following year, implying the demolition of further
property to make the piazza oval and to link it to the church and to

65

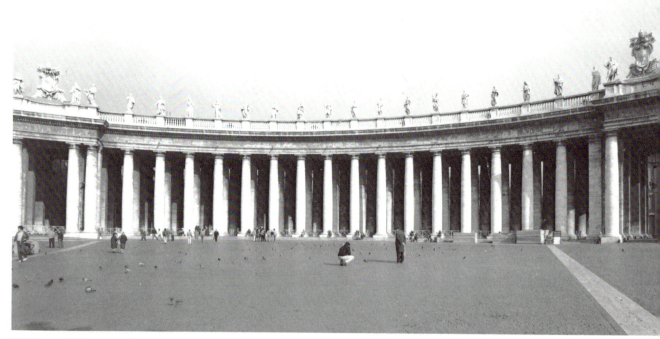

51. Piazza S. Pietro, north
colonnade

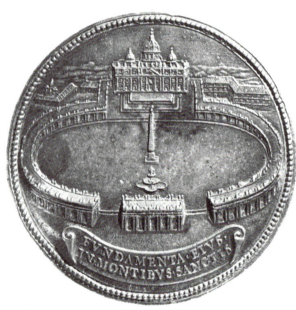

50. Medal, 1658, showing Piazza S. Pietro,
project with twin columns; BAV, Medagliere,
XXII-47

52 (*at right*). Piazza S. Pietro, north colonnade,
detail

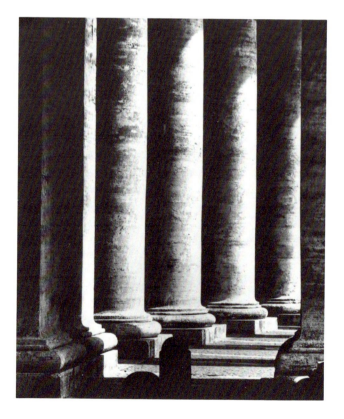

66

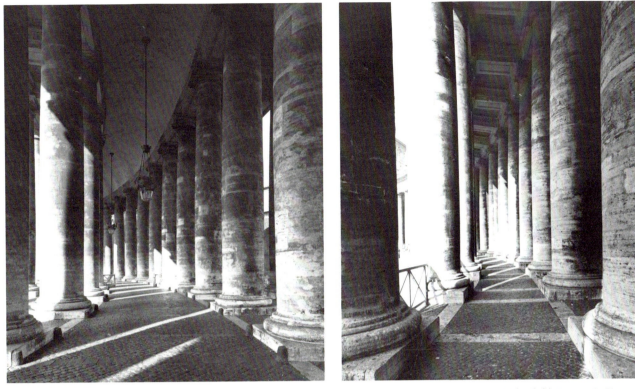

53 (*at left*). Piazza S. Pietro, north colonnade, center drive

54. Piazza S. Pietro, north colonnade, side walk

the Vatican Palace by a trapezoidal forecourt: the latter enclosed by uphill slanting corridors to frame the stairs ascending to the church; the former by arcaded, single-naved porticoes. A life-size wood and canvas model, three or four arches wide, was underway in March and April and set up at the end of May. Criticism, levelled for instance by Virgilio Spada, led to making the porticoes twin-naved rather than single-naved. But long before, in November 1656, Bernini had ordered another life-size model to be constructed, replacing piers and arcades by freestanding pairs of Corinthian columns carrying an entablature. That plan, perfected over the following months and firmly approved by Alexander in May 1657—". . . and so we decide it . . ." he notes—appears on the medals struck for the laying of the cornerstone on August 28, 1658 (fig. 50). However, Alexander was much mistaken regarding the finality of his decision. Just as he was one step ahead of the cardinals' commission, so Bernini kept one jump ahead of him. Exactly five days after the laying of the cornerstone he presented the pope with a new proposal replacing the pairs of columns by stronger single Doric columns (figs. 51, 52). This remained the final design. Its four rows of 300 columns, doubly forceful in their plainness, separate a wide barrel-vaulted center drive from lateral coffered side walks (figs. 53, 54). Underway by the spring of 1658, the colonnades and slanting corridors

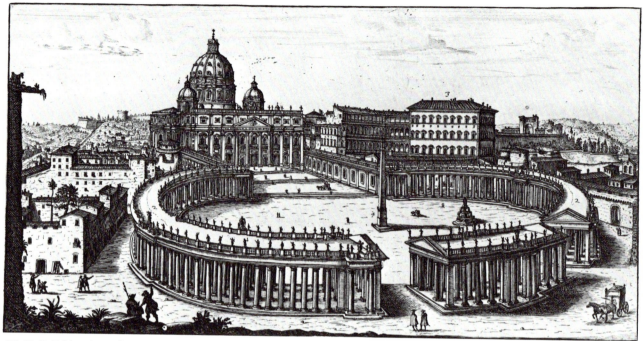

55. G. B. Falda, view of
Piazza S. Pietro with
terzo braccio

were built over the next ten years with a working force drawn from
near and far and at a cost estimated at one million *scudi*. The cardinals'
commission meeting in March 1659 had no choice but to "bend to the
will of His Holiness."

It was carried out under constant pressure from the ever-impatient
Alexander—"che al Colonnato si lavori più con furia"—but it was not
fully carried out. Bernini's plan, one knows, envisaged aside from the
sweep of the lateral arms a transverse arm to fill the gap between the
two, opposite the church (fig. 55). Only two passages, one on either side
of that *terzo braccio*, would have allowed coaches and pedestrians to
enter the *teatro* of the piazza, the grand show, this being the meaning
of *teatro*. Of this grand show, enclosed by the *portici*, the colonnades,
articulated by the obelisk and the twin fountains along its transverse
axis and linked to church and palace by the slanting corridors, Bernini
conceived of as a forecourt: a forecourt for the church in the first place,
to be seen from its steps—Virgilio Spada, Alexander's advisor, leaves
no doubt of that; but also a forecourt for the visitor to give himself over
to the grandeur of the show spread before his eyes. However, it was
more than a show; it was as much a precinct to set off church and
palace and to prepare oneself to appear in the presence of the Lord or
of His vicar on earth, Pope Alexander (fig. 56). Coming from the noisy
bustle of the crowded and wordly *borghi*—Bernini would have liked to

68

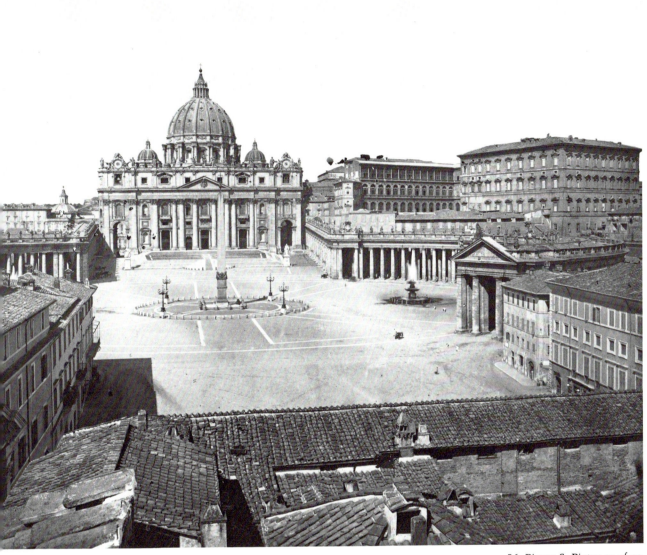

56. Piazza S. Pietro as of ca. 1890

replace them with an avenue (we shall revert to that project); but the avenue too would have been crowded and worldly—the visitor would have been stopped by the barrier of the *terzo braccio*, regardless of whether it lined up with the side arms of the oval or was pushed forward towards the *borghi*—this a later idea of Bernini's. He would have passed through one of the entrances to either side, and stepping onto the piazza and being enveloped by the sweep of the colonnades, have taken in for the first time the full view of church, piazza and towering palace. He would have proceeded further, overcoming a second hurdle marked by the obelisk and the two fountains on the transverse axis and continuing,

69

to be delayed yet a third time where the oval narrowed to open into the trapezoidal square. There he would have slowly ascended the stairs leading to the façade, pausing on each of the three landings and finally entered, not yet the church, but its huge narthex. Only then the nave opened before him, ending in the vista of Saint Peter's grave under Bernini's *baldacchino*. Further back, in the apse, the Cathedra Petri would rise supported high by the colossal figures of the Church Fathers, completed, to be sure, not before 1666. However, planning started as early as 1656 jointly with the first projects for the piazza. In fact, the context strongly intimates that even at that early point the piazza and the Cathedra were seen as complementing each other, beginning and end of a pilgrimage. Or else, the visitor, if royalty, driving through the right-hand colonnade, would alight from his coach at the foot of the bronze door and proceed along the slanting corridor to ascend the Scala Regia, built between 1662 and 1665, and by that grand approach reach Alexander's exalted presence (fig. 57). The sequence of *terzo braccio*, oval piazza, trapezoidal square, steps and landings, whether leading to the church and the Cathedra Petri or to the papal throne, enforced upon the visitor a gradual and deliberate approach. Concomitantly it set apart the grand *teatro* from the city, yet made it part of the urban texture.

Opposition was strong from the outset: right at the first meeting of the cardinals' commission objections were raised against demolishing for the sake of the piazza that much housing, including the Cibo and Cesi Palaces and the Penitenzieria; there would not be enough space left for building a new Canonica as promised, outside the piazza. The entire construction was useless if shorn of the upper-floor apartments; altogether, was it wise to erect in these times of calamity and scarcity— the plague had struck in 1656, and funds were low—a structure only for show, a *pompa*?—and what impression would it make on foreigners if such amounts, rather than to alleviate pressing needs, were spent on sheer decoration and on needless construction? Even a man as loyal to his master and as prudent in his statements as Virgilio Spada did not conceal his qualms about the size proposed for the oval piazza, too large to distinguish coaches and liveries for summoning them, and about the cost of the necessary demolitions and the length of time needed for the construction. Alexander's advisors, Bernini among them, acting as public relations men, were ready with their answers: the entire operation was part of the pope's policy to supplement almsgiving by providing employment and making money circulate; rather than building a palace on the ruins of many small dwellings or laying out a private garden— a dig at the Borghese, Ludovisi, Barberini and Pamphili and their clientele among the cardinals—Alexander preferred a sumptuous building in honor of God and His saints as well as for the common good; a

70

PROSPECTVS SCALÆ REGIÆ AB
EQVITE BERNINO EXTRVCTÆ
SVB ALEXANDRO VII.

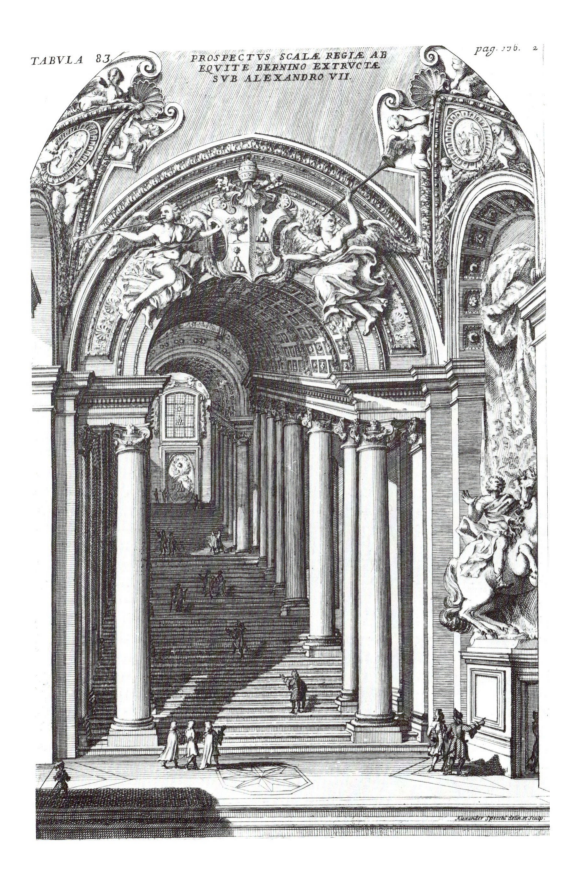

Alexander Specchi delin. et sculp.

building to dominate the entire Borgo and, indeed, the whole of Rome. In magnitude and splendour Piazza S. Pietro would compare to the works of the Roman emperors, a powerful argument with seventeenth century intellectuals.

Moreover, from a practical point of view it was sheer necessity: it would provide work for many hundreds—diggers, quarriers, carters, bricklayers and stonemasons—and was, in fact, an act of almsgiving in disguise. Also, on grand occasions the square would serve as a much-needed parking space—a role, incidentally, to which it had reverted for a while in our days, filled as it daily was with tourist buses. At Alexander's time, his biographer and confidant explains, and Spada confirms it, there was no courtyard suitable for parking large numbers of coaches. On the other hand, the area fronting St. Peter's and the palace was all open and heat and rain "caused great damage to the trappings of carriages and to the bodies of horses and coachmen . . . [and] to the crowds of pedestrians. . . ." Alexander resolved " . . . to put an end to such inconvenience and in a manner to crown at the same time that royal edifice. Therefore . . ." he laid out the oval piazza and the porticoes " . . . to provide cover for coaches as well as pedestrians." This theme of the porticoes providing shelter from heat, storm and rain was taken up in one of the inscriptions placed on the porticoes, "In umbraculum diei ab aestu et in securitatem a turbine et pluvia," drawn from Isaiah 4:6; just as the other two inscriptions, "Venite, procidamus ante dominum . . . et nomen Domini invocemus" and "Venite ascendamus in montem Domini adoremus in templo sancto eius," are biblical quotations. The latter with intended ambiguity alludes all in one to the Temple Mount, the Vatican Hill and the mountains in the Chigi arms as does the motto from Psalm 86:1 on the foundation medal of 1657, "Fundamenta eius in montibus sanctis." All this coincides with the *concetto* formulated but hardly invented by Bernini that the porticoes are the arms of Mother Church opened to Catholics to strengthen them in the Faith, to heretics to reunite them with the Church, to infidels to let them see the light of the True Faith.

The opposition was not silenced either by biblical quotations and *ex post festo* symbolism or by the justifications brought forward by Alexander's public relations men. Criticism continued throughout his pontificate. The square was useless; the expense was ruinous; the design was outsized "to meet the taste of His Holiness"; the digging up and the new foundations would cause malaria and make the Borgo and the Vatican uninhabitable. To Mazarin's agent in Rome, Elpidio Benedetti, Piazza S. Pietro was that "reedy thicket of columns . . . at a cost of two millions." All kinds of architectural criticism, not always clearly specified, *eccetioni ed errori di buona architettura* were bruited about by

Bernini's enemies—very possibly one of them the use of an Ionic frieze over Doric columns, or is it a contamination of heavy Doric columns with the Tuscan order? Nor were critical counterprojects missing, not always intelligent. Even the least hostile among the Venetian ambassadors, after praising the "ancient Roman grandeur" of the design, closes by stating his unwillingness "to discuss whether such an undertaking in these times was a good example and recommendable."

Granted that building Piazza S. Pietro contributed to ruining the finances of the seventeenth century papacy, it still remains Bernini's grandest architectural creation and a key monument in Alexander's remapping of Rome.

5. Overall Planning and Opposition

ALEXANDER from the outset and throughout his pontificate was deeply committed to laying out Piazza S. Pietro as to all his building projects. By the summer of 1656 planning for both S. Maria della Pace, church and square, and Piazza S. Pietro was underway; construction on the latter continued throughout his reign and was never completed. Work on S. Maria del Popolo and on the adjoining city gate had started as early as the winter of 1655-56 and a year later projects for reorganizing the entire Piazza del Popolo were under discussion; so was, by April 1656, the project for the Cathedra in St. Peter's. Even before, in January 1656, the marble for the equestrian statue of Constantine and for the relief above it was quarried and delivered to Bernini. The statue had been commissioned already by Innocent X, albeit for a place inside St. Peter's. Alexander does not seem to have given it first priority and Bernini worked on it but slowly. Thus it was finished only in 1679 and Alexander never saw it set up in place. By the summer of 1657 the project for a grand portal over a flight of stairs leading to the Quirinal gardens at the end of a prolonged Via Babuino-Due Macelli was under discussion—more on it later. This was followed from the spring of 1658 on by plans for clearing and embellishing Piazza Colonna, and from the summer of that year by the project and building of S. Andrea al Quirinale. The winter of 1658-59 saw the clearing of Piazza del Collegio Romano and the planning of S. Maria in Campitelli. In 1660 activity seems to have slowed down temporarily in Rome, but this was when work was going on at Castel Gandolfo and Siena. By 1661-62 new projects come to the fore: Alexander took it upon himself to complete the façade of S. Maria in Via Lata, to clear Piazza della Rotonda and the Corso, and, starting in the summer of 1662, to repair and to plan remodelling the Pantheon, the latter a dream never to be completed. Simultaneously work got underway on the church at Ariccia. By the early sixties, however, funds apparently were running low for new projects. The colonnades on Piazza S. Pietro, their extension by the Scala Regia, and the casting and finishing of the Cathedra Petri swallowed whatever monies were available. The remodelling of the palace on Piazza SS. Apostoli from 1664 on seems to have been the one major building activity begun in these late years. Still, if building in stone and brick was too expensive, Alexander could build, as it were, fictitious architectures and dream up vast projects: still as he lay dying, the façade of a nunnery opposite the Quirinal Palace was being decorated

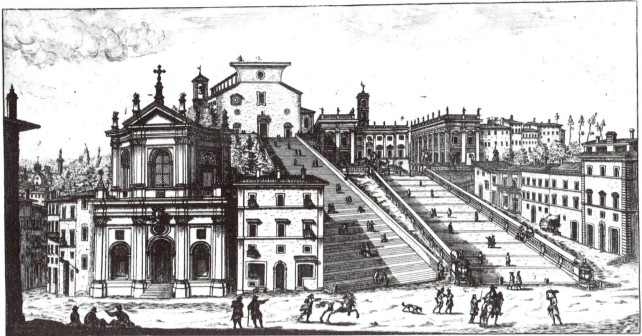

58. G. B. Falda, Capitol, S.
Maria in Aracoeli and S.
Rita da Cascia as of 1665

at his behest with a painted colonnade and he noted down work on
squares and fountains to be finished or to be started.

There were under Alexander's reign few architectural commissions
newly given that were beyond his control. The Jesuits, to be sure, had
Borromini continue his work at the Propaganda Fide, as did the Spanish
Trinitarians on the façade of S. Carlo alle Quattro Fontane, without
Alexander's interfering. Nor did he meddle with planning or construc-
tion at S. Andrea delle Fratte where Paolo del Bufalo in 1653 had com-
missioned Borromini to complete the dome and companile of the church
long started. But new commissions were rare: a handful of family chap-
els—for the Falconieri at S. Giovanni dei Fiorentini, for the Spada at
S. Girolamo della Carità, the Da Silva at S. Isidoro, the Fonseca at
S. Lorenzo in Lucina; and there are S. Giovanni in Oleo at Porta Latina,
remodelled by Borromini in 1658, and S. Rita da Cascia at the foot of
the Capitol (fig. 58). But all this was minor work. The only family that
could promote art and architecture on a scale almost, if not quite com-
parable to Alexander's, were the Pamphili: Don Camillo, nephew of
Innocent X and married to the Princess of Rossano, Olympia Aldo-
brandini, widowed Borghese, a woman of "genius, grace and elegance
. . . and as superior to the general run of women as her husband was
inferior to the general run of men." If that judgment of an intelligent
observer was fair, it was perhaps she rather than Don Camillo who built

75

up the collections both at the villa outside Porta S. Pancrazio and in
their palace on the Corso—it was hers to start with and it became Doria-
Pamphili only a century later—and she certainly continued enlarging
the collection after his death. Whether hers or his the incentive, the
large-scale building activity that goes under Don Camillo's name stands
out in the context of Alexander's Rome. At the time the Chigi pope
was elected, Prince Pamphili was just completing work on S. Nicola da
Tolentino far out on what was then the edge of the *abitato*. He was
also deeply involved in the bothersome situation that had arisen at
S. Agnese, the family church under construction since 1652 at the most
prominent spot in the inner town, Piazza Navona. Carlo Rainaldi, in
charge at the start, had been replaced early by Borromini, who over the
next three years fundamentally changed the plans, but who was in
constant friction with both the patron and his agents and the master
builders and in February 1657 was dismissed; a committee took over,
Rainaldi was reinstated and by 1666 completed construction with re-
visions by Cortona and Bernini. Hardly had the crisis of 1657 passed at
S. Agnese that Don Camillo took upon himself a new financial burden,
construction and decoration of S. Andrea al Quirinale, lasting from 1658
to 1671, five years after his death. Moreover, simultaneously he built,
starting in 1659 and finishing it within four years, the wings added to
his palace on the Corso, to face Piazza del Collegio Romano and at a
right angle Via della Gatta, running from that piazza to what is now
Via del Plebiscito.

It is quite a building program to be financed within twelve years or
so by a private patron, wealthy though he was, and it cost him and his
heirs a fortune. Alexander clearly would have no objection—churches
and palaces in prominent places and at times complementing his own
program, as at Piazza del Collegio Romano, were what he wanted for
the beautification of his city. But he could not let Don Camillo have
carte blanche. During the trouble at S. Agnese he interfered: as early
as the late summer of 1656—Borromini put up passive resistance against
his patron—he let the prince know he should go on building; "che
fabrichi a S. Agnese"; and the dismissal of Borromini six months later
took place with his full consent—"che certamente N. S. non havrebbe
havuto cosa in contrario"—after having personally ordered him, in vain,
as early as January 1656, to present an account of the work done. He
clearly meant to be helpful, but could not resist being domineering at
the same time. At S. Andrea al Quirinale he went further: Don Camillo
was to pay and to have the glory of being the founder of the church;
but Alexander gave his nod to the Jesuits to apply for permission; he
chose the architect—Bernini, of course; he approved and corrected the
plan; and he supervised further changes in planning and execution. Don

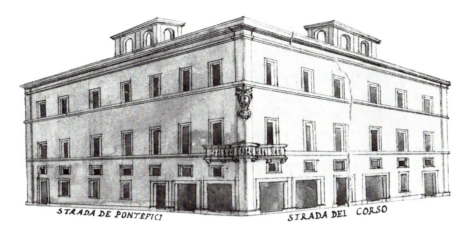

STRADA DE PONTEFICI STRADA DEL CORSO

59. Casa Moretti, presentation drawing; ASR, Notai di Acque e Strade, vol. 91 (101), 1664, after c. 376

Camillo would pay the piper and he did so willingly—"Bernini's orders are to be followed, if it costs all I own"; but Alexander called the tune. Even Don Camillo's palace wing on Piazza del Collegio Romano, not a public building after all, had to pass muster; Jacovacci, *maestro di strade*, brought Alexander the *modello*. Nothing untoward was to be built in Rome as far as Alexander could help it; certainly buildings on the Quirinal, under his very eyes, on Piazza Navona, or on the new Piazza del Collegio Romano, must fit into his vision of his city.

Whether he kept a watchful eye on other private building as well remains in doubt. It is surprising to find the papal arms on the presentation drawings for private commissions: on Casa Moretti at the corner of the Corso and Via dei Pontefici its presence might be explained by the patron-client relationship with the owner, Alexander's court jeweller (fig. 59). But on Palazzo Aste at the corner of the Corso and Piazza S. Marco-Venezia (fig. 20) the best reason one can think of is that the drawing was submitted to the pope for approval—perhaps because the small palace occupied a key position within Alexander's renewal scheme. Or were the papal arms just protocol?

Corresponding to the feverish activity of the early years of his pontificate, Alexander's diary testifies to his almost daily contact with the *maestri di strade*, the municipal executive authority in charge of urban maintenance and development and with their legislative counterpart, the *presidente delle strade*. Likewise he was forever in touch with his artists and architects, with Bernini primarily. It also testifies to his concern with both major and minor enterprises—too much so with the latter, the abate Buti apparently felt, and nastily remarked, "*maximus*

in minimis": widening and straightening streets, clearing and improving squares, paving, planting trees. Removing vendors' stalls from major thoroughfares, squares and ancient monuments was important in his and his contemporaries' eyes—"three times I've ordered that florist away from the porch of the Pantheon," he writes; but then the canons of the Pantheon, S. Maria Rotonda, wanted their rent. The appearance and map of Rome were foremost on his mind; individual buildings, a church, a façade he viewed as elements within larger units, squares or streets, and hence in the context of the urban fabric. All such architectural enterprises he considered his own as much as his architects' creations. He discussed them over and over in the planning stages and would occasionally sketch them—a slim volume survives containing sketches both by Bernini and by him and there are a few others scattered, all rough.

Obviously planning was rarely if ever really his and only his. Suggestions were broached to him by his courtiers, by the *presidente delle strade*, Monsignor Corsini—one recalls the planning of Piazza Colonna—by Virgilio Spada, by Domenico Jacovacci, one of the *maestri di strade*. And ideas came to him, of course, from the architects with whom he worked: from Pietro da Cortona talking him into ever grander and more expensive plans for Piazza della Pace; and from the ever-present Bernini leading him on slowly and consistently from project to project until the final solution had been found for Piazza S. Pietro. All such ideas obviously became Alexander's own, as custom would demand in any seventeenth century court; but Alexander did contribute in the discussions towards the planning or else he was convinced by his associates that he had done so: "abbiamo disegnato col Bernini"— we have planned (or does he really mean designed?) with Bernini this or that, he notes in his diary; or also, "we move him [Bernini] the church further back"—the church being S. Andrea al Quirinale. Even Bernini had to admit that the pope knew something about building. It was self-evident that Alexander would claim title also to buildings begun long before but completed only during his pontificate. The more so that he would contribute considerably towards financing and involve himself with planning their completion. The drawings and models for the façades of S. Andrea della Valle and S. Maria in Via Lata were approved by him and naturally his name appeared on the frieze as that of the builder. Similarly, at S. Ivo Borromini's dome, long built but decorated under Alexander, carries, as seventeenth century protocol demanded, the *monti* and star of the Chigi; so does the adjoining library of the Sapienza—but that was really Alexander's doing from start to finish.

Once planning was over—Alexander's being the final word "we have confirmed" or "we have decided"—Alexander went on needling the

maestri di strade to get underway the required demolitions, and driving the architects to speed up construction, hire more hands, provide more materials. He would visit the construction sites on his daily outings and watch the progress whenever possible from his windows: S. Maria in Via Lata from the Quirinal, the colonnades of Piazza S. Pietro from the Vatican Palace. Time and again in his diary or in random notes he reminded himself of work to be done, either construction in progress or projects once conceived but not carried through. Even in his last illness in the spring of 1667 he scribbled a note regarding such unfinished business: "shift the fountain of Piazza Colonna to Piazza S. Marco, the one here on Monte Cavallo to Piazza SS. Apostoli; move the obelisk from Campo Marzo up here to Monte Cavallo; bring the horses to flank the watergate planned by cutting the corner of that wall"—more of this anon—"finish Porta Pia and place opposite it that watergate; bring the show façade, the *mostra*, of the Trevi Fountain to Piazza Colonna; finish work on Piazza S. Pietro," followed by some details on perfecting the latter. Such switching about of fountains, obelisks and colossal statues—it occurs in other notes of his as well—makes sense once it is recalled that in his room Alexander kept a wooden model of Rome presumably with movable pieces for the major monuments and toyed with it, planning and replanning, even as he was lying on his deathbed. "The pope has all Rome in wood, *tutta Roma di legno*, in his bedroom," the Genovese resident in Rome reports, "as though there were nothing more important to him than embellishing the city"; plainly the resident felt His Holiness had better think about meeting his Maker.

His contemporaries considered him a building buff and when benevolently inclined, coined corresponding puns: "papa di grande edificazione," playing on the double meaning of edification and building; or "soffre di mal di pietra," he suffers from stones, referring to both his kidney stones and his building fury. A satire right after his death depicts him in purgatory designing amphitheatres and fountains, to rebuild the place as he had done in Rome, "where he never spoke of anything but renovating streets." Those less kind and more directly involved complained bitterly: about the exorbitant sums spent; about the demolitions all over town to make room for new structures or for street regulations, the Corso being the most evident example; about houses torn down, façades cut off, rooms halved or turned into triangles; all this accompanied to boot by an improvement tax levied on owners and neighbours. The Venetian ambassadors, clear-headed observers, minced no words— "grumbling is rife at the sight of one's nest being torn down or being forced to contribute to the straightening of streets . . . under the pretext of having the view from one's own house improved . . .": or, more ominously, ". . . the money pressed from the veins and blood of the

poor has congealed into hard stone . . ."; and all this for nothing, for "the buildings multiply but the inhabitants grow fewer . . . in the main streets one sees only empty houses marked *To Let*." Even the well-meaning Nicolò Sagredo, reporting to the Venetian Senate in 1661, was much in doubt whether the forced sales of property in favour of Alexander's building program and street regulations and in particular the construction of Piazza S. Pietro were "in these times" wise measures. The pamphleteers went wild: "He creates glory through stones, through the colonnade of St. Peter's where he spends a fortune on a dive for footpads and a place for dogs to lift a leg, *un pisciatoio per i cani*." To be sure, Alexander's sense of social responsibility was no higher and no less developed than that of any sovereign of his day. And he was a building maniac. But his building program had very clear practical implications and it had, I think, political aims.

Practical considerations, so Alexander and his public relations men insisted, were prominent. A large-scale building program would not only stimulate employment in the construction and allied trades and get beggars off the streets, but would also attract tourists and bring employment to domestics and funds to innkeepers and noble families willing to let their palaces wholly or in part for a few months or longer. Alexander's biographer Pallavicino sums up the arguments: "The Pope," he says, "deemed it wrong to support by alms the able-bodied. Therefore he erected buildings and joined beauty to usefulness. He knew, too, how much wide streets and commodious houses contribute to the health and delight of the tenants, and how much these two would help bring to Rome large and illustrious numbers of foreigners." The context makes it clear that the tenants referred to are not the poor, "Hence, he never ceased to widen streets, tear down mean and small structures . . . [and] to force people to remove stalls protruding from shops, bollards and porches from palace entrances and thus to provide more free space for air and light as well as for coaches . . ."—to relieve the traffic congestion was, after all, a necessity.

No doubt the pope and his advisors were genuinely concerned about difficulties created by growing traffic and by the obstruction of streets and squares by markets all over town. No doubt they were sincerely worried over unemployment and honestly believed that a vast building program was the best remedy and a substitute for almsgiving—not by chance was the cost of construction for S. Maria della Pace accounted for in one breath with *elemosine* spent. No doubt either they were deeply convinced that splendid church buildings like S. Maria della Pace and Piazza S. Pietro were in honour of God and His saints. As so often in life, however, such genuine concerns become convenient justifications needed in the face of constant attacks directed at the finan-

80

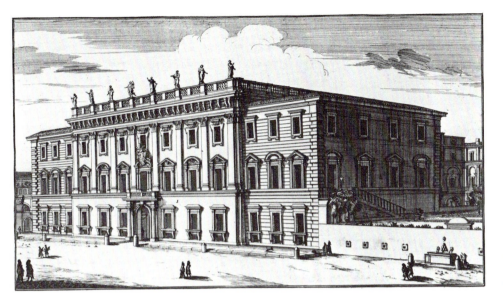

60. A Specchi, view of Palazzo Chigi (Chigi-Odescalchi), Piazza SS. Apostoli

cially ruinous, burdensome, inconvenient, and, so the adversaries, "useless," constructions all over town. But both the general practical considerations and the justifying apologies interlocked with the pope's overriding aim of embellishing Rome and of his and his architects' vision of turning her into a truly modern city. Spacious squares with regular boundaries were needed to facilitate the traffic; and they were decorous and an ornament to the entire city. So were long, straight streets adapted to the passage of coaches. Commodious, well-lit palaces with a pleasant prospect and splendid structures facing squares and important thoroughfares, all such requirements were integral to modern urbanism as understood by Alexander. Likewise integral to it were monumental palaces and church façades in full view, strongly articulated by planes, light and shade, such as those of S. Maria della Pace, S. Maria in Via Lata, or Cortona's palace project for Piazza Colonna. The open area and the bordering buildings must complement one another, and it must be focused on a structure standing out to hold the viewer's attention.

Focusing the open space on a major structure or on another dominant element and thus allowing both piazza and building to be seen to best advantage remain decisive in Alexander's planning. On Piazza SS. Apostoli the palace first rented and then purchased in 1661 by the Cardinal Nepote stands at one long side of the square and in no prominent position. Bernini redesigned it, starting in 1664: raising the seven-bay center block and articulating it by a colossal order of pilasters over a simple ground floor, he set it off against the rusticated, lower and plainer three-bay wings on either side. (fig. 60). Bought in 1746 by the Odes-

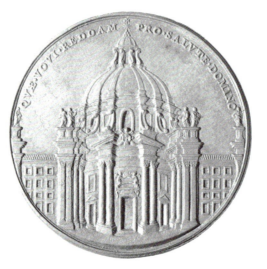

61. Medal, 1662, showing
second project for S. Maria
in Campitelli; Munich,
Staatliche Münzsammlung

62 (*facing page*). Carlo Rai-
naldi, S. Maria in Campi-
telli, façade and convent
buildings

calchi, the façade was extended in the pattern of the center to twice its
length and turned into tiresome reiteration, where Bernini's design
stood out and dominated the square, outweighing the church complex
opposite—the church being lower than today.

When in 1657 Senatore and Conservatori of the Popolo Romano with
the consent of and urged by the pope decided to provide a more decorous
ambience for the sacred icon of the Virgin in the small church of
S. Maria in Porticu, Alexander judged the site to be too modest and
remote. Hence he had the image as well as the regular canons serving
the church and the cardinal's title transferred to the nearby church of
S. Maria in Campitelli built half a century before on a site eminently
visible on the longish piazza of that name. There Alexander decided to
have a new, more impressive church built, the location being "the most
convenient in that neighbourhood and having a spacious piazza in front
enveloped by decorous palaces." Carlo Rainaldi, architect of the *Popolo
Romano*, was in charge. Early projects may have envisaged only adding
to the old nave a new chancel, its sideways conches to house statues
of the pope and the Conservatori in charge. However, as so often the
case with Alexander, the project grew: the entire church was to be
rebuilt and, as submitted for his approval in 1658, it would have been
one of the most overwhelming churches designed for him: a low, domed,
oval nave followed by a short domed chancel and preceded by a high
double-storied narthex, the whole to be flanked by convent buildings
extending the entire length of the longish square; but that project turned
out to be too costly. Reduced by 1662, but possibly two or even three
years before, by omitting the narthex and making the façade—the nave
still a domed oval—only one story high; articulated by pairs of colossal
columns and pilasters it still would have grandly dominated the square
with its flanking convents (fig. 61). But shortly after September 1662

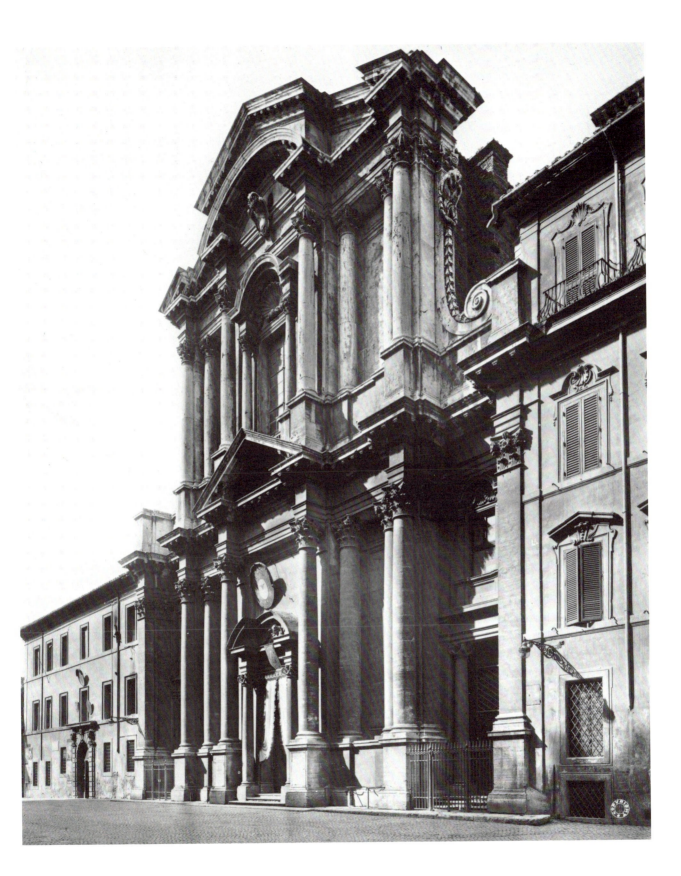

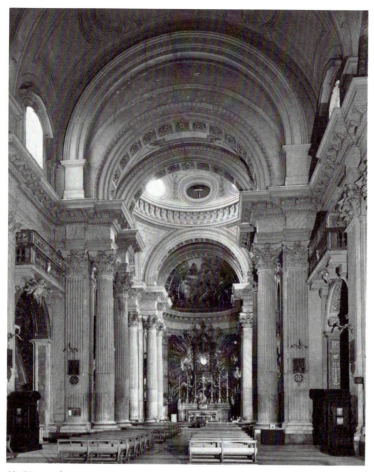

63. View of S. Maria in
Campitelli, interior

when the cornerstone had been laid that project too was thrown out.
Instead, a far less impressive and less expensive "contingency plan," in
readiness, it seems, since 1659, was substituted, using parts of the old
church of S. Maria in Campitelli: the nave thoroughly remodelled and
expanded into cross shape, with a square domed and apsed chancel
added: every corner filled with free-standing columns, the entablatures
broken, the contrasts of light and shade stressed (fig. 63). Like the in-
terior, the double-storied tall façade reflects this Rainaldi's customary
High Baroque idiom. Flanked by convent buildings—only the one to
the right was built, and more simply than projected—the church still
towers over the square, if less grandly than the domed oval projects
would have done (fig. 62).

Having a spacious square dominated by a forceful structure was a
basic tenet of the grand *teatri* planned by Alexander. The strong façade
of the Jesuits' Collegio Romano, begun by Ammanati some eighty years

84

64. Piazza del Collegio Romano, groundplan, as of 1659, showing Palazzo Salviati to be demolished; ASR, Notai di Acque e Strade, vol. 86 (96), 1659, c. 738

before, had never been finished; moreover, while its left-hand, western half faced a smallish square across from the church and nunnery of S. Marta, the eastern half gave on a narrow lane crowded in by Palazzo Salviati right opposite and hence "in parte oscurata et imperfetta e senza il dovuto prospetto e commodità di piazza proporzionata," as Alexander phrased it, without properly presenting itself and the commodiousness of a corresponding square (fig. 64). Hence in 1659 he forced the Jesuits to purchase and tear down the palace, without any cost to himself by the way. As a result, the Piazza del Collegio Romano, nearly tripled in size, would allow the façade of the College to be completed and in its full somber massiveness to dominate the square; it would also make it possible for coaches to approach the College on festival occasions— recitations or promotions. The site of the Salviati Palace not needed for the new square was bought by Don Camillo Pamphili for building the new wing of his palace, thus filling the gap, completing the square

65. Piazza del Collegio
Romano, with Collegio
Romano on the left, and
new wing of Palazzo
Pamphili on the far right

66. G. Vasi, view of Piazza
S. Maria in Trastevere facing
north towards church and
new canonry

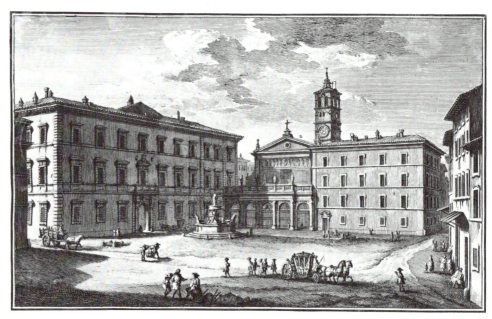

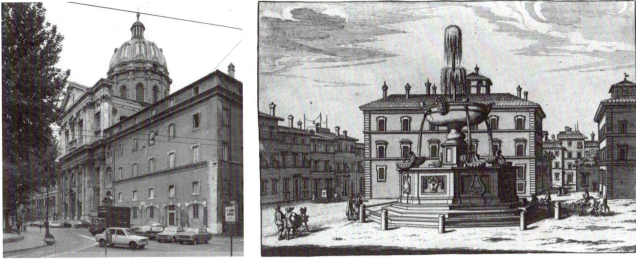

67. (*above left*). S. Carlo ai Catinari and Barnabite convent

68. G. B. Falda, view of Piazza S. Maria in Trastevere facing south, and fountain as of 1690; G. B. Falda, *Fontane di Roma*, Rome, 1690, pl. 32

and counterbalancing the mass of the College (fig. 65). (A minor inconvenience, not new but apparently brought now to Alexander's attention, was that the students from the upper floors of the College could look into the nunnery of S. Marta across the square; presumably the offending windows were boarded up.)

To bring into prominence the prospect of an imposing structure, ". . . acciò si scopri bene la facciata"—one recalls the remark about S. Maria della Pace—practical considerations quite aside, was a guiding tenet of Alexander's as it had been of previous urban planning. If need be, even a small piazza would do. The tiny piazza fronting S. Carlo ai Catinari was enlarged to bring into view, if only sideways, the façade of the adjoining Barnabite convent building: long begun, construction had been held up by the nuns of S. Anna just across a narrow lane for fear of the upper floors' overlooking their monastery and blocking out the good air. Alexander in 1660 cut short the argument, had a blind corridor built in the convent towards the nunnery and over the next years had the convent completed to house the additional Barnabite congregation expelled the year before from Piazza Colonna; the ground-floor shops in the new front wing would bring welcome supplementary income for the enlarged community. Moreover the elegant façade would "provide for the ornament of the city," and the piazza, small as originally it was, would be important enough for Alexander to list it among his achievements (fig. 67).

Where no grand project would hold the attention, the focus for a square would be set up on the square itself—one is reminded of the ship fountain planned for Piazza Colonna. The exact siting of that focus, however, was always carefully considered. On Piazza S. Maria in Tras-

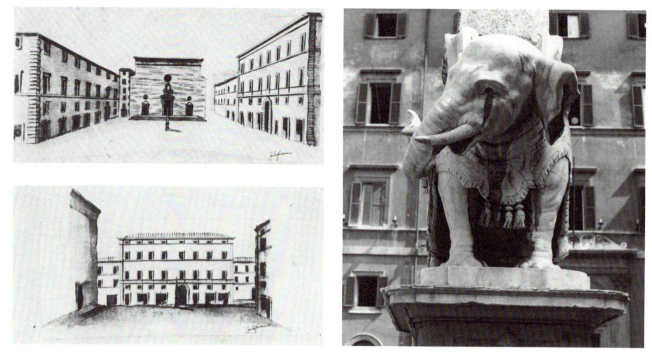

69. Piazza della Minerva, alternative proposals for placing obelisk; BAV, Chig., P VII 9, f. 117

70. (*above right*) Piazza della Minerva, elephant carrying obelisk.

tevere, façade and narthex of the medieval basilica were unimpressive to seventeenth century eyes; hence in 1659 Alexander had the fountain, long extant on the square and relocated and renewed at least twice over the past two centuries, shifted again; exactly halfway between the church and the opposite, east side of the piazza, but much closer to its south than to its north edge, it lines up with the campanile rather than the axis of the basilica and creates a delicate balance (fig. 66). Raised a few steps from the ground, the large center bowl rises high from its base within the eightsided basin, whose panels were marked by the Chigi arms and simple banisters—or were they water jars? On the corners of the basin Bernini placed four large double shells to catch the waterspouts cascading from the center bowl above whence a geyser rose almost four meters high into the air and focused attention on the center. The sides of the square, too, were regularized; next to the church and thus shifting attention away from it a new canonry was built; opposite, the east side of the piazza was squared off by an impressive new house, leaving ample space right and left for the approaching streets. Not by chance did Falda choose that view for another engraving of fountain and piazza (fig. 68).

Placing the Obelisk of the Minerva dug up in the summer of 1665 in the right spot on the square fronting the church apparently was likewise a problem in the months following its discovery; a drawing among

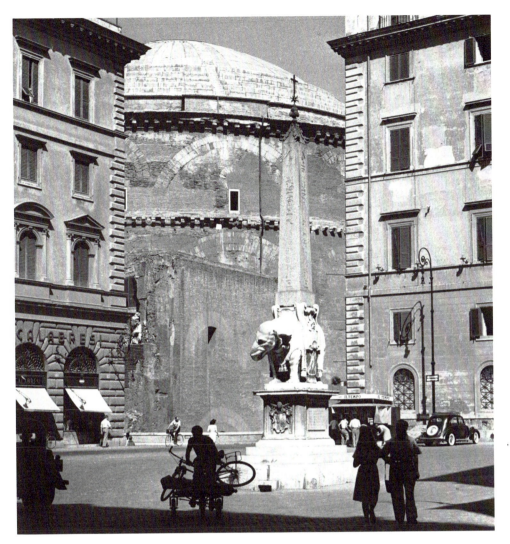

71. Piazza della Minerva

Alexander's papers shows two alternatives weighed before Bernini had designed his elephant—one on axis with the church, the other in front of Palazzo Fonseca on the south side of the square and thus on line with the street coming from the Collegio Romano (fig. 69). When in the spring of 1666 Alexander chose the project with the elephant— Bernini had designed it thirty years earlier for the Barberini gardens— it was placed on line with the church in the very center of the square so as to draw the attention of the onlooker to both the imposing if bare façade of the Minerva—it was to be provided with "modern" half-oval steps—and to the obelisk and its carrier: a symbol of Divine Wisdom and thus contrasting with the wise but human Egyptians—so Alexander's inscription—but also one of the wittiest inventions of Bernini's slyly winking across its trunk at the beholder (figs. 70, 71).

89

6. Teatri II: Prospects

IN FRONT of S. Andrea della Valle, too, a piazza was to be opened. The body of the church had long been completed, but the façade, designed by Carlo Maderno, had remained unfinished save for its base. In the winter of 1658-59 Rainaldi was called in by Alexander to present a drawing for steps with rounded corners to be placed in front; two years later work was resumed on the façade following rather than Maderno's a design of Rainaldi's, thoroughly revised and simplified by his young assistant Carlo Fontana who even then seems to have been much influenced by Bernini. It was built over the next five years (fig. 72). Clearly such a façade needed a piazza in front to be seen at best advantage, and in fact a small square was laid out, framed left and right by unprepossessing older structures. But the square was just large enough to shelter the church steps; it did not provide the distance necessary to take in the overpowering and somewhat overloaded façade. Hence a more far-reaching project was being discussed (figs. 31, 73): the street issuing into the square starting from Piazza S. Apollinare, some four hundred meters to the north, was to be widened "so as to run straight down to S. Andrea"; a feasible plan to be realized by demolishing four small blocks of houses along the way and widening the last hundred meters of the existing street. It would have been an avenue just as wide as Corso Rinascimento, broken through in 1938, and would have brought the façade and dome of S. Andrea into full view from afar. But it came to nought.

The most ambitious project of that kind would obviously have been an avenue leading to Piazza S. Pietro. Starting at Piazza di Castello on the Tiber bank just south of Castel S. Angelo, it would have been laid out by simply doing away with the *spina*, the blocks of buildings separating Borgo Vecchio and Borgo Nuovo, the two main streets of the Borgo (fig. 47). Such an avenue had been discussed ever since 1586 when Sixtus V planted the obelisk on Piazza S. Pietro on axis with the center line of the *spina* rather than St. Peter's. The project was taken up and elaborated upon a generation later when Ferrabosco, following a project of Maderno's, built the entrance arm to the palace jutting out at an acute angle to the façade of St. Peter's; a corresponding arm on the opposite south side and rows of arcades continuing the arms eastward were to outline the trapezoid of a piazza. Lining up approximately with Borgo Vecchio and Borgo Nuovo, these arcades would have accompanied an avenue narrowing progressively as it reached Piazza di Castello, the *spina* having been removed—on paper, that is; buying up all that real

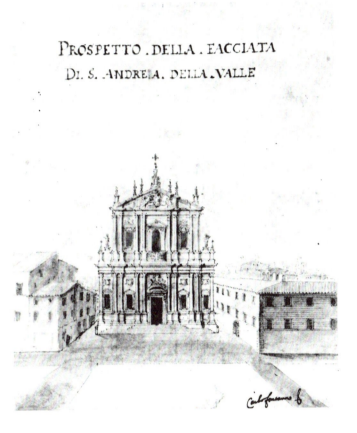

PROSPETTO . DELLA . FACCIATA
DI . S . ANDREA . DELLA . VALLE

Carlo fontana f

72. C. Fontana, S. Andrea della Valle, façade and piazzetta; BAV, Chig., P VII 9, f. 90r

73. C. Fontana, survey of streets and blocks of houses leading from S. Andrea della Valle towards S. Apollinare; BAV, Chig., P. VII 9, f. 90v

estate was far too expensive. Nonetheless this or a similar project was discussed again in 1651 by the *Congregazione della Fabrica di S. Pietro* in some detail: there were to be eighty-one arches in each of the two arcades; the width of the avenue was to increase from 90 *palmi* at Piazza di Castello to twice that width at Piazza S. Pietro; and the expense was estimated at a minimum of just below 60,000 *scudi*. There was no great enthusiasm among the members of the commission and among the objections raised—expense, depopulating the Borgo, health hazards, uselessness—it was acutely observed by Cardinal Pallotta that as the terminal feature of such a long and wide avenue St. Peter's would shrink to nothing—as indeed since 1938 the vista along Via della Conciliazione proves.

There is so far no evidence that Alexander ever entertained the project of such an avenue. Bernini in 1651 was in favour of the idea, praising its *magnificenza e bellezza*, and as a few years later he was developing his plans for Piazza S. Pietro he must have thought of the idea and of how to counter Cardinal Pallotta's objection. The *terzo braccio*, the connecting link between the two curved main arms of the porticoes,

91

Fig. 74. L. Cruyl, Piazza S.
Pietro with *terzo braccio*
moved east; Oxford,
Ashmolean Museum

planned from the very outset, was obviously and primarily meant to
complete the enclosure of the oval piazza. But it would have acted also
as a barrier interposed between St. Peter's and an avenue, had this latter
been built. Coming from Piazza di Castello at the Tiber, the visitor
would have seen from afar the dome and just the top of the façade of
St. Peter's; halfway down the avenue only the dome remained in view;
and as he approached the colonnade of the *terzo braccio*, even the dome
was gone. Only after passing through or by that third arm and entering
the piazza would St. Peter's present itself in full view: stairs, façade,
nave, dome and all. As Bernini developed his last projects for Piazza
S. Pietro from 1665 to 1667, the function of the *terzo braccio* as a barrier
withholding the view of the church from a visitor approaching and
coterminally the planning of an avenue would seem to have become
almost a necessity. The last, westernmost palace of the *spina* was to
be torn down and the *terzo braccio* moved eastward, out of line with

92

the curving arms of the colonnades and close to what had now become the end of the *spina* (fig. 74). Its enclosing function thus was abandoned; instead, in its new position it further anticipated the disappearance from view even of the dome as one approached the third arm; a clock tower planned atop would have increased the height of the barrier. Yet, standing nose to nose against the end of the *spina*, facing a tiny square, the *terzo braccio* has no raison d'être. It makes sense only as a barrier drawn across an avenue laid out in place of the *spina*. Then it would have cut off more and more, as one approached, the view of St. Peter's. Only after crossing onto the piazza, slightly prolonged eastward by an "ante-piazza" right behind the *terzo braccio*, could the church be taken in fully. Carlo Fontana's avenue project, published thirty years later as his own, is probably Bernini's somewhat changed—for the worse.

If Bernini, then, had in mind as his ultimate goal such an avenue in place of the *spina*. Alexander would have known. Rumours were rife in Rome anyhow. The planned siting of the *terzo braccio* left no doubt. But, the project of moving the *terzo braccio* eastward to near the end of the *spina* was so firmly established by 1667, obviously with Alexander's consent, that mapmakers and draughtsmen of *vedute*, such as Falda, Matteo Gregorio de Rossi and Lieven Cruyl, took for granted its construction and siting. The tiny *piazzetta* left to separate it from the *spina* was obviously a solution arrived at *faute de mieux*: Bernini would presumably have envisaged it as the thin end of a wedge to prepare Alexander's mind for the need of replacing the *spina* by an avenue. But Alexander by 1667 was a sick man and worried about finances. He would have shied away from discussing or indeed thinking of so far-reaching and expensive a project. Even building the *terzo braccio* he preferred putting off; the Congregazione della Fabrica on February 19, 1667, noted with satisfaction that His Holiness favoured giving priority to having the piazza paved and postponing to a later time discussion of that structure. However, there was no later time for Alexander. On May 22 he was dead.

In fact Alexander never saw come to fruition any of the long streets focused on a grand terminating prospect of which he dreamt. Only his projects survive. But they give an idea of what he had in mind. Quite early in his pontificate, in July 1657, he recorded in his diary that he had ordered Bernini "to open up at the Babuino so one can see from the obelisk on Piazza del Popolo to the *portone*, the gate, of this garden," meaning the Quirinal where he was in residence. An *avviso* confirms that the project of such a *portone* was under consideration and estimates the cost of the undertaking at no less than 40,000 *scudi*, obviously including the extension of Via del Babuino to the foot of the gate. Indeed, a plan survives tracing the necessary breakthrough from Via Due Ma-

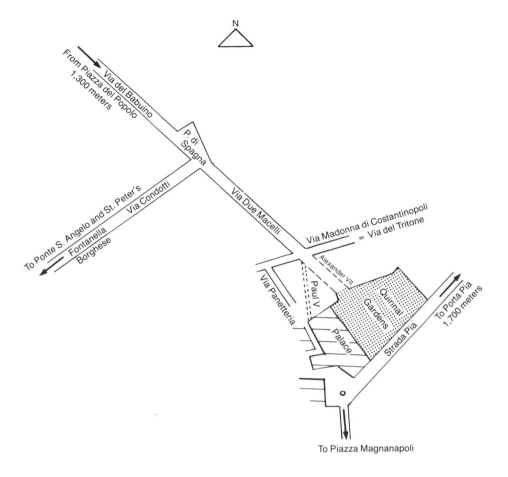

75 *(facing page)*. Plan for breakthrough from Via Due Macelli (Strada Paolina) to Quirinal Gardens; BAV, Chig., P VII 10, ff. 32v-33r

76. Sketch plan of streets from Piazza del Popolo to Quirinal Gardens, as projected in 1657

celli, which continues Via del Babuino to the cliff of the Quirinal Hill where the *Traforo* now gapes, the tunnel pierced early in this century through the hill (fig. 75). On the plan are marked the houses to be condemned and the names of the owners to be indemnified. Creating an exit on this north flank of the Quirinal Palace and Gardens was not a new idea. Paul V, some forty years before, had planned one with the aim of linking the papal residence to Via Due Macelli and turning at a right angle to Via Condotti and Fontanella Borghese as a commodious processional route to the Borghese Palace and beyond to St. Peter's. To Alexander laying out that route was less important than placing the new *portone* well in evidence as the terminating prospect at the end of Via del Babuino and the lengthened Via Due Macelli. "To be seen from the *guglia del Popolo*," as he writes, it was to attract the attention of visitors from the North entering Rome through Porta del Popolo. Travelling down that mile of a street they were to approach through the new *portone* his exalted presence (fig. 76).

95

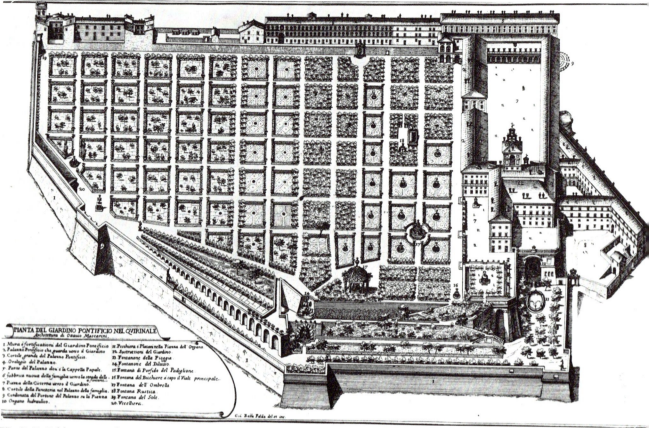

PIANTA DEL GIARDINO PONTIFICIO NEL QVIRINALE
Architettura di Ottavio Mascarini

1 Mura é fortificationi del Giardino Pontificio 11 Peschiera e Platani nella Piazza del Organo
2 Palazzo Pontificio che guarda verso il Giardino 12 Austrattione del Giardino
3 Cortile grande del Palazzo Pontificio 13 Fontanone della Pioggia
4 Orologio del Palazzo 14 Fontanone del Diluuio
5 Parte del Palazzo doue è la Cappella Papale 15 Fontana di Porfido del Padiglione
6 fabbrica nuova della famiglia uerso la strada delle 16 Fontana del Bicchiere á capo il Viale principale
7 Piazza della Cisterna uerso il Giardino 17 Fontana dell' Ombrella
8 Cortile della Panetteria nel Palazzo della famiglia 18 Fontana Rustica
9 Cordonata del Portone del Palazzo su la Piazza 19 Fontana del Sole
10 Organo hidraulico 20 Vccelliera

Gio. Batta Falda del et inc.

77. G. B. Falda, Quirinal
Gardens as fortified by Ur-
ban VIII

To be sure, no portal ever existed at that point of the Quirinal Gardens.
Nonetheless Alexander, when scribbling his diary note envisioned it so
clearly, presumably after having discussed it with Bernini the previous
evening, that he spoke of it as something actually there. To build one,
indeed, would have required major structural changes, since Urban VIII
in 1625 had fortified the Quirinal, palace and garden, with a huge bat-
tened wall and bastions, one of them precisely on the site of the *Traforo*
(fig. 77, foreground). High up, the garden terrace 8 meters above the street
carried a huge gushing fountain. Piercing the wall of that bastion to an
inner staircase would have been possible. But no gate at street level could
possibly have been seen from Piazza del Popolo, 1,500 meters away.
However, Lione Pascoli, writing before 1728 but well informed, reports
a project of Bernini's to build at the end of a street broken through from
Via Due Macelli "a grand flight of stairs to be surmounted by a noble
gate leading to the Quirinal Gardens" and framing the Fontana della
Pioggia—a watergate (fig. 78).

That flight of stairs could have been built only by cutting the wall

96

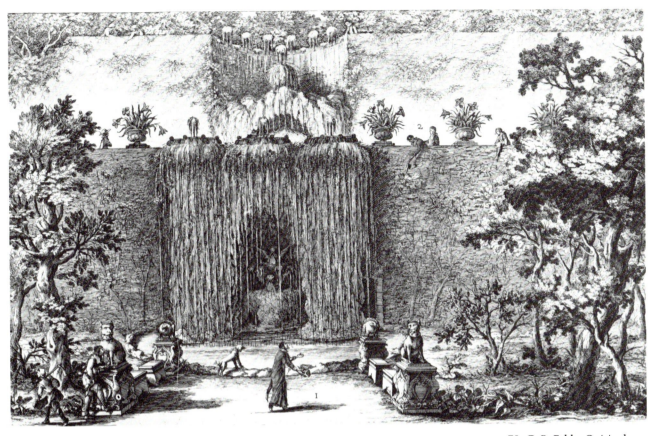

78. G. B. Falda, Quirinal
Gardens, Fontanone delle
Pioggia

of the bastion projecting at that point from the fortifications of Urban
VIII and this in turn explains a phrase in the note scribbled during his
last illness by Alexander in 1667 to remind himself of unfinished busi-
ness: "Place the horses either side of the watergate designed [to be set
up] by cutting the corner of that wall and place it opposite Porta Pia."
The horses can only be the statues of the horse-tamers standing forever
in front of the Quirinal Palace and long attributed to Phidias and Pra-
xiteles; the corner of the wall to be cut is the bastion; and the watergate
is in all likelihood the very gate originally designed for the garden
entrance above the planned flight of stairs opposite Via del Babuino-
Via Due Macelli. Only as an afterthought was it to be placed on Piazza
del Quirinale at the western end of Strada Pia-Venti Settembre opposite
Porta Pia at its eastern terminus. To be seen from afar, that gate, flanked
by the horse-tamers in the position originally intended, would have to
be colossal; and being created for Pope Alexander it would have to
proclaim his fame. Among Bernini's projects never carried out one sur-
vives in a workshop drawing that fills the bill: an imposing gate, flanked

97

P

by the horse-tamers; and they, ever since the sixteenth century, were believed to represent the great Alexander and his Bucephalus (fig. 79). Placing them on either side of the gate was a fitting compliment to the pope—he would be only too willing to disregard, as did his flatterers, more recent scholarly identification of the statues as the Dioscuri. Moreover, the gate was to be huge, invitingly concave and surmounted by the outsized *monti* and the star of the Chigi. Thus it would have greeted from afar ambassadors and other visitors riding along Via del Babuino and Via Due Macelli from Piazza del Popolo to pay obeisance to Alexander in his residence on the Quirinal.

If the planned prolongation of Via del Babuino to the Quirinal and the grand stairs and garden gate came to nought, presumably for lack of funds, a similar project, the approach to the Trinità dei Monti, fell victim to the intricacies of high politics. Church and convent of the Trinità, high on the Pincio above Piazza di Spagna, were French property. Mazarin, Louis XIV's prime minister, in 1660 proposed to have the ascending path, tree-lined three years before, replaced by a grand flight of stairs or ramps and to have the façade of the church redone. The entire remodelling was to be dedicated to peace, ostensibly to the Peace of the Pyrenees just concluded between Spain and France, and to be placed under the aegis of his royal master, whose equestrian statue was an integral part of the project envisaged by Mazarin. The pope, he writes, would welcome the project, "intent as he was on embellishing the city to which nothing could be of greater ornament." Mazarin's agent in Rome, Elpidio Benedetti, was to solicit drawings from Roman architects, Bernini in the first place. Benedetti, informing himself through Jacovacci, *maestro di strade* and an intimate of both Alexander's and Bernini's, sent some plans but tried to sidetrack his master from insisting on his approaching Bernini: Alexander obviously would not consent to having a monument to French glory in the middle of his own capital; the more so that at the Peace of the Pyrenees he had been badly slighted by Mazarin. Nor would Bernini, the pope's right hand, want to get officially involved in that enterprise. In fact, Mazarin's scheme has been interpreted convincingly as a political move intended to embarrass Alexander. All this Benedetti knew only too well, but could not tell Mazarin in so many words. The rest can only be surmised: Mazarin insisted; Bernini, tempted by the task and eager to stay on good terms with France, where he had always wanted to be invited—as indeed he was five years later—must have given way on condition that his name not be mentioned. In any event his project or a copy thereof, disguised as a design of Benedetti's own, went to Mazarin while another copy, likewise as Benedetti's, was shown to Alexander (fig. 80). One supposes that everybody involved saw through the fiction but all

79 (*facing page*). Bernini workshop, portal flanked by horse-tamers and surmounted by Chigi arms; Berlin, Staatliche Museen, Kupferstichkabinett, KdZ 1584

99

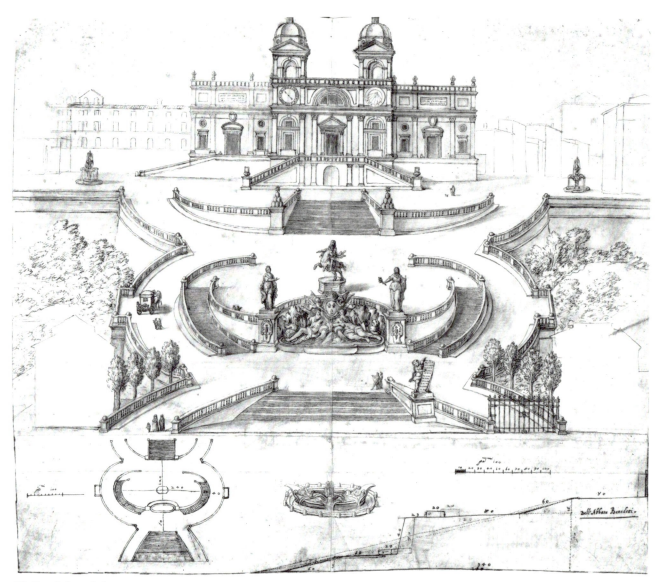

80. Bernini workshop, approach to Trinità dei Monti as planned in 1660; BAV, Chig., P VII 10, ff. 30v-31r

concerned played the game with a straight face; only twenty years later when the main actors were dead did Benedetti lift the veil and show a visitor, the Swedish architect Tessin, a model of the project as Bernini's. Alexander, as one might have expected, refused his consent: no seventeenth century sovereign could have suffered in his capital the statue of a foreign ruler—it was an implicit claim to sovereignty; and that from Louis XIV, the most overbearing monarch of his day, was just too much for Alexander. Mazarin did not or did not want to understand. Apparently hopeful until the last moment that the pope would not be able to resist so tempting an addition to his remapping plans, he was

100

offended by the rejection of his offer and the whole idea was dropped. Alexander's heart must have bled throughout this comedy, for Bernini's was a splendid plan, composed of a flight of stairs at the bottom, flanked by wide ramps for coaches; these continued upwards, sweeping outward and inward to envelop halfway up a grand fountain filled with rocks and river gods surmounted by the bronze statue of Louis XIV on his prancing horse; carrying outward again, ramps on the uppermost side of the hill flanked a last flight of steps. What a culminating prospect it would have made for anyone approaching from Via Condotti and beyond; and what a pity that Mazarin would insist on having that statue of his king! That the new structures built all over Rome should redound to the Chigi name and to Alexander's and to nobody else's glory was self-evident in the century of absolutism. Thus Mazarin's project came to nought. Sixty years later it was revived in different shape when Specchi designed the Spanish Stairs—as splendid if less comfortable than Bernini's project.

Practical requirements, genuine concerns about unemployment, traffic congestion and honouring God and His saints, self-justification, his own and his family's glorification, striving for beauty of urban design, grandeur and grandiloquence all intertwine in Alexander's program. All were integral elements in his ultimate goal to turn his capital into the most beautiful and most modern city in Europe.

7. Roma Antica e Moderna

ANY PROJECT aimed at turning Rome into a modern city would have to accommodate her tradition, almost two thousand years old; the more so in a century as conscious as the seventeenth of its classical foundations. Certainly Alexander meant to, and did his best as far as it suited him to integrate Rome's ancient monuments into his *Roma Alessandrina*. His approach to antiquity was that of any cultured gentleman of his time. He knew his classics by heart; and he never questioned what he had been taught to admire as good architecture, exemplified by the great monuments of Rome, her pride. They were his models, not to be followed, mind, but to be emulated in grandeur and splendour, and to be fused as well as possible with the new squares, streets and buildings he was having designed. Rome, so a contemporary addressed him, would "be raised again to the beauty bestowed on her by Augustus, Titus, Trajan and other emperors, followed by Your Holiness." His was to be truly the *Roma antica e moderna*, as guidebooks for some time had been calling and continued to call the city. Hence he felt responsible for maintaining, restoring and incorporating into his new Rome, not by any means all ancient monuments surviving, but those which stood out and enhanced, or at least did not obstruct, his envisioned remapping of the city and the image he meant to present.

The Arco di Portogallo, which spanned the Corso and was an obstacle to traffic, simply had to go (fig. 16). But then, doubts had long arisen regarding its antique origin since it was obviously composed from spoils. Alexander conscientiously covered himself by having this view confirmed by written opinions from antiquarians, complemented by the archaeological evidence sworn to by the masons and architects on the demolition squad. They, among them Carlo Fontana and Felice della Greca, concluded that the arch, built from spoils and resting on older foundations, was "neither ancient nor triumphal and only bedecked with sundry ancient ornament"; and a few weeks later Alexander "diverted himself in the ruins"—so a malicious *avviso*.

The Pyramid of Cestius, on the other hand, far out at Porta S. Paolo and incorporated into the city wall, stood out as a great monument of antiquity. Attested to by inscriptions and hence particularly precious in an age nourished by the reading of the ancient writers and its ever-growing epigraphic collections, the monument was famous and eminently visible. To have it restored had been on Alexander's mind from the outset, the summer of 1656. But then the plague struck and only three years later could he launch the project, declaring that the ruin of

102

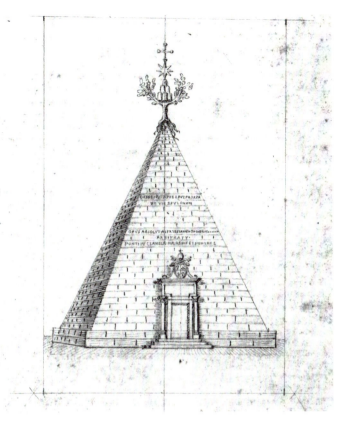

81. F. Borromini, Pyramid of
Cestius crowned by Chigi
emblems; BAV, Chig., M IV
L, f. 160r

such a monument "would have decreased the fame of the magnanimity
of the old Romans indeed and made less frequented by foreign artists,
virtuosi forestieri, the road to Rome to enjoy the Roman antiquities
and to indoctrinate themselves with their example. . . ." Clearly he
meant to preserve the image of the glory that was Rome. As time went
on, though, he must have had second thoughts. When in 1663 work
was finally completed the inscriptions he drafted took up a different
theme: the dead from the plague were buried at the foot of the pyramid
and in ever new variations he plays on the motif of the pagan tomb's
symbolizing eternal death and its being rededicated in intercession for
so many Christian souls and eternal life. Apparently he felt the need
to justify his spending so much effort and funds on an ancient ruin;
indeed, it is presumably in this context that a proposal to christianize
the pagan monument was submitted to him by Fioravante Martinelli,
antiquarian, prolific author and intimate of Borromini's. The proposal
was accompanied by a drawing from Borromini's hand: a witty fancy,
an oak tree carrying the *monti* and star, all three Chigi emblems, sur-
mounted by the cross, was to be planted atop; literally planted—the
roots of the oak grip the point of the pyramid (fig. 81). Inside, a chapel

103

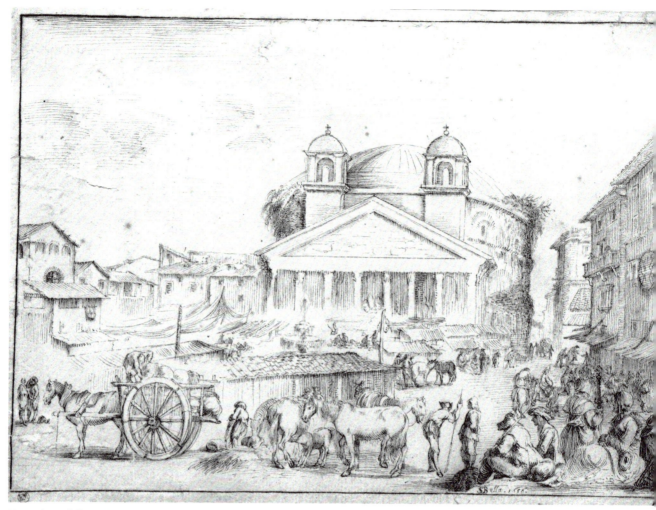

82. Stefano della Bella, view of Piazza del Pantheon as of ca. 1650; Stockholm, Nationalmuseum

was to be installed, dedicated to Saints Peter and Paul; and its door for good measure was to be topped again by Alexander's arms. But for once he resisted temptation—the work of restoring and digging up the surrounding ground to the original level had been expensive, totalling over 3,600 *scudi*—and so he limited himself to having engraved on the pyramid, front and back, *"Instauratum An. Domini MDCLXIII"*—the simplest inscription he ever composed, with no mention of his name and no arms.

Where the Pantheon was concerned no conflict existed for Alexander between his admiration of an ancient pagan monument and his Christian conscience. The Pantheon had been converted more than a thousand years before into a church, S. Maria Rotonda, and tradition had well preserved the memory of all the pagan demons and their mother Cybele being driven out and being replaced by the Virgin and all of the saints. Hence it was to the general consciousness both a church and a

104

83. G. L. Bernini, sketch of
Pantheon restored as of old;
BAV, Chig., a I 19, f. 66r

monument of antiquity, the greatest to have survived within the me-
dieval town. Like any medieval church, too, it had been engulfed by
medieval life: small houses attached to the walls of the huge cylinder
and to the flank of the porch, like puppies; the ground all about had
risen high and steps descended to the portico where formerly steps had
ascended from the old Roman level; two columns were missing from
the portico's left flank and the intercolumniations except the one center
front had been blocked by walls serving as backwalls for so many booths.
The square in front was all cluttered up with vendors' stands; Roman
antiquities, a porphyry tub among them, stood in between ever since
the Middle Ages; and both square and building were regularly flooded
by the river and by a defective sewer system (fig. 82). Alexander, from
the start, strove to rescue the Pantheon from what he saw as a de-
meaning situation—"majesty cleansed from sordidness," so runs the
inscription on the commemorative medal. After all, not only had the
Pantheon ever since the fifteenth century been held by architects and
the educated public to be the grandest and most exemplary architectural
monument of antiquity, but also it was identified through its inscription
with the Augustan age and the great Agrippa. It was also highly visible:
located at a key point of the inner town and, preceded by the square,
it lent itself splendidly to forming the focus and prospect of one of those
architectural units which dominated Alexander's remapping scheme.
Hence he went to work.

To reconstruct the Pantheon in its ancient glory, raised high from
the ground, its pediment crowned by statues, was obviously a dream—
Bernini toyed with it in one of his sketches (fig. 83). But the building

105

could be rescued "from the squalor and meanness caused by the market" held on the square—*subiacentis fori situ squalescere et vilescere videat*—so Alexander complains, and its dignity could be restored. As a first emergency measure—and one can imagine his indignation—he had removed in June 1656 a market stand, conveniently installed atop the porphyry tub on the piazza. Early the next year all the vendors' stalls on the square were confined to marked sites rather than being allowed to clutter up the whole square; at the same time there was talk of tearing down the houses attached to the rotunda—property of the canons and hence a sensitive issue. Apparently not much came of it. But two and three years later, after many deliberations with his advisors and waxing impatient, Alexander engaged in the project in earnest. The situation was touchy to handle: the canons of the church drew considerable rent from the houses and vendors' stalls. Finally, in the summer of 1662 he struck, overriding on his sovereign authority, *regia manu*, the canons' protests. He had the houses torn down—two sketches of Bernini's show those condemned. The vendors were forcibly removed to Piazza di Pietra and settled between and behind the columns of Hadrian's Temple (fig. 24)—no respect being paid to its remains, strange as it seems. Plans to settle them there permanently led to nought. In fact, the exile of fishmongers, *fruttaroli*, butchers and others lasted but briefly; nine months later they were back in Piazza del Pantheon, albeit with their stalls neatly grouped behind and on either side of the fountain and the canons again collected their rents. Likewise the pope, much against his will, one supposes, had to allow them to build in place of the houses demolished, another house three floors high and with shops, another shopping center, albeit further back so as to be less visible from the piazza and therefore less disturbing. However, Alexander did not give in so easily. Perhaps at this point he thought, after all, of sending the vendors away for good by assigning them shops in the new buildings of the Collegium Germanicum adjoining S. Apollinare and opposite S. Agostino.

Alexander's plans went far beyond relocating stalls and clearing away buildings from the Rotunda. All around the square houses were to be aligned by cutting fronts. Street entrances were cleared; the street to the left of the Pantheon leading to Piazza della Minerva, formerly but 18 *palmi*, 4 meters wide, and "always an eyesore—sempre piena di brutture" was to be widened to three times its width, 50 *palmi*, by providing arcades, presumably on the ground floors of the flanking houses, extant and to be built. There was even discussion of demolishing the block of houses between Piazza del Pantheon and Piazza della Maddalena, thus extending the square in front of the Rotunda northward to twice its length; but that was too costly a dream and Alexander

106

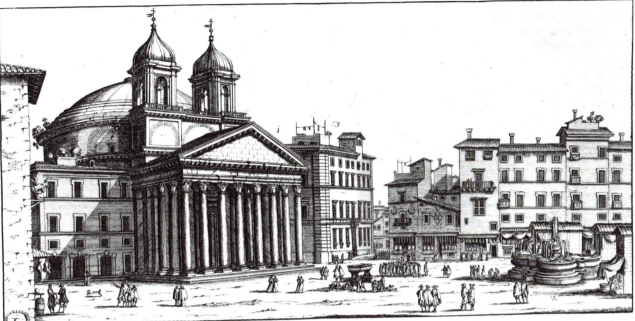

84. G. B. Falda, view of Piazza del Pantheon as of 1667, graded, canons' house rebuilt, columns of porch replaced

himself dropped it. In any event, the level of the piazza had to be lowered so as to free the Pantheon from the earth that had encased it (fig. 84). Obviously the piazza could not be sunk to the Roman pavement, thus freeing the steps that originally ascended to the portico of the Rotunda and raising the building high from the ground. That pavement was over three meters below the seventeenth century level and going down to it would have cut off the square from the approaching streets. But the piazza could be and was made to slope down from its north end towards the building. Thus the ground was cleared from the portico and it was raised, if not to the original seven, at least one step above the piazza. The proposal was illustrated by a clay model presented to Alexander late in the summer of 1662, but execution was delayed till 1666.

Restoring the Pantheon not only outside but inside as well was Alexander's aim, if not from the outset, at the latest from 1662 on. The portico was the first part to be repaired. The walls inserted in the Middle Ages between the columns to contain the earth accumulated were removed, the two columns missing on the east flank were replaced by two of corresponding size found near S. Luigi dei Francesi; the entablature was made anew bearing on the soffits of the cornice the Chigi star and *monti*. All this was carried out, if with a delay of four years, and the Pantheon became the grand focus of the square and its surroundings which Alexander meant it to be. Moreover a project was considered by the *Congregazione delle Strade* to bring to the portico

107

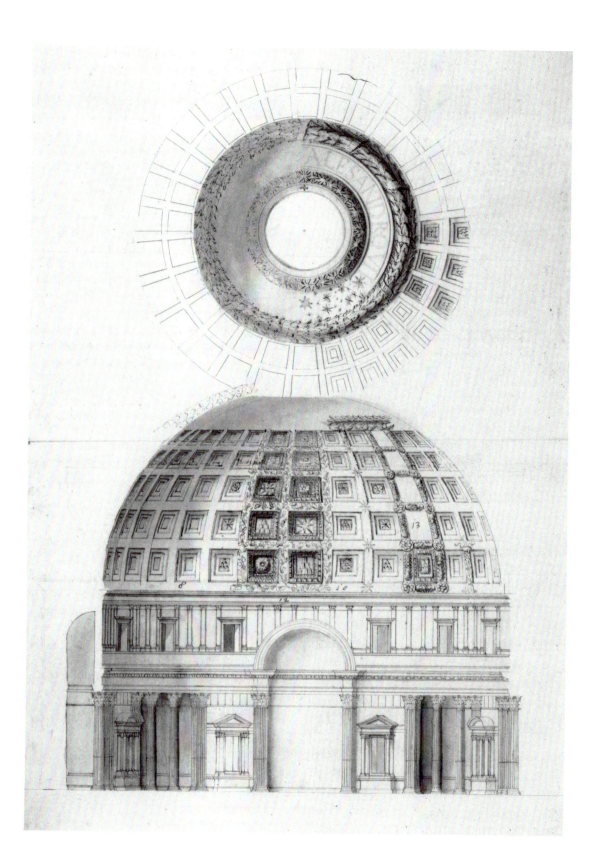

the porphyry sarcophagus of Helena, then in the Lateran—it was really meant to be Constantine's—and the one with Bacchic subjects from S. Costanza and to move into the portico also the "tomb of Marcus Agrippa," presumably the porphyry tub which since time immemorial had stood on the piazza in front. As many glories of antiquity as possible were to be gathered in this the most glorious of ancient buildings to the glory of its rescuer, Alexander.

The entire project of restoring the Pantheon receives indeed its true meaning only when seen in the context of the redecoration of the interior which Alexander had in mind. The marble revetment and the columns were to be cleaned and polished—that goes without saying. Beyond that, the huge oculus was to be protected by a glazed-in lantern. More incisive and more revealing still was the redecoration planned for the dome: around the rim of the oculus, framed by heaped stars and a laurel wreath, Alexander's name was to be written in huge letters; and the coffers of the dome were to be marked with the Chigi arms, the *monti* and the star with rosettes in between (fig. 85). The whole of the building thus was to redound to Alexander's glory; a watercolor presentation drawing from Carlo Fontana's hand illustrates the scheme. Bernini, it was rumoured after Alexander's death, had refused to be a party to such sacrilege. And Alexander himself seems to have considered the project so outrageous that he meant to keep it secret; Negrelli, the *senatore di Roma*, was to pretend that the idea was his. But Alexander meant to have his way. The Pantheon, the greatest reminder of antiquity in Rome, was to be his. He died before work was started. Only his diary notes, the estimates of the entrepreneurs and drawings by Carlo Fontana survive, all dating from 1662 to 1666, a few months before Alexander's death, and one of the last entries in his diary runs, "più denari per la Rotonda."

The Forum Romanum was yet another reminder of Roman antiquity, in indecorous shape at the time and yet highly visible, with the columns of a few temples rising high and famous all over Europe. It, too, was bound to turn into an object of, and indeed a key element in, Alexander's remapping plans. Located at the edge of town right behind the Capitoline Hill, it was no longer the wasteland it once had been; it had become a link, as it were, between the built-up town and the *disabitato*. Ever since the mid-sixteenth century impressive structures had been rising along its rim: to the south, on the slope of the Palatine, the Villa of the Farnese, the Orti Farnesiani, and at the foot of the hill, the church of S. Maria Liberatrice; to the north a whole series of churches— S. Nicola de' Falegnami, Cortona's SS. Luca e Martina, S. Adriano, S. Lorenzo in Miranda, SS. Cosma e Damiano, S. Francesca Romana— all except the first two ensconced in Roman ruins and all remodelled

85 (*facing page*). C. Fontana, Pantheon, interior, project for redecorating dome and oculus with Chigi emblems and Alexander's name; BAV, Chig., P VII 9, ff. 111v-112r

109

in the first half of the seventeenth century, the last one, S. Adriano, between 1653 and 1656. Before these, extending to the foot of the Palatine, spread the Campo Vaccino, a sheep and cattle pasture used since the late sixteenth century for the biweekly cattle markets, its surface irregular, set with a few sheds and since 1593 a fountain for men and cattle. Alexander in 1656 eliminated what he would have called "the indecencies," moving the market to near S. Giorgio in Velabro, having the surface planed and four rows of trees planted from one end of the Forum to the other to form a carriageway in the center flanked, as it were, by sidewalks—the last sad remnants disappeared a hundred years ago (figs. 86, 87). The justification given by him for planting this tree-lined avenue was that it would provide convenient access to the churches; but it obviously served also or perhaps primarily as a shaded promenade for both the elegant world riding in coaches or on horseback or carried in sedan chairs and the common folk on foot to take the air in the cool of the evening. Thus the Forum not only regained dignity but also became a suburban public green, part of the town, yet reaching out.

That avenue across the Forum was but the first link in a long chain of shaded roads, flanked more modestly by only one or two rows of elms or mulberry trees, all planned and some planted that same year 1656; in fact, on September 24 Alexander sent Don Mario, his brother and the governor of Rome, the rolls of drawings for planting trees all over Rome—"elm trees they must be. . . . Let him see whence to dig up the money . . ."—a simple way of solving the financial problem. The draft of an estimate, presumably somewhat antedating that entry in the pope's diary, has survived, envisaging the planting of a total of 5,500 trees, elms and a few mulberry. Somehow Don Mario dug up the funds. Indeed, by the end of Alexander's pontificate a chain of tree-lined roads, starting from the Forum, covered the entire southeastern sector of the *disabitato* as proposed by the draft estimate. From the Arch of Constantine a shaded avenue ran to below S. Gregorio Magno and from there to the head of the Circus Maximus. Thence one road lined with mulberry trees turned west towards S. Maria in Cosmedin and S. Giorgio in Velabro, while another continued east through what is now the Passeggiata Archeologica to S. Sisto Vecchio. From there tree-lined roads went northeast to the Lateran whence what is now Via Merulana leading to S. Maria Maggiore was likewise to be protected by trees. From S. Maria Maggiore the road to S. Croce in Gerusalemme was planted with trees as was the one eastward leading to Porta S. Lorenzo. Other avenues outside the walls were to run along Via Tiburtina, Via Nomentana to S. Agnese and, across the Tiber, from the Borgo to Ponte Molle. Most of the program laid out in the draft estimate was carried out, except the avenues leading from S. Maria Maggiore to

86 (*facing page*). Forum planted with tree-shaded avenue, project; BAV, Chig., P VII 10, f. 94r

INDICE DELLA PIANTA
del Campo Vaccino

A, Arco di Tito
B, Chiesa di Sta Francesca
C, Templum Pacis
D, Chiesa de SS: Cosimo, e Damiano
E, Chiesa di S: Lorenzo in Miranda, delli Speziali
F, Sito che risalta in fuora, che riquadrato ascende alla somma di @ 13 e p̃ 000 in circa
G, Chiesa di S: Adriano
H, Chiesa de SS: Martina, e Luca
I, Chiesa di S: Giuseppe de Falegniami, e sotto d; S: Pietro in Carcere
K, Arco di Settimio
L, Fontana di Campo Vaccino
M, Chiesa di Sta Maria Liberatrice
N, Portone del Giardino, del Duca di Parma.
O, Strada delli Pantani, che è quella del passeggio delle Carozze, in tempo di feste, ad alcuna delle predette Chiese, et anco, in tempo del Perdono, à S: Gregorio

Gioseppe Leoncini Sottomro

Scala di p̃ 150 Romani

87. G. van Wittel, view of
Forum as of 1683; Rome,
Galleria Pallavicini

the Lateran and along Via Nomentana. The maps of Rome published during Alexander's pontificate and shortly thereafter clearly show these long tree-lined roads cutting through the *disabitato*.

To be sure, Alexander's were not the first shaded public avenues in Rome. But these forerunners since the early seventeenth century had been limited to single spots on the city map—in Trastevere; at the eastern foot of the Capitol; on the ascent to S. Trinità dei Monti. Alexander was the first to think in terms of a vast overall program, enlarged as its execution proceeded; as late as 1666, a new avenue was planned near S. Giorgio in Velabro. The principal function of the program was obviously to provide shade: for pilgrims on their way to the great churches: for outings by coach; or for common folk and labourers on their way to their vineyards and gardens, in the quarter of the *disabitato* not reclaimed by the huge villas of the great families on the Pincio, Quirinal, Viminal and northern Esquiline. Moreover, an enterprise of that size would fit into Alexander's program to combat unemployment. However, there was, one suspects, an ulterior purpose. The renewal of Rome was to extend beyond the city proper; the vast enveloping area of the *disabitato* and its offshoots into the countryside, the highways, were to be integrated with the built-up core and like this core architecturally articulated by the long, scenographic vistas of tree-lined avenues, green *teatri*, as it were. The zone of gardens and fields extending to the Aurelian walls and the highways beyond, like the built-up area, was an integral part of Alexander's Rome, as he envisioned it.

8. Piazza del Popolo: City Planning and Stage Design

SQUARES and long straight streets terminated by grand prospects open up further dimensions in this remapping of Rome as conceived by Alexander. From the Renaissance on, town planning had been interwoven with stage design. An ideal city, hard to build in the real world, was easily constructed in canvas and wood on the stage. Two types of stage design seem to have prevailed: a trident of streets leading into the distance, separated and flanked by impressive palaces interspersed with monuments evocative of Roman antiquity—as in the Palladio-Scamozzi stage at Vicenza; and an open stage bordered by grand structures and terminated by a backdrop marked by ancient monuments—a temple, an amphitheatre, a triumphal arch—as in the panels in Baltimore, Urbino and Berlin. Finally, stage design to a large extent was coterminous with decoration temporarily erected to celebrate festival events, themselves not unlike stage performances. These "showes" were—to quote an English visitor—"divers, both Sacred and Prophane. As the Whipping Processions in the Holy Week, the Great Procession from S. Marcello Oratory to St. Peter's Church . . . The Procession of the Priests of the Oratory upon Shrove Tuesday to the Seven Churches . . ." the latter enlivened by a picnic. Then there were the cavalcades of the pope and the cardinals, and among ". . . the Prospective Shows . . . the solemne Entries of Embassadors, especially those of Obedience, where each Princes Embassador strive to out vye the other . . . by excessive expenses . . . their cavalcades to Court upon their publick audience." Such shows, not to forget the Corpus Christi procession or the *possesso* of the newly elected pope, brought forth onto the squares and along the streets the constituent elements of such festival celebrations: the setting—triumphal arches spanning the streets, tapestries hung from windows, cornices and windows illuminated, a façade of wood and canvas set with symbolic figures and emblems masking the front of a palace or a church; the participants—clergy, dignitaries, nobility, possibly the pope himself, both actors and the public in the know; and a broader public, the crowds, eager to see—such feasts and an occasional hanging being their only entertainment. When in 1664 Alexander in the Corpus Christi procession had himself carried under the canopy, kneeling and holding up the host in its monstrance for hours, the edifying spectacle was greatly admired and recorded by himself as the event of the year in a medal. Similarly, inside a church

114

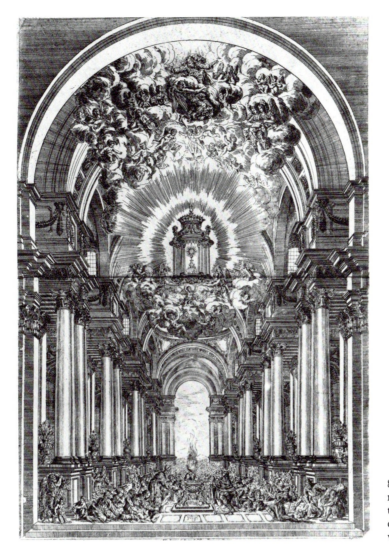

88. C. Rainaldi, Gesù, decoration for *Quarant'ore*; Istituto di Archeologia e Storia dell'Arte, Raccolta Lanciani, vol. 38, I, n.p.

religious solemnities would be performed in the framework of a stage set: Pietro da Cortona's splendid fictitious architecture designed in 1633 for the celebration of the *Quarant'ore* at S. Lorenzo in Damaso survives in a drawing, as does Bernini's corresponding *apparato* for the *Quarant'ore* in the Cappella Paolina and Carlo Rainaldi's designed in 1650 for the Gesù (fig. 88); but there were innumerable others lost to us. One recalls too the cultivation by the Jesuits of the *Theatrum sacrum* and the performances of such religious plays inside the Gesù throughout the better part of the Seicento and the architectural stage sets designed for those plays by artists like Carlo Rainaldi and Andrea Pozzo.

Inevitably in Alexander's Rome urban and stage design interlock. The façade of a church is masked by an architecture of wood and canvas for

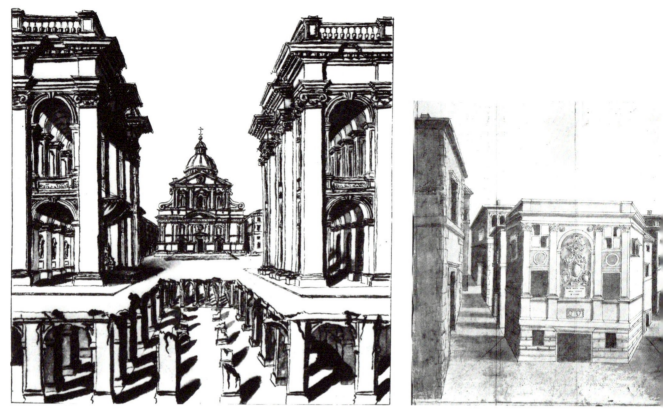

89. Pietro da Cortona, stage
set for religious play (in
Gesù ?); Martinelli, Disegni
d'edifici in Roma, I, f. 40,
Raccolta Bertarelli, Milan,
Castello Sforzesco

90 (at right). Stage set show-
ing Zecca and flanking
streets; BAV, Chig., P VII
13, f. 54

the funeral celebration of royalty, as is the façade of Palazzo Farnese in
honour of Queen Christina's residence. Conversely Piazza della Pace
in Vasi's engraving is made to convey an impression of both size and
grandeur far beyond reality; buildings loom high, people are reduced to
puppet size (fig. 37). As on a stage set too the grand boundaries conceal
insubstantial structures. Vice versa, stage designers in Alexander's Rome
loved to integrate in their designs elements of the actual cityscape.
From Pietro da Cortona's circle comes a stage design showing two pal-
aces inspired by those of Michelangelo on the Capitol, and in the back-
ground the Gesù, the whole surmounting a subterranean ruin (fig. 89).
Is it then possible that Cortona's drawing was done for a religious play
in the very church represented? The overlapping of reality and fiction
goes yet further when Bernini on the backdrop of the stage shows a
second audience for which the play is being performed, mirroring both
the real audience and the play; and then to top the illusion he shows
that fictitious audience leaving the theatre across "Piazza S. Pietro by
moonlight, many on horseback, cavaliers, coaches, pedestrians, torch-
bearers." Correspondingly, there survives in an engraving a stage set
designed for a performance in honour of Queen Christina, the prosce-

116

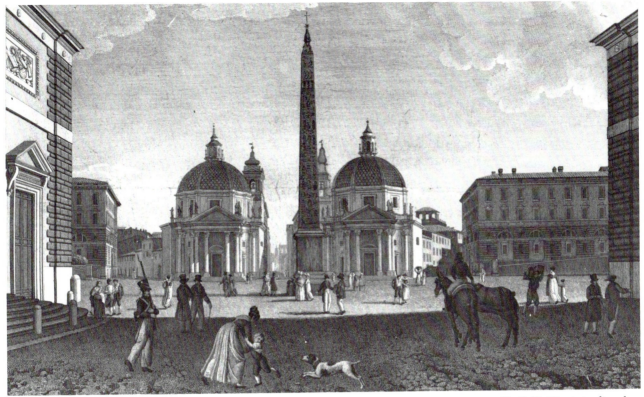

91. F. M. Giuntotardi and A. Testa, view of Piazza del Popolo and trident of streets, as of ca. 1830; Istituto di Archeologia e Storia dell'Arte, Raccolta Lanciani, no. 18369

nium flanked by grand palaces while the backdrop shows Castel Sant'Angelo and St. Peter's as seen from Palazzo Borghese, where the performance took place. Or again, among the Chigi papers, a drawing shows Sangallo's Zecca, later the Banco di Santo Spirito, and the two streets issuing from there, Via dei Banchi Vecchi and Via dei Banchi Nuovi, transposed into a stage set (fig. 90). Reality and fiction intertwine. The stage is a piazza in the city; conversely, real piazze, buildings and streets are *teatri*, showpieces, in which modern buildings and ancient monuments reflect the glories of ancient and contemporary Rome.

Nowhere in Rome is the intertwining of stage design and city planning more clearly evident than in Alexander's remapping of Piazza del Popolo (fig. 91). Prior to his election, the area right behind the city gate, Porta Flaminia or Porta del Popolo, where visitors from the north since the sixteenth century would have entered Rome, was a shapeless, longish space. From its short southern edge three streets issued: the Corso, the Roman Via Lata in the center, ending on Piazza S. Marco below the north cliff of the Capitol; to the right Via di Ripetta, laid out early in the sixteenth century and leading into the heart of the *abitato*; to the left, Via del Babuino, traced a few years later and running itself dead at

117

the north foot of the Quirinal. A fountain had been set up near the center of the piazza by 1578, the obelisk nearby in 1589, placed so as to be on axis with the intersecting sightlines of the three streets. But the area still remained unimpressive, filled as it was with cattle, carts and farm folk, the gate itself and the city wall half-ruined, the buildings on the two wedges between the three streets, houses and a chapel, all mean (fig. 92). It forecast, as late as 1640, a country town rather than a world capital, and Rome at that; this, notwithstanding the impressive fifteenth century church adjoining the gate, S. Maria del Popolo, and the obelisk set up by Sixtus V. It was not a prelude, to quote a contemporary guidebook, "to make the entry into Rome [appear] so majestic that from such portent one might gather what a city that famous would offer."

Remodelling under Alexander started with S. Maria del Popolo. Agostino Chigi, the Croesus and pride of the family in the early sixteenth century, was buried in one of its chapels, designed by Raphael. But church and chapel over the past one hundred and fifty years had fallen into disrepair and Alexander, while still Monsignor Fabio Chigi, had started restoring both. When cardinal, he was advised by Holstenius on the completion of the sculptural program of the chapel left in suspense in the sixteenth century. He planned to commission from Bernini the statue of Daniel, from Algardi that of Habakkuk, "so as to improve the work through competition." Once the former was finished in 1657, Bernini carved the Habakkuk as well, Algardi having died in 1654. Indeed, after Alexander's elevation to the papacy work on the church continued with ever greater vigor: throughout, the pavement was newly laid; in the nave, the stucco statues which lie above the cornices of the arcades were carved by Bernini's workshop; in the transept a splendid organ was installed, its case enveloped by the oak of the Chigi; the dome was restructured and painted by Raffaele Vanni; all over, Alexander's arms were placed in evidence; on the façade modern double-curved lateral gables replaced a pair dating from the late sixteenth century; and all along its front a high flight of "modern" stairs, rounded at the ends, took the place of the earlier straight-bordered one. All this was carried out between July 1655, four weeks after Alexander's election, and the summer of 1657. Meanwhile, starting in the late spring of 1656, remodelling spread to the city gate: to glorify both the Chigi name and the entry in December 1655 of Queen Christina of Sweden, when the authorities and the nobility in coaches and on horseback assembled at the gate to accompany her along the Corso, the gate was redesigned by Bernini (fig. 93); a double broken gable was placed atop displaying the festooned Chigi mountains and crowned by their star enclosed in a roundel. The inscription "to a happy and fortunate entry,

92 (*facing page, at top*). J. Lingelbach, Piazza del Popolo as of ca. 1640; Vienna, Akademie der Bildenden Künste, Gemäldegalerie

93 (*facing page, bottom*). Porta del Popolo

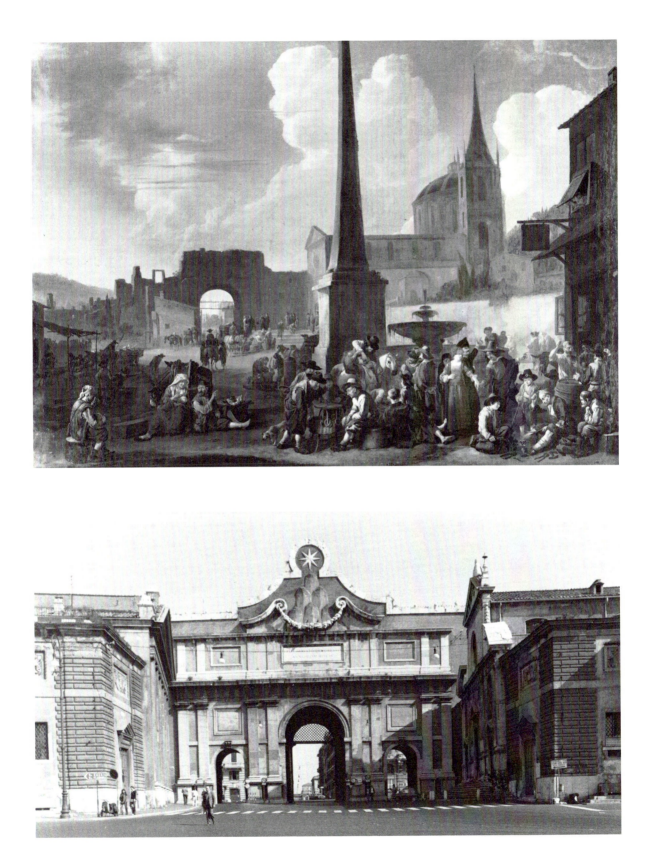

94. Porta del Popolo, detail

95 (*at right*). Piazza del Popolo, project, envisaging curves on wedges, 1656-57; BAV, Vat. lat., 13442, f. 34

1655," meant originally to welcome the Swedish queen, now greeted and still greets all comers from the north (fig. 94).

Starting from such limited plans, Alexander was soon lured, as so often he was, to a far vaster project: to shape into a grand square the undistinguished area behind the gate to its southward termination, whence issued the trident of streets. As early as the fall of 1656 he made inquiries regarding the ownership of the buildings on the two wedges between the streets, perhaps stimulated by Bernini; demonstrably the latter was involved when a few months later a project had apparently been prepared to place porticoes on these wedges, obviously to mask the higgledy-piggledy structures and to beautify the square "per ornamento del Popolo." Concomitantly plans were prepared to hide as much as possible the unequal width and length of the wedges and to articulate the entire area: the former either cut straight and somewhat simplistically equalized; or else equalized but terminated by delicately concave curves complementing each other and well-suited to carry porticoes (fig. 95). Moreover, on the later plan those curves form part of an elegant solution for shaping the entire area into a clearly organized piazza: narrowing behind the gate into a short reversed funnel corresponding in length and inclination to the façade of S. Maria del Popolo, the space was to open into a wide funnel as far as the obelisk; thence it was to continue with parallel sides, to flare out once more at the end into the slanting axes of Via del Babuino and Via di Ripetta. Some time over the following three years—construction as always moved slowly for there were no funds—the project changed. Instead of porticoes twin

120

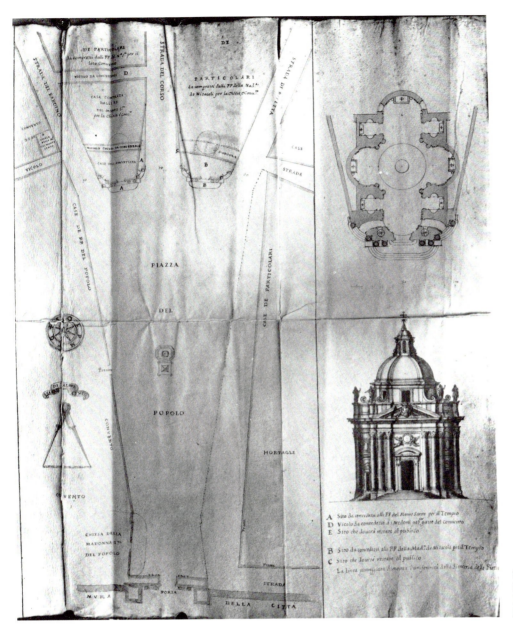

96. C. Rainaldi, Piazza del Popolo and churches, plan, 1661; ASR, Disegni e Mappe, cart. 81, 279

churches were to be placed on the wedges—there was talk about that project as early as April 1657—admittedly with the thought of having the two monastic communities settled nearby, the Discalced Carmelites of S. Maria di Monte Santo and the French Tertiaries of S. Maria dei Miracoli, take them over and share the expense of construction. Simultaneously Carlo Rainaldi, for some time involved in the enterprise, was commissioned to design the churches and saw his project approved late in 1661 by papal *chirografo* (fig. 96). The cornerstone of

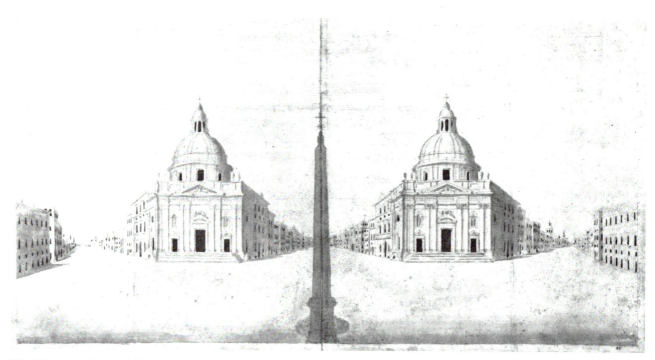

97. C. Fontana, Piazza del
Popolo and churches,
counterproject, 1660-1662;
BAV, Chig., P VII 13, ff. 25v-
26r

S. Maria dei Miracoli, the right-hand church, was laid a few weeks later, long before the site had been cleared; the aim being to make the two wedges equal in width and length "al para e paralello," to enlarge the opening of the Corso and to have two churches of equal design terminate the view "ad ornato della Città e della detta Piazza."

There seems, however, to have been trouble: either Alexander had qualms about Rainaldi's project or Bernini grumbled, for early in 1662 the pope noted, "Bernini . . . about Piazza del Popolo, whether he has anything to say." There was in fact reason for discontent with Rainaldi's project—the elegant sequence of spaces along the piazza had been replaced by a continuous long funnel space extending from S. Maria del Popolo to the trident of streets. The façades of the twin churches as proposed were marked by clustered columns, broken cornices and gables and by heavy volutes buttressing the low drums: High Baroque elements, diametrically opposed to the Baroque Cinquecentismo cultivated by Bernini in these years, as witness his churches at Ariccia and Castel Gandolfo or S. Andrea al Quirinale. In fact, an alternative project for Piazza del Popolo much more in keeping with Bernini's taste was being presented to Alexander around 1660, a grand *veduta* designed by Carlo Fontana, Rainaldi's collaborator, but in his architectural concepts much closer to Bernini (fig. 97). Clearly based on the project of a piazza formed by a sequence of spaces—the two large buildings with rows of

122

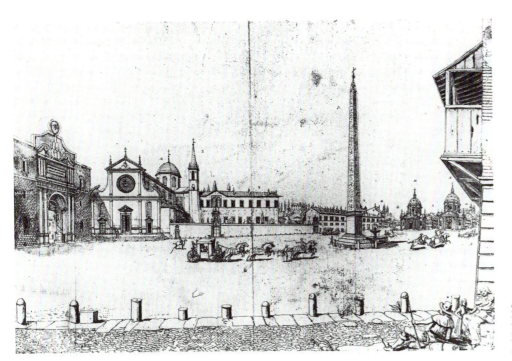

98. L. Cruyl, Piazza del Popolo and churches as planned 1664; Cleveland Museum of Art

ground floor *botteghe*, regular shopping centers, at either edge of the drawing, stand parallel to one another rather than oblique as the continuous funnel shape of Rainaldi's *chirografo* plan would have had it—the twin churches in the *veduta* were conceived of as simple volumes defined by thin planes with an overlay of shallow Corinthian pilasters and unbroken cornices and gables; concepts quite alien to Rainaldi's architecture. True, for the piazza a continuous funnel shape was accepted—it was a saving, too, in that less terrain had to be appropriated. The planning remained in Rainaldi's hand, as witness in 1662 the inscription on the foundation medal, "Carolus Rainaldus inventor." However, the character of the successive changes in the design of the churches conveys the impression that Fontana, backed presumably by Bernini and Alexander, pushed Rainaldi gradually towards an architectural vocabulary and concepts closer to Bernini's. The colonnaded gabled porch, proposed by 1662 and recorded on the foundation medal, recalls specifically the entrance porches to the colonnades on Piazza S. Pietro where Carlo Fontana just then was working; a high slender drum, as it appears in the drawing of Lieven Cruyl late in 1664, likewise has a Berninesque flavour; so does the repetition of the porch on both flanks as well as in the front of each church—but that idea was dropped because it would have all but closed to traffic the Corso as well as Via di Ripetta and Via del Babuino (fig. 98).

123

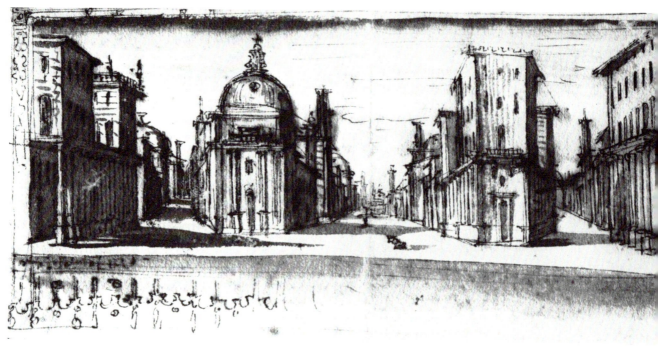

99. Bernini workshop, tapestry showing stage set based on Piazza del Popolo; whereabouts unknown

The building history of the churches in later years—construction was started in earnest not before 1673, and only by 1679 were both churches completed, the *campanili* being added after 1758—has no bearing on the shape of the piazza or on Alexander's projects for the remapping of Rome. As he envisioned Piazza del Popolo, whether terminated by porticoes or by twin churches, the decisive element was the shape of the area, either formed by a sequence of spaces and thus more sophisticated or simplistically reduced to the continuous flow of a funnel as indeed it was executed. This basic element was of course lost when Valadier, following a long period of planning starting in 1824, enlarged the piazza sideways by hemicycles and thus replaced the longitudinal axis with the present transverse one; beautiful though it is, it runs counter to the concept of the piazza as envisioned by Alexander and his architects. As they had planned it, the visitor entering through Porta del Popolo was to be sucked, as it were, into the short, reversed funnel flanked by the façade of S. Maria del Popolo and its new flight of stairs. Thence he was projected into the piazza proper and slowly led towards its southern end, taking in the successive views as from a theatre pit; the obelisk and its fountain, the river to the right and across it in the distance the dome of St. Peter's; to the left the slope of the Pincio, planted with vineyards, gardens and trees; straight ahead the "frontispiece" of the city, the trident of streets and the wedges marked by porticoes or churches; slightly in front, the two "shopping centers," framed a kind of proscenium. The whole recalled a stage set and as on a stage set the

124

perspectives along the three streets were enlivened by the rising towers and domes of churches, S. Atanasio dei Greci on Via del Babuino, on Via di Ripetta S. Maria Porta Paradisi, and further down S. Girolamo degli Schiavoni, all marked on Fontana's alternate *veduta*. Also, as demanded by the conventions of the stage set, the view along the Corso was interspersed with monuments of antiquity: the Column of Marcus Aurelius still rose above the rooftops and at the far end of the Corso the landmark of the Capitol, not yet hidden by the Monumento Vittoriano: the Tower of Paul III, Aracoeli, and the tower of Michelangelo's Palazzo del Senatore. Had the grand breakthrough been carried out at the end of Via del Babuino and Via Due Macelli, terminating in the flight of stairs and the garden gate of the Quirinal flanked by the horse-tamers, a great scenic view would have presented itself to the visitor along that axis as well. Not by chance did the view even without that third prospect and with only slight changes—palaces with colonnaded porticoes rather than shopping centers flanking the proscenium and with but one church—seem appropriate for a tapestry, perhaps a theater curtain, shown in a sketch from Bernini's circle (fig. 99). Stage set and urban texture intertwined.

9. The Reverse of the Medal

Like Piazza della Pace or Piazza S. Pietro, Piazza del Popolo was envisaged as a *teatro*, a showpiece inserted into the urban fabric and superimposed on the life of the population. For that fabric and that interwoven life had persisted, essentially unchanged, since the late Middle Ages. They had a reality of their own, quite separate from the grandeur of Alexander's *nuovi teatri*, built or planned, but just as real. That reality of the urban fabric is reflected in the impressions of one or the other open-eyed traveller shocked by ". . . ces rues étroites et tortues et qui sont bordées de maisons inégales . . ."—this, to be sure, was written in 1630, but it was equally valid forty years later when an English visitor, admittedly critical of the papal government, remarks that "there is not a town in these parts of the world where the churches, convents and palaces are so noble and . . . the other buildings are so mean." Adjoining Piazza del Popolo toward the river, still in 1664, spread a slum "inhabited by poor people, and most of it taken up by haylofts." The situation is mirrored in detail in the edicts of the authorities in charge of maintaining the streets, the *maestri di strade* and the *presidente delle strade*. They forbid letting hogs run free through town; cows and buffaloes likewise are to be leashed when driven through the streets—as incidentally happened still sixty years ago. Another edict prohibits slaughtering or displaying fresh meat in the streets of Rome; or to fry fish or dough in public thoroughfares or squares "per il decoro ed igiene della città." Moreover, there are the admonitions by the authorities to remove from streets and public squares market stands and booths—one recalls the flower vendor three times chased from the Pantheon by Alexander in person; or to orderly disposal of garbage by depositing it at specified places along the Tiber bank—not behind S. Giovanni dei Fiorentini or at the Renella, a sandbank north of the Tiber Island, for in either case it would block the current; and to keep in good shape and, if need be, repair the pavement before one's house "a regola d'arte," professionally and with good materials, especially if torn up for the laying or checking of sewers. All these edicts are, to be sure, repeated time and again during the century; apparently they had little effect.

Nowhere, however, does this darker side of Rome come to the fore more openly and is discussed more explicitly than in a memorandum addressed to Alexander by one Lorenzo Pizzati from Pontremoli, a hanger-on at the papal court, having lost a sinecure and desperately looking for a job. The memo he composed piecemeal from 1656 to 1658 and rewrote with additions in 1667 addressed to Alexander's successor

Clement IX Rospigliosi. To be sure, the man was a poor devil and apparently a congenital beefer. Most of all, though, he was a social reformer born three centuries before his time and a fool for bringing his proposals to and expecting promotion from the very people, Alexander primarily, against whom his complaints were directed. He may have exaggerated a bit in painting black on black the physical deterioration of Rome. But on the whole he sounds true to life, as if speaking from bitter experience. And he writes vividly, if in atrocious Latin, and without mincing words, on the four topics into which he divides his memo: against the "pest of dirt," against the epidemic (of 1656-57, needless to say), against war and "pro ornatu urbis," for the beauty of the city. The first and the last of these chapters are where he goes all out in describing the shady side of Alexander's Rome and suggesting somewhat simplistic remedies. His pages are well worth reading, a guide, as it were, to that other *Roma Alessandrina*.

"Good Shepherd," he addresses the pope, "by your leave, we no longer live in Rome, but in a pigsty. For our consolation and health we would need milky ways after having laboured with body and soul day and night by the sweat of our brow to look for and earn our bread. But when we leave our homes, churches, markets and workshops to relax our half-dead minds, we have to find quiet in muck, serenity in garbage, rest in the utter confusion of broken-up streets . . . what's the use of living in the grandeur of Rome . . . if one is to walk like beasts rather than human beings. . . . Raise, holy father, the poor from the excrement." If the streets were put into shape "they would not need to be repaired every year. Sewers and waterpipes would not break down so often if off and on rain entered; instead they carry a mass of dirt, pitch and the pell-mell of the whole city which clogs them." As a result, sewers and water conduits are in constant disrepair and the water ruins street paving, houses and churches. "Hence all the expense and squandering of public and private funds—and what is the cause but the rotten state of the city [administration] of Rome." Street cleaning, while ordered over and over by the *maestri di strade*, was insufficient or lacking. "On Corpus Christi and a week after nearly all streets are swept, but a few days later you want again leggings [to pass]. . . . No one, whatever his rank and condition, should dare throwing garbage out of the windows or otherwise on public or private thoroughfares." Instead, Pizzati proposes a system of public garbage collection: metal containers should be placed before houses and shops on corners so as not to obstruct traffic; and the carts which early at daybreak bring *pozzolana* to the building sites all over town, once emptied, should drive through "streets, alleys and neighborhoods," two at least for each *rione*, collect the garbage and deposit it on the appointed rubbish heaps along the Tiber bank; all this

127

to be paid for and supervised by a small clerical staff per *rione* and the entire system to be headed by an overseer—Pizzati.

Like streets, sewers and aqueducts, the buildings were in poor shape, many unfinished and in disrepair, and housing was lacking for the middle classes and the poor. As things stand, so Pizzati, "one should refrain for a few years from construction and finish what long has been started" as simply and quickly as possible. One can imagine Alexander's reaction had he ever read the memorandum. "Right now, the building craft must be like [he means, must act as if making] a plain garment, durable and serviceable, which fits the limbs and is complete in all parts . . . without so much ornament and fashion [*ornatu et modis*]. . . . Where so many buildings are unfinished and out of joint, no fancy work is needed." First all church façades ought to be finished, like that of S. Ignazio, "with all parts complete but plain; if time and funds are left, you can adorn them with columns and mosaic work so that the matter outdoes the work or the work with its outlandish inventions surpasses the matter"—whom and what did Lorenzo Pizzati have in mind? All such completion should be placed under a general planning director empowered to set a timetable for the remodellings and restorations, to stop in urgent cases all other construction in town and to commandeer workmen from less pressing sites to shore up buildings in danger of collapse. "Where there is no such danger and only the domes [*fastigia*] are missing and the church is serviceable for Divine Worship and no obstacle in the street, as at S. Ignazio and S. Andrea delle Fratte . . ." further construction might well be postponed.

To carry out that program of completing churches long started, Pizzati proposes that all convents and nunneries render account to a public official as to their income and expenses and be held to use the surplus for terminating construction, subsidized by the pope and by fundraising from the great families. Likewise, proceeding from *rione* to *rione*, "palaces long begun should be completed; and in case of the owner's being unwilling or unable, they should be subdivided among his relations or others, each to finish his share, all with separate entrances and stairs . . . only so that roofs, floors and windows be uniform." The many palaces started years before and never terminated are in fact a pet complaint of Pizzati's and all that "because some heady and bilious people with money prefer to live on the Lungara or near S. Isidoro and S. Maria Maggiore . . ."—a not so delicate hint, one suspects, perhaps at Queen Christina's residence across the river at Palazzo Riario-Corsini, at the Montalto-Perretti estate on the Esquiline and certainly at the Ludovisi, residing in their huge villa on the Pincio near S. Isidoro, while their town palace at Montecitorio remained a fragment. Finally, all empty lots in the heart of town should be built up in conformity with the

neighbouring constructions or sold at a fair price; and "landlords who
from maliciousness and cruelty keep houses empty for many years
rather than accepting a fair rental . . . or repairing buildings about to
collapse . . . should be forced to comply." Small houses on main streets
and near tall buildings should be raised correspondingly and "old or
new, all houses should be restored inside and out . . . to more decent
and commodious use, be provided with healthier air and be given larger
doors and windows, of stone which they often lack, and decent entrance
halls and courtyards—*antra et atria.*"

His somewhat naïve reform proposals are less important in drawing
a picture of the "other side" of Alexander's Rome than his ever-new
and very specific complaints. "Rome has become a Babel, where one
lives in constant noise . . .," so much so, he admits, that one can un-
derstand the rich moving to their villas on the quiet hills. In fact, the
town has become just one big building site and, before starting work,
"the builders should think over where to assemble their tiles, stone
and beams, where to cart off the demolition material or the earth from
the foundation trenches, where to keep lime, sand, tufa, brick, *peperino*
. . . without obstructing the whole neighbourhood; all of which could
be brought there after foundations, cellar, vaults, sewers . . . and paving
in adjoining streets and squares have been completed . . . [and] without
churches, porticoes and narrow alleys serving as workshops and building
sites." The monuments of antiquity, too, all in disrepair, should be
restored and—Pizzati being an educated man—marked by tablets giving
in both Latin and Italian the name, the date of foundation and name
and date of the restorer—Alexander VII obviously.

Where poor Lorenzo writes with real feeling is when it comes to
housing, whether for families or singles of modest means. He knows
the problem and apparently has suffered from it. Rents were exorbitant
as they had ever been in Rome; since at least the fifteenth century,
papal decrees had tried to combat rent gouging, naturally in vain. As it
was, people just balked at paying the prices demanded while newer
housing stood empty. Nothing had changed when Pizzati wrote "what
is most needed among all these churches, convents, monasteries, col-
leges, hospitals, confraternities, palaces and squares . . . is modest hous-
ing at fair rental." Small houses were in poor repair and the landlords—
churches, convents and confraternities the majority—unwilling to in-
vest in improvements. Also, rents should be fixed and landlords forced
to rent. Worst off was the person who had to find a single room or bed
or was given one in his employer's residence. The rich, Pizzati says,
"should refrain from evicting without due notice from cubicles, garrets
and holes in the wall . . . educated exemplary men"—like himself, one
completes the phrase. "Nobody should have to live in humid quarters

or in pestilential air; or in company detrimental to his conscience; or on a butcher's bench or on the bare marble floor of a church or a shop. And decent men—*gente per bene*, we would say—and particularly *aulici*—hangers-on at the court—should not be confined to a humid room on the ground floor next to the street or high up under the naked rafters in a ridiculous hole full of flaws and a nest of spiders, mice, scorpions and geckoes . . . and that because dwellings are not completed and while houses, palaces and pious institutions stand empty." To remedy the plight of the homeless, he suggests housing in the empty rooms of the Oratory or the Sapienza ". . . poor bishops, priests and other . . . learned men." Similarly, the Lateran Palace "where Your Holiness does not reside" could be turned into a kind of residential hotel with a common kitchen and larder for "bishops and other needy of the better sort." Likewise the uninhabited parts of the Quirinal Palace and the Vatican could be put to use. Thus, those white elephants, *"istae machinae*, would be preserved rather than deteriorate and collapse in their solitude and what is more, Your Kindness would provide better air and better counsel to our minds." Poor widows and women abandoned by their husbands, too, must find shelter in unused palaces and pious institutions or part thereof, to be protected from defilement. And, needless to say, there must be a home for repentant prostitutes and a hospice and hospital for beggars.

No, Alexander's Rome was not really a nice place in which to live—not for everyone.

10. City Planning and Politics: The Illustrious Foreigner

THIS WAS the background against which the *teatri* of Alexander's were placed. They were showpieces indeed, different and separated from the fabric of a reality apparent to everybody but not supposed to be acknowledged. Their function was not so much to conceal that reality—though the colonnades planned for and the churches built on the wedges of Piazza del Popolo or the palatial façades delimiting Piazza della Pace were meant to do just that. Rather they were to create another reality: a Rome to be seen by and to impress a visitor; specifically a visitor travelling from the north gate, Porta del Popolo, to the Vatican. Indeed, the large majority of Alexander's *teatri*, rather than being scattered haphazardly over the map of Rome, appear to be laid out in a clear pattern. True, there are exceptions: S. Maria in Campitelli, far south of the Capitol, near the river; S. Andrea al Quirinale; and S. Maria della Pace. But with each of these special circumstances had determined the location: S. Maria in Campitelli had to be situated as close as possible to the abandoned church of S. Maria in Porticu which it replaced; S. Andrea took the place of an older chapel within the compound of the Jesuit novitiate on the Quirinal; and S. Maria della Pace being Chigi-linked was *eo ipso* an exception.

However, most of the *teatri* lie along the route travelled by important visitors on their official entry into Rome: the route taken by Queen Christina on December 22, 1655. At that time, to be sure, none of Alexander's *teatri* existed or had even been planned. But they were laid out over the following ten years: on Cruyl's map of 1665 they stand out as a string of white spots (fig. 100). They start with Piazza del Popolo where Alexander, according to a contemporary guidebook, "enlarged the piazza, removing all obstacles, brought to perfection the city gate . . . and to heap beauty on the entry to Rome in the eyes of the foreign visitors—*per colmare di bellezza l'ingresso in Roma alla vista delle nazioni forestiere*—has commanded [to erect] the porticoes of two churches opposite [the gate], having already straightened the entire Corso til Piazza S. Marco in a splendid and noble perspective"; a prospect to make ". . . the entry into Rome so majestic as to conclude from such beginning what wonders that city might shelter." The constituent elements of that prospect are of course the three streets issuing south from the piazza: Via di Ripetta, the Corso and Via del Babuino; and the latter, had the towering gate to the Quirinal Gardens ever been set up,

131

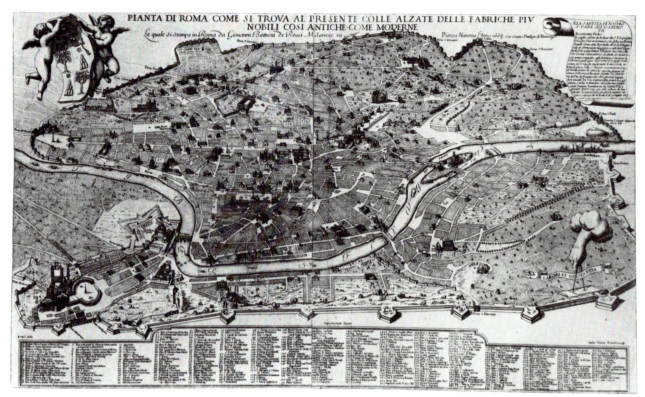

100. L. Cruyl, map of Rome,
1665

would have been even more prominent in that triad of views. As it
turned out the Corso remained the main axis of the prospect. Driving
down that street in his coach, the foreign visitor, having passed by S.
Giacomo degli Incurabili, almost a century old but still impressive,
would note to be sure that Gesù e Maria was still a fragment. But a
hundred meters further down, work on S. Carlo al Corso had been taken
up again in 1665 and three years later the dome was being built after
Cortona's design (fig. 101). Proceeding further, he would pass on his left
Via Condotti and see at its end, if not the grand sweep leading to the
Trinità dei Monti planned for Mazarin, at least a decent ascent shaded
by trees; while on his right rose the monumental if antiquated façade
of Palazzo Rucellai-Ruspoli (fig. 14). He would reach Piazza Colonna
with the Column of Marcus Aurelius and the new Chigi Palace nearing
completion; of the projects to bring to the square the Trevi Fountain
he would be told (fig. 102). And all along the Corso he would notice
that Alexander had "removed all ugly spots so that foreigners upon
their first view on their entry were spared anything repulsive," such as
mean houses, projecting façades or the traffic hazard of the Arco di
Portogallo. Further on he would admire Pietro da Cortona's façade of
S. Maria in Via Lata, underway since 1658 and completed in 1665 at

132

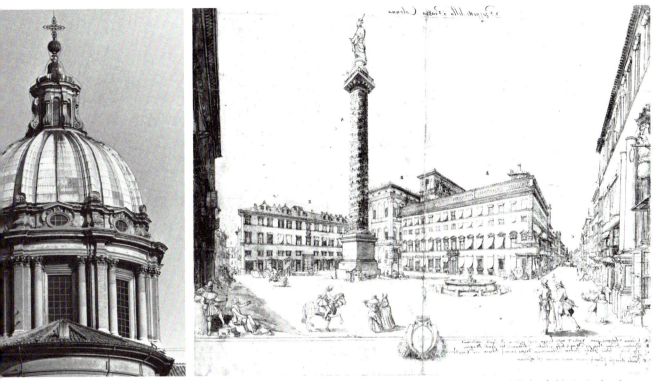

101 (*at left*). S. Carlo al
Corso, dome

102. L. Cruyl, Piazza Colonna looking northwest as
of 1664, completion of Palazzo Aldobrandini-Chigi
anticipated, Cleveland
Museum of Art, Dudley P.
Allen Fund

Alexander's expense, having been watched over by him from his windows at the Quirinal Palace (fig. 103). At the corner of the Corso facing
Piazza S. Marco, he would notice the small but elegant new Palazzo
d'Aste, marked on Cruyl's map (fig. 20). Turning the corner of the Corso
westward the visitor would take in on his left the view of Palazzo
Venezia and of Piazza S. Marco-Venezia, still quite narrow but terminated by the wing of the Palazzetto jutting forward from the mass of
the Palazzo and, rising above, the Tower of Paul III, the roof of S. Maria
in Aracoeli and, soaring higher, the Tower of the Palazzo del Senatore;
this rather than the Monumento Vittoriano. He would turn into the
wide Via del Gesù, now the Via del Plebiscito, unblocked under Alexander, and he would pass Palazzo Gottifredi-Grazioli, all rebuilt under
Alexander VII. He would reach the Gesù and the square in front and
facing it to the right of the street Palazzo Altieri, its main body just
completed (fig. 104). At that point did the visitor's coach enter the
narrower streets of the old town and along the *via papalis*, Via dei
Cesarini in its first stretch, reach S. Andrea della Valle, its façade just
terminated in 1665 with help from Alexander, the small square in front
sheltering the flight of rounded steps, the plans for which occupied him
through the winter of 1658-59 (fig. 72).

133

103. Pietro da Cortona, S. Maria in Via Lata, façade

104 (*at right*). G. B. Falda, Piazza del Gesù as of 1665, left-hand edge Palazzo Altieri

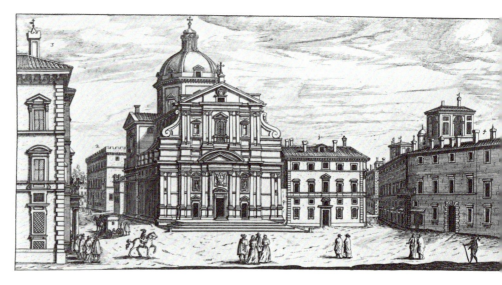

The route continued between Palazzo Massimi alle Colonne to the right, and to the left, the view through Via dei Baullari and across Campo dei Fiori towards Palazzo Farnese and a glance at the Cancelleria to

134

105. Piazza Navona

Piazza del Pasquino. A short detour would have brought the visitor to Piazza Navona, the Pamphili preserve, with Bernini's Four River Fountain, 1650-1653, and the church of S. Agnese, still unfinished at the time (fig. 105); but on Queen Christina's entry that visit was omitted. Rather the route continued along Via del Governo Vecchio to Piazza di Monte Giordano. There the foreign guest would admire not only Borromini's clock tower of the Filippini compound, but also his Palazzetto Spada begun in 1661 for the Banco di Santo Spirito and unloaded by Alexander on the Spada heir; but then, the building hastily completed was well worth seeing and, a block of unsightly houses having been razed, it turned the previously shapeless square into a real showpiece (fig. 106). The illustrious visitor was led on from *teatro* to *teatro*, for nearly all of which Alexander claimed responsibility. Through Via dei Banchi Nuovi he would reach Piazza di Ponte and cross Ponte S. Angelo

135

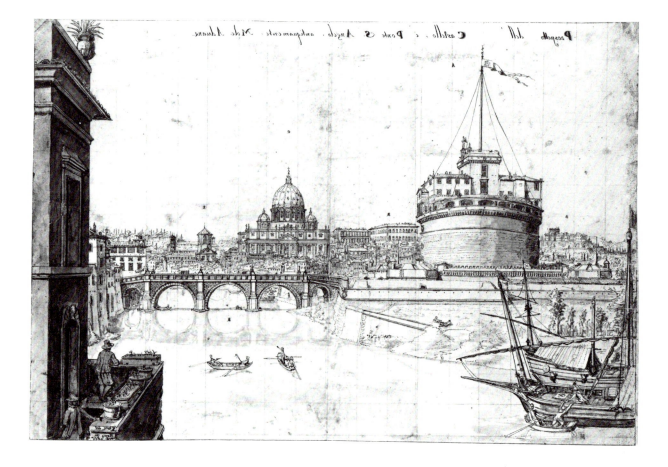

Prospetto dell Castello, e Ponte S. Angelo, anteguamente costrutto Mole Adriana.

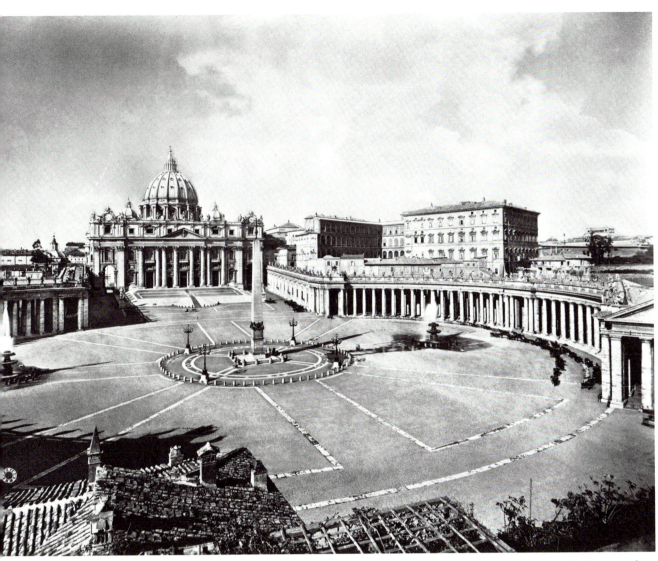

108. Piazza S. Pietro as of
ca. 1870

106 (*facing page, at top*).
G. B. Falda, view of Piazza
di Monte Giordano with
Palazzetto Spada (Banco di
Santo Spirito)

107 (*facing page, bottom*).
L. Cruyl, view downriver of
Castel S. Angelo, Ponte S.
Angelo and St. Peter's;
Cleveland Museum of Art,
Dudley P. Allen Fund

into the Borgo—Alexander seems to have planned twin chapels to flank
the bridge, but to commission the angels was left to his successor, Pope
Clement IX (fig. 107). Through the dark streets of the Borgo the visitor
would approach Piazza S. Pietro. Possibly he would have heard that
there were plans afoot to replace them by a wide avenue terminated by
the *terzo braccio* of the colonnades. He would enter the piazza enclosed
by its 380 columns and almost completed except for that short third
arm, and slowly proceeding would find himself at the foot of the steps
ascending over two landings to St. Peter's (fig. 108). Crossing the
narthex—Bernini's Constantine to the right at the foot of the Scala Regia
was set in place only after Alexander's death—and entering the nave

137

he would see below the dome and surmounting the apostle's grave the *baldacchino*, Bernini's and Borromini's early work. Framed by its columns and much further back in the apse would appear, as it does to this day, the Cathedra Petri, Alexander's crowning donation and Bernini's crowning achievement, completed early in 1666 after eleven years' planning and execution (fig. 109). In fact, from the outset the cathedra and the colonnaded piazza had been viewed as complementing each other and were discussed jointly in the same documents as Bernini's contribution to St. Peter's under Alexander's aegis. Or else, the visitor might be driven through the right-hand colonnade of the piazza, alight at the bronze gate and ascend the Scala Regia, completed by Bernini in 1666, and approach the papal presence (fig. 57).

There were to be sure *teatri* off that route—S. Andrea al Quirinale, S. Maria in Campitelli, S. Maria della Pace and its piazza, Piazza SS. Apostoli where an old Colonna Palace was being remodelled for the Cardinal Nepote and provided by Carlo Fontana with a grand façade designed by Bernini. And of course there were older *teatri*, if but a few, which every tourist would want to have visited: Michelangelo's *area Capitolina*, just completed by the erection under Innocent X of the Museo Capitolino opposite and in elevation a literal copy of the *divino*'s Palazzo dei Conservatori; Piazza Farnese, dominated by the palace to which Michelangelo had put the finishing touches; finally the one great *teatro* just preceding Alexander's reign, Piazza Navona, the Pamphili enclave, which no traveller would want to miss. They had to be visited separately by the curious traveller who obviously would visit and revisit also those he had seen pass by on his entry along the official route from Piazza del Popolo to Piazza S. Pietro. But it is hardly by chance that the largest number of Alexander's showpieces was distributed along just that route. It was the illustrious foreigner entering the city along the route traced for the Swedish queen who was to be impressed by the image of a Rome remapped and reborn through Alexander. He was supposed to see and and with the Roman Senate and People to address Rome: "... greater than Romulus is Alexander; that one built thee on large foundations / but he erected structures like in all to the magnificence of the ancients, gave nobler shape to squares and streets and thus renewed and adorned, rather more gloriously founded thee...."

None of this remapping and rebuilding, though, was done idly to rival the splendour of ancient Rome, nor for beauty's sake alone nor with the sole intention to immortalize Alexander and the Chigi name. All these motivations are there. But Alexander's vision of a Rome renewed and reborn and outshining all of the royal capitals of Europe wants to be understood on a wider plane still, as a political statement.

Art as a tool of politics was nothing new by his time. It had been

109 *(facing page)*. G. L. Bernini, Cathedra Petri

138

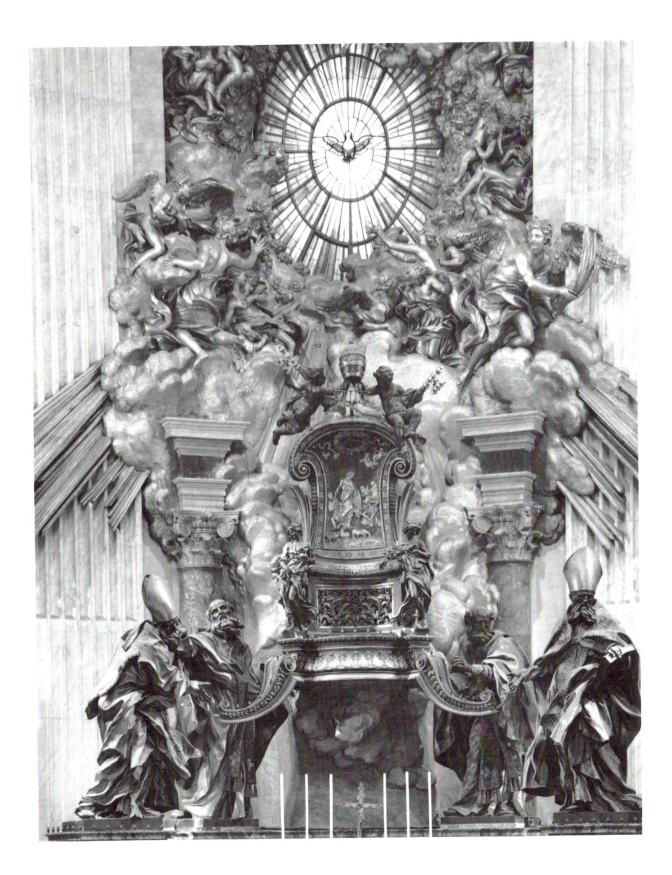

used throughout the sixteenth century in Rome as well as all over Europe for the propagation of religious and political ideas. It was in Alexander's days a powerful instrument in the hands of Richelieu and Mazarin and after them of Louis XIV and Colbert for the glorification of France and her king. In Rome it had served on a large scale the Borghese and the Barberini. More than any of his predecessors was Alexander in need of employing emphatically art as a means of public relations, both domestically and in foreign politics. He had spent many years in the diplomatic service of the Church, first as nuncio, then as the Cardinal Secretary of State under Innocent X. His most important post abroad had been at Cologne; there, for five long years starting in 1643 he was deeply and emotionally involved in the endless negotiations to end the Thirty Years' War. In vain did he try to urge into common action the Catholic powers—Spain, the emperor in Vienna, France and the Catholic princes in Germany. France, striving to counterbalance the threatening preponderance in Europe of the Habsburg monarchies, Spain and Austria, had been fighting for the last fifteen years of the war on the Protestant side. The treaty turned out to be the worst defeat the Catholic cause in general and the Catholic Church in particular had suffered since the Reformation: the Protestant powers—England, Holland, Sweden and their overseas possessions were lost forever; in Germany, Austria, Hungary and Poland, the "heretics" were recognized in their territories as equal partners; the principle sustained of the ruler's religion determining that of his subjects—*cuius regio eius religio*—effectively eliminated Catholic minorities in the lands of Protestant princes; and the consequent loss of dozens of bishoprics, abbeys and other ecclesiastical properties located in non-Catholic territories and their vast income was an irreparable blow to both the prestige and the coffers of the Roman Church—not to mention the loss of so many souls; the corresponding gains in Catholic lands were much smaller.

Chigi's refusal to sign the Treaty of Westphalia as well as Rome's protest before and during his tenure as Secretary of State were empty gestures. He knew it and, as I see it, he never overcame the "trauma of Münster" grown from frustration and defeat. This feeling, one suspects, was at the basis of his vacillating and insecure foreign policy and it was only worsened during his twelve-year pontificate. His negotiating efforts at Münster had placed him right between the two major Catholic powers, France and Spain, and his further endeavors to mediate the war which thereafter continued between these two earned him the mistrust of Spain and reinforced the enmity of France and of her leader Mazarin against him; the emperor in Vienna, bound to neutrality in the French-Spanish conflict and hard-pressed by the Turks, was of no help. Hence, all his time, Alexander was bedevilled by the need to maneuver between

Madrid and Paris and was trusted by neither. France in particular, starting with Mazarin's efforts to block his election, continued to snub and humiliate him at every step. In fact, a genuine conflict between France and Rome had been smouldering these twenty years—the Church's stand against Jansenism and the inevitably resulting complaints of France over Rome's equally inevitable interference in French domestic-ecclesiastical affairs; and this in the face of the rise of French absolutism and its claim for total control in Mazarin's late and Louis XIV's early years. The Créqui affair in 1662—the papal guards had gotten into a fight with those of the French ambassador, a welcome pretext for further insults directed at Alexander and for the temporary occupation by the French of the papal enclave at Avignon—ended with the Cardinal Nepote's having to go to Paris tendering Alexander's apologies in 1664; one wonders whether part of the reparations was the papal permission granted Bernini to go to Paris for three months the year after.

Alexander, then, from his days at Münster on, should have known and probably did know deep down fully well that the Church was no longer a political power of the first magnitude. The fate of the world was decided in Paris and Madrid, and perhaps in Vienna, not to mention London, Amsterdam and Istanbul. But it was no longer decided in Rome. Such thoughts obviously no pope could acknowledge to himself, Alexander less than anyone else. He would have to banish them, we would say today, to his subconscious, and try to counteract them by cultivating that deep conviction of the papacy's and hence his own exalted place. To him, notwithstanding all political setbacks, the papacy was not only the one legitimate spiritual power, but it also towered over all temporal powers in this world; the pope was the God-given arbiter between the kings of this earth, at least those Catholic: hence he would try to mediate the conflict between the crowns, Madrid and Paris. Hence also his stubbornness in defending territorial claims over reputedly papal dominions in Italy in the face of French resistance; so much so that contemporaries did ask Stalin's question—"How many divisions has the Pope?"—in their terms, ". . . to pick a quarrel with one who has bees in his bonnet, armies at his beck and call and millions at his feet is a bad game for the popes who have only the two raised fingers"—to bless.

The awareness of Rome's and his own political impotence would rankle, unacknowledged though it was. Jointly with the compensatory exalted view held of the Church and himself it became one of, if not indeed the primary motivating element in Alexander's drive to remap and to create a new Rome, equal to that of antiquity. He felt the need to reside in a capital that would outshine all royal capitals as had Imperial Rome. A king's greatness, Bernini insisted, was reflected in the

splendour of his residence; how much more then, Alexander would conclude, should the city whence he ruled mirror the majesty of the Church of God whom he, the pope, represented. A new grand "image" of Rome was needed to impress that majesty on both Romans and the world abroad and primarily on visitors to Rome.

The opinion held by foreigners of the Church as she presented herself in Rome had become ever since his return from Germany a major preoccupation of Alexander's. He felt desperately insecure about the impression made on visitors from abroad by Rome and Romans. Shortly before the arrival of Queen Christina he thought it necessary to lecture the cardinals assembled in consistory on minding their manners. It was incredible, he told them, how the *oltramontani* took umbrage at priests conversing at the altar, even briefly; how they paid close attention to every custom, saying, gesture and glance of Italians. They put down their observations in their diaries, leaving them to posterity. He himself at Cologne had read the travelling journals of a Catholic gentleman shocked by the worldly conversation of cardinals in Rome: they talked of wine, the weather, the pleasures of the *villeggiatura*, of gardening, fountains, hunting, the theatre. But never did they mention the Church, the Gospel, the Church Fathers or the conversion of heathen or heretics. He, Alexander, had excused the appropriateness of such topics of conversation with a military gentleman but "could not help blushing inside." And, one would like to add, if that happened with Catholics, what of heretics? One could not be careful enough, he continued, with those northerners, "con quelle nationi," and particularly prelates and cardinals should watch out. And, so his biographer, he did set an example of proper behaviour during religious functions.

In this same context one should understand, I feel, the guidebooks' and *avvisi*'s referring time and again to Alexander's efforts at beautifying the city and improving streets and squares as being directed towards the *illustre forestiere* or the *nazioni forestiere*, the distinguished foreigner, presumably from abroad: Piazza del Popolo had been heaped with beauty for the eyes of foreign nations; from the Corso "he has removed all flaws to spare foreigners upon their first view on entering the city anything repulsive"; and Pallavicino, Alexander's biographer, expected, one recalls, a large and illustrious number of foreigners to be drawn to Rome by the pope's urban improvements. This new visitor, the illustrious foreigner, is clearly no longer a pious pilgrim or a layman or a cleric come to Rome on business. Nor is he an archaeologist or amateur intent primarily on studying the antiquities, ruins, sculptures and epitaphs. He is a tourist come to see the sights: a young gentleman on the Grand Tour to get acquainted with the world, both countries and men, accompanied by his tutor; or an educated traveller of years'

142

planning to look seriously at Rome and come to know the intellectual
and artistic milieu, the circle of Alexander or that being gathered around
Christina of Sweden. And in any event, he is attracted by contemporary,
that is, modern Rome, as much as if not more than by its traditional
sights.

A new type of tourist indeed must have come to Rome by the time
of Alexander's pontificate. It cannot be by chance that just in these
years a new type of engraved view of Rome and her monuments comes
onto the market, obviously to satisfy the demands of a new class of
buyers. Engraved views and maps of Rome had been available to be sure
ever since the sixteenth century in large numbers, appealing to different
tastes and interests: for the pilgrim trade the Seven Churches, singly
and jointly; for architects, scholars and the educated public the gran-
deurs of Rome, as in the *Speculum Romanae Magnificentiae*, depicting
in surveys and reconstructions the monuments of antiquity with just
a sprinkling of "modern" work—Michelangelo's Capitol or his St. Pe-
ter's model; for the nostalgically inclined, views of Roman ruins, of
greatness fallen, such as first Dupérac's *Rovine di Roma*, to be followed
through the early seventeenth century by Giovannoli's *Vedute degli
antichi vestigi di Roma* or Mercati's *Alcune vedute di luoghi disabitati
di Roma*. Or else, there were for the "modern" taste, addressed pre-
sumably to patrons of building and architects, selected exemplary six-
teenth century structures—Palazzo Farnese, the Gesù, again St. Pe-
ter's—in elevation, section and plan, mostly in single sheets. A volume
of plates, the *Palazzi di Roma*, was planned and begun by Ferrerio
apparently in 1638 or earlier, but it was not finished before the fifties
when Falda completed it; it shows thirty palaces, conservatively cho-
sen—only three date after 1620—and in dry elevations. *Vedute* of mod-
ern Rome, showing the new buildings, streets and squares, had been
exceedingly rare, if they existed at all: only a few small series of views
done by Israel Silvestre in the forties come to mind.

On the contrary, with the sixties of the century, such *vedute* come
to the fore with a vengeance, starting with two large and beautiful series,
both presenting the newest architectural creations in splendid views as
they face the new streets and piazze and rise amidst their surroundings.
One is Lieven Cruyl's sequence prepared in the winter of 1664-65 in
twenty-one splendid large drawings, all done in reverse for the engraver
and, indeed, engraved from 1665 on. The other series is Falda's *Nuovo
Teatro delle fabriche . . . di Roma sotto . . . Alessandro VII*, the first
volume published in 1665, the following three continued into the nine-
ties. Cruyl includes in his selection some views of ancient and a number
of Renaissance monuments, but recent buildings and *piazze* form the
majority. Falda, faithful to the title of his work, limits himself to the

143

buildings of Alexander foremost; with the understanding that monuments which were a must in a selection of Roman *vedute*, such as the Capitol, were included under the pretext that Alexander had made improvements in the Palazzo dei Conservatori and that it was under him that S. Rita was built at the foot of the Aracoeli stairs. Also, reflecting Alexander's taste and that of his time, squares, streets and buildings, in both Cruyl's and Falda's views, are shown to be spacious and streets in particular long and straight beyond all reality: Piazza della Pace becomes a huge area expanding into a wide Via della Pace, almost an avenue; the figures are small puppets. The four streets intersecting at the Quattro Fontane are turned into broad avenues extending into endless distance; a coach on Piazza del Popolo is about two feet tall. This was the Rome the new class of tourists meant to remember.

They wanted the new *vedute* and they wanted new maps of the city. No up-to-date map had been published since Greuter's as adjusted in 1623; Schayck's of 1630 was but a reprint and Maggi's of 1625 was so rare that no copy survives, except the reprint published in 1774. In the 1660's, on the other hand, no less than five new maps hit the market, all dedicated to Alexander and stressing his building activities: in 1661-62 Giovanni Giacomo De Rossi's new edition of Tempesta's 1593 map revised and brought up to date by inserting the new structures; in 1665, Cruyl's beautifully clear plan with all important churches, palaces, squares and streets standing out along with—but no less and perhaps a bit more important—the monuments of antiquity; in 1666 Agnelli's and in 1667 Falda's Small Map, both stressing in drawings and legends Alexander's *teatri*, streets and tree-lined avenues; finally Matteo Gregorio De Rossi's in 1668, but—so the dedication to Clement IX—still approved by Alexander. The *illustre forestiere* come to Rome meant to take home needless to say the engravings of ancient Rome—after all, he still was brought up in the classical tradition as were his sons and grandsons for another two hundred years. But he also meant to keep alive his memories of modern Rome, and thus gathered whatever possible of maps and *vedute* of the new Rome that had impressed him as much as or more than that of antiquity. The publishers rushed to fill the demand.

It was this new class of Rome travellers that was attracted by Alexander's campaign of remapping, improving and beautifying Rome and it was they at whom the campaign was aimed. The new visitor to Rome, modern-minded, notwithstanding his traditional admiration for classical antiquity and her monuments, might be a Catholic to be sure; and to him Rome naturally would be the Holy City, the capital of the Church and the See of the Pope. Into that Christian frame the antiquities had been incorporated; and Alexander's new showpieces to him would

only confirm the everlasting grandeur of Rome and her Church. But the new Rome traveller might be a Protestant as well, whether from Germany, the Low Countries or England; and in that case he would be anti-papist or at least highly critical of the papal misgovernment and its nepotism. Even so his attitude towards Rome and her Church had radically changed as compared to that of his greatgrandfather and even his father: Rome was no longer only the Babylonian Whore, the City of Iniquity; nor, for that matter, on quite separate a level only the site where classical learning found its visible confirmation. Rather she was a cultural center where a young man on the Grand Tour would learn good manners and polite conversation, have his first gallant adventures and meet the great world; and where an educated and learned gentleman, Protestant or Catholic, would exchange ideas with the local scholarly community and browse in the great libraries of the city.

Likewise, the attitude towards Protestants had changed among Catholics in Rome, at least in educated circles. They were, to be sure, as far as the Church was concerned heretics and condemned *in aeternum*. But on the level of *this* world it had turned out that condemnation, force of arms or refusal to recognize their existence led nowhere; also that taken as individuals they were valuable members of society and many worth knowing. That spirit of the "secularizarion of society," of keeping the religious contrasts on a level of their own, had long prevailed in Rome among educated Catholics, churchmen and laymen: in 1634 Cardinal Francesco Barberini had gone out of his way to honour and charm John Milton; and Burnet forty years later cannot praise enough the warmth of Cardinal Howard and the good company of a couple of learned Italian *abbati*. German princelings on the Grand Tour accompanied by their tutors, like the young Margrave of Brandenburg-Bayreuth on his tour in 1660-61 or, the year after, the Duke of Brunswick-Bevern, would be courted by visits from the papal household or even by being received in audience by Alexander himself. After all, there was always the possibility of conversion and a discreet sounding-out of the entourage would do no harm—had not Margrave Ernest of Hesse-Rheinfels, and Duke Christian of Mecklenburg-Schwerin and a dozen more minor royalty returned to the fold? Even though less spectacular than Queen Christina's, a princely conversion would always make a splash; so would, in different circles, the winning back of a great scholar such as Holstenius' conversion had done in the early thirties.

People of quality, whether or not Catholics, were the target Alexander had in mind in his campaign of setting up his *nuovi teatri*—royalty, noblemen, great men in the arts and sciences, people that counted. They were to be impressed by the Rome renewed and beautified by Alexander: Rome, the glory of antiquity, obviously; the See of the Church, as she

110. G. B. Falda, Small Map,
dedication group, 1667

had been ever since apostolic times; and interwoven with these old a
new facet, the Rome of the Chigi pope: with spacious squares, airy long
streets, splendid new churches, palaces and fountains; the capital of the
Church which he ruled, renovated and brought up to date so as to hold
in new times the exalted place due her as of old, thus counteracting
any gnawing thought of political decline. This is what Alexander strove
for: to create a new image of his city, a city the world would come to
see; the seat of the Church obviously; but no less an attraction for the
cultivated in all camps, a must for every educated person; the Rome of
the tourist to be won over by the grandeur of its old and new glorious
monuments and through them, if possible, of its old yet new Church.

Falda's Small Map of 1667 carries in its left upper quarter a long-
winded dedication to Alexander. It is inscribed on a drapery held by
two female figures: to the left Faith, seated wrapped in a sheet, carries
the cross; to the right another figure holds in her left hand compasses
and a setsquare—obviously Architecture. Two *putti* accompany the
figures, each carrying a banister and the one to the right moreover what

146

111. G. L. Bernini or C. Ma-
ratta, sketch for Falda's ded-
ication group; New York,
private collection

appears to be a watergauge; while Faith tramples on Heresy, Architec-
ture stands victoriously over Time, on the ground and still holding his
scythe (fig. 110). The engraving is based on a Berninesque sketch, pos-
sibly by Maratta, which renders the *primo pensiero* more freely and
concisely (fig. 111): the composition is more compact, the figures closer
together, the drapery narrower and carrying instead of the dedication
only the papal arms; Architecture is solidly seated, Time spreadeagled
below her; the *putti* are missing, as is Heresy; and the place of Faith
was taken in that first *pensiero* by a figure wearing the tiara and carrying
a rudder and what may have been a crozier—whether the Church or
the Papacy. Only as an afterthought the draughtsman sketched above
the group a figure of Faith as reused by Falda.

The meaning is obvious. The Church (or Faith) and Architecture are
the two pillars on which rests Rome as envisioned by Alexander. Jointly
they are intended to impress and attract the *nazioni forestiere* and
eventually to bring them under her rule. And Architecture subjugates
Time, rescuing from oblivion the name of the Chigi pope.

Bibliographical Note

THE BULK of the evidence for Alexander's building activities and his urban planning is based on my own research in recent years, focused on the buildings themselves and on the rich material, documentary and visual, held by the Roman archives and libraries, primarily the Vatican Library (BAV), the Vatican Archive (ASV) and the Archivio di Stato (ASR), and of course on the work of those who before me have explored the architecture of Rome at the time of Alexander VII—primarily H. Brauer and Rudolf Wittkower in their standard work *Die Zeichnungen des Gianlorenzo Bernini* and Anthony Blunt in his recent *Guide to Baroque Rome*. Any omission, mistake or misinterpretation in that field is entirely mine.

On the other hand, I am no Church historian nor am I versed in the economic or political history of seventeenth century Rome or, for that matter, the intricacies of the Treaty of Westphalia or the political interplay between Alexander and France. For all such questions I have been leaning heavily on the familiar works: Sforza Pallavicino's *Della Vita di Alessandro VII*; Ludwig von Pastor's *History of the Popes*, vols. XXX and XXXI; the *Cambridge Modern History*, vol. V.

Abbreviations

ARCHIVES AND LIBRARIES

Arch. Chig.	Archivio Chigi, BAV
ASR	Archivio di Stato, Rome
ASV	Archivio Segreto Vaticano
Barb.	Fondo Barberino, BAV
BAV	Bilioteca Apostolica Vaticana
Casan.	Biblioteca Casanatense, Rome
Chig.	Fondo Chigiano, BAV

BIBLIOGRAPHY

Art Bull	*Art Bulletin*
ASRStP	*Archivio della Società Romana di Storia Patria*
Bartolotti	F. Bartolotti, *La medaglia annuale dei romani pontefici: Da Paolo V a Paolo VI, 1605-1967*, Rimini, 1967
B d'A	*Bollettino d'Arte*
Bernini in Vaticano	*Bernini in Vaticano*, ed. Comitato Vaticano per l'anno Berniniano, Rome, 1981
Blunt, *Guide*	A. Blunt, *Guide to Baroque Rome*, London, 1982
Bösel-Garms	R. Bösel and J. Garms, "Die Plansammlung des Collegium Germanicum-Hungaricum," *Römische Historische Mitteilungen* 23 (1981), 335ff.
Br-W	H. Brauer and R. Wittkower, *Die Zeichnungen des Gianlorenzo Bernini*, 2 vols., Berlin, 1931
Bull Comm	*Bullettino della Commissione Archeologica Comunale di Roma*
Chantelou	P. Fréart de Chantelou, *Journal de voyage du Cavalier Bernin en France*, ed. L. Lalanne, Paris, 1885 (Pandora reprint, Aix-en-Provence, 1981)
Connors, *Borromini*	F. Connors, *Borromini and the Roman Oratory: Style and Society*, New York-Cambridge, Mass.-London, 1980
Diary	R. Krautheimer and R.S.B. Jones, "The Diary of Alexander VII: Notes on art, artists and buildings," *Römisches Jahrbuch für Kunstgeschichte* 15 (1975), 199ff. (excerpts from Chig. O IV 58)
Diz. biogr.	*Dizionario biografico degli Italiani*, Istituto della Enciclopedia Italiana, Rome, 1960ff.
Ehrle	F. Ehrle, "Dalle carte e dai disegni di Virgilio Spada," *Atti della Pontificia Accademia Romana di Archeologia*, ser. III, *Memorie* II, 1928, 1ff.
Eimer, *S. Agnese*	G. Eimer, *La fabbrica di S. Agnese in Navona: Römische Architekten, Bauherrn und Handwerker im Zeitalter des Nepotismus*, 2 vols., Stockholm, 1970-1971
Fagiolo dell'Arco, *Bernini*	M. and M. Fagiolo dell'Arco, *Bernini: una introduzióne al gran teatro del barocco*, Rome, 1967

Fea, *Diritti*	C. Fea, *Dei diritti del Principato*, Rome, 1806
Fea, *Miscellanea*	C. Fea, *Miscellanea filologica critica antiquaria*, Rome, 1790
Fraschetti, *Bernini*	S. Fraschetti, *Il Bernini*, Milan, 1900
Frutaz, *Piante*	A. P. Frutaz, ed., *Le piante di Roma*, 3 vols. Rome, 1962
GBA	*Gazette des Beaux-Arts*
Gigli	G. Gigli, *Diario Romano (1608-1670)*, ed. G. Ricciotti, Rome, 1959
Golzio, *Documenti*	V. Golzio, *Documenti artistici sul Seicento nell'Archivio Chigi*, Rome, 1939
Güthlein I	K. Güthlein, "Quellen aus dem Familienarchiv Spada zum römischen Barock. I. Folge," *Römisches Jahrbuch für Kunstgeschichte* 18 (1979), 173ff.
Güthlein II	K. Güthlein, "Quellen aus dem Familienarchiv Spada zum römischen Barock. II. Folge," *Römisches Jahrbuch für Kunstgeschichte* 19 (1981), 173ff.
Güthlein III	K. Güthlein, "Quellen aus dem Familienarchiv Spada zum römischen Barock. III. Folge," *Römisches Jahrbuch für Kunstgeschichte* (in preparation)
Hager, "Zwillings-kirchen"	H. Hager, "Zur Planungs- und Baugeschichte der Zwillingskirchen auf der Piazza del Popolo," *Römisches Jahrbuch für Kunstgeschichte* 11 (1967-68), 189ff.
Haskell, *Patrons and Painters*	F. Haskell, *Patrons and Painters: A Study in the Relations between Italian Art and Society in the Age of the Baroque*, London, 1963
Haus	A. Haus, *Der Petersplatz in Rom und sein Statuenschmuck: Neue Beiträge*, Berlin, n.d. (Ph.D. diss., Freiburg im Breisgau, 1970)
Helbig-Speier	W. Helbig, *Führer durch die öffentlichen Sammlungen Klassischer Altertümer in Rom*, ed. H. Speier, Tübingen, 1963ff.
JSAH	*Journal of the Society of Architectural Historians*
JWCI	*Journal of the Warburg and Courtauld Institutes*
Kitao, *Square of Saint Peter's*	T. K. Kitao, *Circle and Oval in the Square of Saint Peter's: Bernini's Art of Planning*, New York, 1974
Krautheimer, *Studies*	R. Krautheimer, *Studies in Early Christian, Medieval and Renaissance Art*, New York, 1969
Martinelli-D'Onofrio	C. D'Onofrio, *Roma nel Seicento*, Florence, 1969
MemPontAcc	*Atti della Pontificia Accademia Romana di Archeologia, Memorie*
Nipotismo	[G. Leti], *Il nipotismo di Roma . . .* , Amsterdam, 1667
Noehles, *SS. Luca e Martina*	K. Noehles, *La Chiesa dei SS. Luca e Martina nell'opera di Pietro da Cortona*, Rome, 1969
Nolli	*Roma al tempo di Benedetto XIV: La pianta di Roma di Giambattista Nolli del 1748*, ed. F. Ehrle, Vatican City, 1931
Ozzola	L. Ozzola, "L'arte alla Corte di Alessandro VII," *Archivio della Società Romana di Storia Patria* 30 (1908), 5ff.
Pallavicino	Sforza Pallavicino, *Della vita di Alessandro VII*, 2 vols., Prato, 1839-1840

Pastor	L. von Pastor, *The History of the Popes from the Close of the Middle Ages*, vols. XXX, XXXI, London, 1940
Quaderni	*Quaderni dell'Istituto di Storia dell'Architettura*
Ragguagli Borrominiani	*Ragguagli Borrominiani: Mostra documentaria, Archivio di Stato, Roma*, Rome, 1967
Regesti	*Regesti di bandi editi notificazioni . . . relativi alla città di Roma*, ed. Comune di Roma, vol. VI, Rome, 1956
Relazioni	N. Barozzi and G. Berchet, eds., *Relazioni delli Stati Europei lette al Senato dagli ambasciatori Veneti nel secolo decimosettimo*, ser. III, *Italia, Le relazioni di Roma*, vol. II, Venice, 1879
Röm Jbch	*Römisches Jahrbuch für Kunstgeschichte*
Rossi, 1939	E. Rossi, "Roma ignorata," *Roma* 17 (1939), 39ff. and *passim*
Sindicato	[G. Leti], *Il sindicato di Alexandro VII: Con il suo viaggio nell'altro mondo*, n.p., 1668
Spini	G. Spini, "Italy after the Thirty Years' War," *Cambridge Modern History*, vol. V, Cambridge, 1975, 458ff.
Wittkower, *Pelican*	R. Wittkower, *Art and Architecture in Italy: 1600-1750*, Pelican History of Art, Harmondsworth, 1958
Wittkower, *Studies*	R. Wittkower, *Studies in the Italian Baroque*, London, 1975
ZKG	*Zeitschrift für Kunstgeschichte*

Notes

pp. 3ff.

For the use by Alexander and others of *teatro* when referring to Bernini's Piazza S. Pietro, see, for example, ASV, *avvisi* 103, c. 272, December 23, 1656: "portico . . . da fabricar attorno il disegnato teatro" (Kitao, *Square of Saint Peter's*, 20); ASV, *avvisi* 105, c. 148, September 8, 1657: "Teatro dei portici"; ASV, *avvisi* 110, c. 136, June 8, 1661: "il nuovo teatro"; and Diary, 947, December 16, 1666, a very late entry and the only time Alexander seems to employ the term for St. Peter's Square. On the other hand, he speaks of the *Teatro della Madonna della Pace* as early as October 5, 1656, Diary, 54: "modello dell'alzato e teatro," and December 27, 1656, Diary, 64: "disegno . . . della facciata e teatro."

References to Roman theaters and amphitheaters in sixteenth century architectural writings or drawings are too frequent to warrant listing; suffice it to mention Cesariano's translation of Vitruvius, Como, 1521, c. LXXXIr and v (ed. C. Krinsky, Munich, 1969), and for amphitheaters, *ibid.*, c. LXXXIIv. For the use of *teatro* to designate only the spectators' area, see J. S. Ackerman, *Il cortile del Belvedere* (*Studi e documenti per la storia del Palazzo Apostolico Vaticano, III*), Vatican City, 1954, 87 and docs. 221, 223; J. Coolidge, "The Villa Giulia," *Art Bull* 25 (1943), 177ff., esp. 215, n. 256, quoting Ammanati; and K. Schwager, "Kardinal Pietro Aldobrandini's Villa di Belvedere in Frascati," *Röm Jbch* 9/10 (1961-62), 189ff., esp. *Exkurs II*, 379ff.

The suggestion that Piazza S. Pietro was called *teatro* because of its oval shape is Kitao's, *Square of St. Peter's*, 19ff., based on Baldinucci's definition and G. Alveri, *Roma in ogni Stato*, Rome, 1664, whence our quote. For the identification of *teatro* with a hemicycle, see, for instance G. B. Falda, *Fontane delle ville di Frascati . . .* Rome, 1691, unpaginated, "Teatro e Giardino" at Villa Mondragone, and "Teatro d'Acqua" at Villa Aldobrandini; and correspondingly, Eimer, *S. Agnese*, 735, Glossary, "curved part of courtyard or square." However, the *avviso* of December 23, 1656 uses *teatro* nearly three months before Bernini surprises the *Congregazione della Fabrica*, the cardinals' commission in charge of all work linked to St. Peter's, with the project of his oval piazza; and it seems most unlikely that an *avviso* writer would have known what went on in Bernini's mind, or would have referred (Kitao, *Square of St. Peter's*) to the "oval" area to be cleared at that time by demolishing houses, not to mention the use of *teatro* for Piazza della Pace.

"Théâtre" for stage is used by Chantelou on October 8, 1665. I am grateful to E. and J. Garms' "Mito e realtà di Rome . . ." in *Storia d'Italia, Annali* 5, Turin, 1982, 361ff., esp. 612, for having led me on to F. Du Bellay, *Les regrets*, Editions du IV Centenaire, Paris, 1925, 57, no. LXXXII. The quote regarding a *Cappella Pontificia* as *teatro* is from Pallavicino, I, 335. Finally, the description of the counterproject to Maderno's façade of St. Peter's is quoted Haus, 5, from BAV, Barb. lat., 4344, 5rff., esp. 7v and 8v.

For the use of *teatro* or *theatrum* in the different context of encyclopedic learning but with the same meaning of show or display, see R. Bernheimer, "Theatrum Mundi," *Art Bull* 38 (1956), 225ff. Kaori Kitao who read my man-

uscript for the publishers points out a passage from R. Fludd, *Theatrum Orbis*, unknown to me but quoted by F. Yates, *Theatrum Mundi*, Chicago, 1969, 143, to the effect that the parts of a speech should be clearly displayed "as on a public stage."

THE MAN AND HIS TIME

pp. 8f.

Our picture of Alexander's personality is based on his Diary; on Pallavicino, *passim*, which, however, breaks off with the year 1658; on his own autobiographical notes, BAV, Arch. Chig., Atti di famiglia, fasc. 232, f. 4r, published by G. Incisa della Rocchetta, "Appunti autobiografici di Alessandro VII . . . ," *Mélanges Tisserant, VI (Studi e Testi, 236)*, Vatican City, 1964, 439ff., and used in part verbatim already by Pallavicino, I, 34ff.; and on the Venetian *Relazioni, passim*. The pamphlets, such as *Sindicato* and *Nipotismo*, despite their bias, are at times useful.

Among recent publications, M. Rosa's article in *Diz. Biogr.*, II (1960), 205ff. gives the best summary known to me of Alexander's life, personality and policies. Pastor, XXXI, 1ff., notwithstanding his apologetic bias and the resulting one-sided interpretation, remains indispensable; his collection of the material in his text, footnotes and appendix (XXX, 413ff.) is unsurpassed.

Alexander's autobiographical notes and, based on them, Pallavicino's report on his general education and within it on his archival, historical and art historical studies, *ibid.*, 41, whence our quote; see also his student excerpts from Ptolemy, Euclid and Vitruvius, BAV, Chig., a I 17, and from history, Chig., a I 25. His notes on early paintings and painters in Siena (BAV, Chig., J I 11) have been published by P. Bacci, *Bullettino senese di storia patria*, n.s. 10 (1939), 197ff., 297ff. For samples of his learned correspondence with Kircher and Holstenius, see Fea, *Miscellanea*, I, ccxciiiff.; for the malicious remark about his focusing on antiquarian quisquilia, BAV, Barb. 1at., 4690, c. 7r; for the transfer of the Urbino library, M. and L. Moranti, *Il trasferimento dei "Codices urbinates" alla Biblioteca Vaticana; Cronistoria, documenti e inventario*, Accademia Raffaello-Urbino, Collana di Studi e Testi, n. 9, Urbino, 1981.

Alexander's circle of intimates is reflected in Diary, *passim*; Pallavicino, *passim*; D. Bernino, *Vita del Cavalier Gio. Lorenzo Bernino*, Rome, 1713, 96f. On Virgilio Spada in particular, see now the rich excerpts from his notes, ASR, Archivio Spada, published in Güthlein I-III, and the sketch of his personality and his role in Roman building activities given by Connors, *Borromini*, 15f., 96ff. On Pallavicino, see P. Giordano, "Sulla vita e sulle opere del Cardinal Sforza Pallavicino," in Pallavicino, I, 3ff., and I. Affo, *Memoria della vita e degli studi di Sforza Cardinale Pallavicino*, Faenza, 1792.

Regarding Alexander's punctilious observation of religious functions, Pallavicino, *passim*, and in particular for the Corpus Christi procession in 1664, the medal minted that year, Bartolotti, 68; see, however, P. Romano, *Pasquino e la satira in Roma*, Rome, 1932, 55f., who, based on an unnamed source, reports that the pope, covered by his *pluviale*, seemed to kneel while in reality being seated.

pp. 9f.

The insriptions are gathered in BAV, Chig., J VI 205, cc. 270ff.; with some questions of Alexander's (to Holstenius?) regarding others proposed, in BAV, Chig., R VIII c, cc. 1ff.; other inscriptions in A. Ciacconius, *Historiae Pontificum . . .* , IV, ed. A. Oldoinus, Rome, 1677, 724ff. See also Diary, 20, 21 after June 3 and 23, June 13, 1656; *ibid.*, 368, December 8, 1659 and *passim*; also V. Forcella, *Iscrizioni nelle chiese ed altri edifici di Roma*, Rome, 1869, *passim*. For the annual medals, Ciacconius, *op. cit.*, 720, and Bartolotti, 58ff.; for the medals in general, see the collections of the Vatican Library—a small selection having been published by L. Michelini-Tozzi and M. Worsdale, "Bernini nelle medaglie e nelle monete," in *Bernini in Vaticano*, 281ff.; for the lists of achievements, Diary, *passim*, the earliest 567, June 10, 1662, and BAV, Chig., J VI 205, cc. 361ff.; and for the eulogies addressed to Alexander, the series BAV, Chig., D II 25, D II 45, D III 28, D III 35. Buti's remark is reported by Chantelou, 124, August 28.

Determining for the choice of his name—Alexander—was ostensibly the memory of his predecessor Pope Alexander III (see Alexander's own remark, *Ragguagli Borrominiani*, 138f., no. 207), fellow Sienese and "defender of the papal dignity against the great of this world" (Pallavicino, I, 255) whose tomb monument in the Lateran basilica he therefore wanted distinguished by the choice of marble rather than stucco; see also Spada, Güthlein I, 229, no. 42. *Ragguagli Borrominiani, loc. cit.*, a possible hint of Chigi's having chosen his name also so as to extinguish the memory of Alexander VI.

The Cortona drawing (British Museum, 1860-6-16-27) was engraved by François Spierre; the inscription, in the drawing simply "Alexander VII Pont. Max.," in the engraving was changed to the stilted flattery "Nomen idem et maior virtus facit ausibus artem"—the name is the same but the greater spirit provides for bold ventures.

The family history, *Chigianae familiae Commentarij* (BAV, Chig., a I 1), written in 1618 with corrections and additions after 1626, contains Agostino's lengthy biography, the latter published by G. Cugnoni, "Agostino Chigi il Magnifico," *ASRStP* 2 (1879), 37ff., esp. 46ff.; *ibid.*, 75; and 4 (1881), 56ff., from BAV, Chig., a I 32, his notes taken in 1626 regarding the reappropriation and first repairs of that chapel as well as those regarding work on the chapel at S. Maria della Pace in 1627-28 (*ibid.*, 65ff.).

pp. 10ff.

On Alexander's initial refusal to let his relatives come to Rome, Pallavicino, I, 272ff. and, e.g., *Nipotismo*, I, 32ff.; on his change of mind, Pallavicino, II, 5ff.; also *Relazioni*, 193ff., Report Angelo Correr, July 9, 1660, esp. 198 and *ibid.*, 227ff., esp. 237, Report Nicolò Sagredo, September 20, 1661, where (236f.), reference is made to attempts at limiting income of *nipoti*. See also Pastor, XXXI, 20f. The opinions of the cardinals' commission on the question are gathered in BAV, Chig., C III 70, 156ff. Whether Pallavicino (see his memo addressed to Alexander, Pastor, XXX, 424f.) broke off his biography of Alexander because he felt let down by the increasing riches heaped on the Chigi remains open; see also *Nipotismo*, I, 320ff. Fr. Oliva certainly by 1676 had undergone a change of heart due to the scandal created by Alexander's relatives. See G. B. Scarpinelli, "Il memoriale del P. Oliva S.J. al Cardinale Cybo sul Nipotismo," *Rivista di Storia della Chiesa in Italia* 2 (1948), 282ff.

A balanced present-day assessment of seventeenth century nepotism as against the embarrassed apologies and silences of Pastor, *passim*, is found in G. Lutz, "Rom und Europa während des Pontifikats Urbans VIII," in *Rom in der Neuzeit*, ed. R. Elze et al., Vienna and Rome, 1976, 72ff., especially 139f., quoting W. Reinhard, *Papa Pius . . .* , in Von *Konstanz nach Trient*, ed. R. Baumer, Munich-Paderborn-Vienna, 1972, 262ff., and *idem, Papstfinanz und Nepotismus unter Paul V (Päpste und Papsttum, 6)*, Stuttgart, 1974. On Alexander's limited personal finances—as nuncio 82 percent of his income came from his salary, 230 *scudi* annually—see K. Repgen, "Die Finanzen des Nuntius Fabio Chigi," in *Geschichte, Wirtschaft, Gesellschaft, Festschrift Clemens Bauer*, Berlin, 1974, 229ff.

p. 12

On Alexander's career prior to his election, Pallavicino, I, 48ff., the chapters in Pastor, XXX, 1ff., and Rosa's excellent thumbnail biography, *Diz. biogr., loc. cit.*; on his activity as nuncio in Cologne, Pallavicino, I, 124ff. and in particular, making use of his diaries, BAV, Chig., a I 8, N. Kybal and G. Incisa della Rocchetta, *La nunziatura di Fabio Chigi (Miscellanea Società Romana di Storia Patria, 14, 16)*, Rome, 1943, 1946, which unfortunately stops with the year 1645.

On the Church's defeat by the Treaty of Westphalia and the fruitless efforts of Chigi to avert or mitigate it, as well as the papacy's protests after its conclusion, Pastor, XXX, 94ff. K. Repgen, *Die römische Kurie und der Westfälische Friede* I, 1, 2 *(Bibliothek des Deutschen Historischen Instituts, 24, 25)*, Tübingen, 1972, deals only with the period prior to 1645; a second volume planned for the decisive years thereafter has never been published.

Alexander's high opinion of the papacy and of himself *qua* pope is brought out by Pallavicino, *passim*; by Nicolò Sagredo in *Relazioni*, 227ff., in particular 243, who stresses both his punctiliousness in performing all ceremonies and his choice of well-born and well-bred courtiers; and by Quirini, *Relazioni*, 313ff., in a report written in 1668, hence after Alexander's death, ". . . the natural defect of the popes to transfer from the heart to the head the triumph of the papacy." This unrealistic, at the same time headstrong and in the end disastrous policy of Alexander's, in particular regarding France, brought out by Rosa's excellent analysis in *Diz. biogr.*, II, 205ff., comes to the fore already in 1663 in a cleverly malicious French pamphlet published under the name of the Venetian ambassador Basadonna, *Relazioni*, 259ff., exposing the narrow and obstinate policy of the Chigi pope and his relatives. Like these policies, Alexander's withdrawal from public affairs and the increasing interference of the *nipoti* are sharply criticized by Quirini, as above—the bluntness of judgment probably explained by the report's postdating the pope's death.

Malevolent, benevolent and neutral sources all agree on Alexander's inability to reach decisions, in particular in his later years; see BAV, Barb. lat., 4690, cc 2v, 5r; report Quirini, *Relazioni*, 313ff., esp. 317; and the forgery which goes by the name of Basadonna, *ibid.*, 259.

pp. 13f.

A thumbnail sketch of the economic and demographic overall decline of Italy as a consequence of the Thirty Years' War—but not that alone—is provided by Spini, 466ff.: the Levant trade lost, banking insignificant, the economy

almost entirely agrarian, the cities reduced to administrative centers and residences for the big landowners, their population by the end of the seventeenth century halved, for example, in Venice and Milan.

Regarding conditions in the Stato Pontificio in particular, the Venetian ambassador Sagredo in 1661 (*Relazioni*, 246) paints an appalling picture of its depopulation, its hopeless finances, its insufficient income from taxes, office sales, foreign contributions, primarily from Spain, its mounting debts in government loans, *monti*, and the ineffective remedies tried—everything except curtailing the exorbitant expenditures both for building enterprises and enriching the *nipoti*. To understand the financial setup of papal administration in the seventeenth century, see the clear analysis provided by W. Reinhard, as above, note to pp. 10ff.

The annual population figures for Rome are given by F. Cerasoli, "Censimento della populazione di Roma dall'anno 1600 al 1739," *Studi e documenti di Storia e Diritto* 12 (1891), 1ff. Those for Alexander's pontificate start with 122,978, sink in 1657 as a result of the plague to 100,119 and slowly rise again to reach 110,489 by 1667.

p. 14

The rich sources on Alexander's patronage of art and on his building activities are published only in part. Outstanding are in the BAV, Chig., P VII 9-13, five volumes of building surveys and projects, with some more scattered in other volumes, such as Chig., M VIII LX; the pope's diary, Chig., O IV 58, the excerpts on art and architecture being published in Diary and G. Morello, "Bernini e i lavori a S. Pietro nel diario di Alessandro VII," in *Bernini in Vaticano*, 321ff.; and the abundant documentation contained in the *collectanea*, Chig., G III 78, Chig., H II 22, H II 40, H II 47, H II 57, Chig., M VIII LX, R VIII c, and others to be quoted in their appropriate places. Likewise in the BAV, the Archivio Chigi, on deposit, is rich in documentation, both visual and written. In the ASV we have used the *avvisi* covering Alexander's pontificate, Avvisi stampati, vols. 25-39, and Avvisi manoscritti, vols. 102-112; and *Miscellanea*, Arm. VII 50, 51 and 56, dealing with work on the Pantheon, S. Maria in Via Lata and S. Carlo ai Catinari, repectively. In the ASR, the collection Disegni e Mappe, cart. 80-89, contains abundant visual material (a handlist has been published by Lodolini, "Roma attraverso la sua topografia," *Roma* 7 [1929], 528ff. and *ibid.*, 8 [1930], 18ff., 119ff), as do the files of the Notai di Acque e Strade for Alexander's years, vols. 82-94 (these are the catalogue numbers; the signatures on the volumes which we shall quote in parentheses are one decade higher, hence 92-104); written documentation is provided by the *chirografi*, gathered ASR, Camerale I; and by the diary of Carlo Cartari, Fondo Cartari-Febei, Effemeridi Carlo Cartari, busta 77-81 and 191. Another diary of importance, that of Monsignor Neri Corsini, has survived in the Bibliotheca Corsini, Rome, Cors. 2116, albeit in fragments. Among the holdings of the Bibliotheca Casanatense are the diary of Giuseppe Cervini, Casan. 5006 (excerpts published by Rossi, 1939), and the nearly complete collection of edicts issued by the *presidente delle strade* and the *maestri di strade* regarding planning, corrections, maintenance and sanitation of streets for the years that concern us; digests of the edicts are published *Regesti*, 6.

Printed sources contemporary with Alexander or nearly so are: Pallavicino; G. Alveri, *Roma in ogni stato*, 2 vols. Rome, 1664; and the guidebooks of the

period, primarily F. Martinelli, *Roma ricercata*, the editions from 1662 to 1677, including the manuscript of one of 1658-1660, quoted here as Martinelli-D'Onofrio. Among more recent publications of sources excerpted are: still Fraschetti, *Bernini*, and Pastor, XXXI, 278ff., both of whom quote abundantly from the *avvisi* in ASV, from BAV, Chig., H II 22, and from the account books in the Archivio della Reverenda Fabbrica di S. Pietro in their footnotes; a collection of such excerpts drawn heavily from Fraschetti and Alveri, but from other sources as well, was published by Ozzola. Full documentation on the palace at Piazza SS. Apostoli, on Ariccia, Castel Gandolfo and S. Maria at Galloro is provided by Golzio, *Documenti*; similarly for work on the Lateran basilica and its baptistery as well as some documents regarding Piazza S. Pietro and S. Maria della Pace, all Spada material, Güthlein I, II, III, *passim*.

The artists employed in decorating the gallery of the Quirinal Palace and the original program assigned to each are listed Diary, 110, August 16, 1657; see also Ozzola, 41ff., who has published a number of pertinent payments. S. Jacob, "Pierre de Corone et la . . . Galérie d'Alexandre VII . . .," *Revue de l'Art* 11 (1971), 42ff. has discussed Cortona's role in supervising the decoration and in particular the framing fictitious architecture. On Vanni's work at S. Maria del Popolo in 1656-57, G. Cugnoni, "Agostino Chigi il Magnifico," *ASRStP* 6 (1883), 523ff.; on Alexander's dissatisfaction with it, an *avviso* quoted by Fraschetti, *Bernini*, 280, n. 1. Whether Alexander took a particular liking to Mola, as maintained by V. Martinelli, "Alessandro VII e Pierfrancesco Mola," in *Studi offerti a Giovanni Incisa della Rocchetta (Miscellanea Società Romana di Storia Patria*, 23), Rome, 1973, 283ff., based on L. Pascoli, *Vite de' pittori scultori ed architetti moderni*, I, Rome, 1730, 124, had best be left open.

On Alexander's collecting objets d'art and surrounding himself with silver and gold plate, textiles, embroideries and the like, Ozzola, 68ff. and Diary, *passim*.

THE URBAN SUBSTRUCTURE

pp. 15f.

Our thumbnail sketch of the city of Rome as it presented itself at the time of Alexander's election is based primarily on the city maps, both as regards the *abitato* and the *disabitato* with its fields, gardens and *ville*. Unfortunately, however, no new map was published between 1625 and 1661-62. Schayck's map of 1630 is but an adjusted edition of Maggi's map of 1603 and this in turn was but Tempesta's plan of 1593, brought up to date. (Frutaz, *Piante*, pls. 323ff., and the corresponding text, *ibid.*, I, 209f.) As it is, Greuter's map of 1618 *(ibid.*, pls. 285ff.) and, even better, the corrected edition of 1625 and Maggi's map of 1625, the so-called Maggi-Maupin-Losi map, despite its unreliability as to detail *(ibid.*, pls. 307ff.), give the best idea of pre-Alexander Rome, taking into account obviously such major changes as the layout of Piazza Navona.

I. Insolera, *Roma (Le città nella storia d'Italia)*, Bari, 1980, valuable in tracing the urban development from the fifteenth century onward, provides, 96-243, a clear picture of the development from 1550 to 1650, based for the latter half of the sixteenth century on J. Delumeau's standard work, *Rome au XVIe siècle*, Paris, 1975. In our context, the chapters on the activities of Paul V (1605-1621) and Urban VIII (1623-1644) are of particular value. For the city planning of

Alexander VII, on the other hand, Insolera's short survey, 260ff., is strangely void of information or interpretive interest.

p. 17

The lack of a Chigi villa in Rome is notable indeed. The residences in Ariccia and Castel Gandolfo were no substitute for a suburban retreat. Not before 1664 did Don Mario, Alexander's brother, by means of a legacy, come into possession of a modest garden on the southward slope of the Quirinal, *il Giardino alle Quattro Fontane*, provided with a *casino*; the garden was enlarged by his son, Cardinal Flavio, in 1689; see Golzio, *Documenti*, 189ff., and Falda's Large Map, Frutaz, *Piante*, pl. 359.

pp. 17ff.

Alexander's street corrections are listed and explained in the legend of Agnelli's map of 1666 (Frutaz, *Piante*, pl. 344).

Regarding the street leading from Piazza S. Apollinare by way of Piazza S. Agostino to Via della Scrofa and the new, parallel street running one block south, now Via S. Giovanna d'Arco, formerly Via del Pinaco (Nolli, 813), see Alexander's undated *breve*, Bösel-Garms, 340f. A huge map with Alexander's *chirografo*, April 3, 1666, concerning the breakthrough of Via Baccina, survives in ASR, Disegni e Mappe, cart. 81, no. 325; a sketch, perhaps autograph Alexander's, in BAV, Chig., J VI 205, c. 380r; *ibid.*, c. 377r, his note "non è cosa che meriti il nome del papa."

On the function and early history of the *maestri di strade*, see L. Schiaparelli, "Alcuni documenti sui Magistri aedificiorum Urbis," *ASRStP* 43 (1920), 5ff. The *maestri di strade* active during Alexander's pontificate are listed BAV, Chig., M VIII LX, cc. 190f.; his reviving the *Congregazione delle Strade* is noted Diary, 1, August 1, 1655, the names of the outgoing and newly elected *maestri di strade*, *ibid.*, 9, 10, both under December 20, 1655. The characterization of Jacovacci and the remark concerning his intimacy with the pope are contained in an *avviso*, BAV, Barb. lat., 6763, c. 808r and v, dated March 2, 1658, concerning his appointment as one of the *maestri di strade*.

The inscriptions tried out for the approach to the Quirinal both from Fontana di Trevi and from Piazza Magnanapoli are in BAV, Chig., J VI 205, cc. 350r and v, and 351r.

pp. 19ff.

A handy survey of the Corso, the buildings along it and their history is provided by *Via del Corso*, ed. U. Barberini et al., Rome, 1961. For the churches and palaces, left unfinished or finished by Alexander's time, see Blunt, *Guide*, *passim*. Those terminated under Alexander's aegis are discussed below, *passim*. Alexander's fruitless pleading with Prince Ludovisi to continue construction on the palace at Montecitorio is reported in an *avviso*, BAV, Barb. lat., 6367, cc. 810ff., March 16, 1658, published Rossi, 1939, 321.

p. 24

A copy of Alexander's *chirografo* authorizing the *maestri di strade* to confiscate and demolish buildings and parts thereof for the sake of straightening streets and clearing squares is found BAV, Chig., H III 57, cc. 159ff.; another copy, ASR, Camerale I, Chirografi, no. 24, cc. 16ff., this latter dated August 7, 1660. The removal of the Arco di Portogallo is discussed in detail below, p.

161

102 and note. Corrections of the streetline along the Corso are attested to many times: a plan among Virgilio Spada's *collectanea*, BAV, Vat. lat., 11257, cc. 153v-154r; another plan with *chirografo*, ASR, Disegni e Mappe, cart. 80, no. 251, dated September 29, 1657; the text of the *chirografo* of August 7, 1660; and diary notes such as Casan. 5006, c. 10v, September 9, 1659, and *ibid.*, c. 20v, March 1 and April 21, 1662, to mention but a few examples.

The variants for the inscriptions tried out by Alexander to record his having widened and straightened the Corso are found BAV, Chig., J VI 205, cc. 348ff.

pp. 25ff.

For the problems created in Rome by coach traffic since the late sixteenth century, see W. Lotz, "Gli 883 cocchi della Roma del 1594," in *Studi offerti a Giovanni Incisa della Rocchetta* (*Miscellanea Società Romana di Storia Patria*, 23), Rome, 1973, 247ff. The quotation about the stress laid by everybody of rank in eighteenth century Italy on making *bella figura* in their coaches comes from S. Sharp, *Letters from Italy ... 1765 and 1766*, London, 1767, 112, as quoted by L. Schudt, *Italienreisen im 17. und 18. Jahrhundert*, Vienna, 1959, 212f. The large numbers of coaches at the entry into Rome of the Maltese ambassador and of Queen Christina are reported on, for instance, by Gigli, 470 and 474f.; for similar receptions, see among many others, ASV, *avvisi stampati* 27, 481, November 10, 1657. For luxury coaches, see the description in 1692 of those of the Imperial ambassador as given in the legend of Wouters' engraving (fig. 17), ". . . the first coach . . . of gold brocade and crimson red embroidered with foliage and 'frogs' . . . inside and out and the body of the coach gilded with superb statues"; see also the coach designed by Bernini for Queen Christina and the state coach for Lord Castlemaine, 1686-1687, G. Masson, "Papal Gifts and Entertainments in Honour of Queen Christina," in *Queen Christina of Sweden* (*Analecta Reginensia* 1), ed. Magnus von Platen, Stockholm, 1966, 244ff. As to the width of coaches seating six, see Chantelou, 15, June 4. For quarrels over precedence Lotz, op. cit., 248, and Casan. 5006, c. 6, August 23, 1657. Maffeo Barberini's move from the old palace because of the lack of parking space is reported in an *avviso*, October 31, 1607, J.A.F. Orbaan, *Documenti sul Barocco in Roma* (*Miscellanea Società Romana di Storia Patria*), Rome, 1920.

The quotation regarding squares being an ornament to the city, and hence to stay unencumbered, comes from a *breve* of Alexander's, Bösel-Garms, 341.

pp. 29ff.

To Palazzo d'Aste: the sixteenth century palace, owned by the Duke Sannesio, was rented to Monsignore Sperelli—plans and elevations of both the old and the new palace, the latter with Alexander's arms, and the sales contract, in ASR, Notai di Acque e Strade, vol. 85 (95), 1658, 215f. (301f.); see also Casan. 5006, c. 7r, February 2, 1658 (Rossi, 1939, 272) and *Regesti*, 6, nos. 657, 660, January 18 and 29, 1658, all regarding the demolition of the old palace and the sale of the remaining lot, smaller than the old one because of its no longer projecting towards Piazza S. Marco-Venezia; for the new palace, built by G. A. De Rossi for the Cavalier Francesco d'Aste, see Wittkower, *Pelican*, 359, n. 3 and Blunt, *Guide*, 161. The alterations along Via del Gesù-Via del Plebiscito are attested to *Regesti*, 6, no. 674, February 8, 1658, and no. 725, June 28, 1658 (demolition of a house at the corner of Vicolo della Gatta and "case a S. Marco"). For the rebuilding of Palazzo Gottifredi-Grazioli, see Blunt, *Guide*, 182.

For straightening Via Romualdo, see Casan. 5006, January 26, 1658, c. 7v (Rossi, 1939, 272), and for linking it visually to Via del Gesù, thus stressing the east-west axis, Martinelli, *Roma ricercata* (1677), 124, "strada del Corso ... slargata ... nell'ingresso della Piazza S. Marco col gettito di un Palazzo col quale si è anche drizzata la strada Papale dalla Piazza de' SS. Apostoli fin verso li Cesarini" and similarly the legend of Agnelli's map, whence our quotation.

pp. 30f.

The clearing of Via del Babuino and its continuation, Via Due Macelli, ordered by Alexander, Diary, 102, July 1, 1657, is discussed in detail below, pp. 93ff.

Enlarging Via S. Dorotea entailed the demolition in part of buildings under construction which further restricted the narrow street so as to "straighten the aforesaid street *per ornamento della Città*," see Fea, *Diritti*, Appendice, 57f. Christina moves into Palazzo Riario, now Corsini, in July 1659 (Pastor, XXXI, 67f.); for the length of such negotiations one might compare the long, drawn-out dickerings about the acquisition by the Chigi of Palazzo Aldobrandini on Piazza Colonna.

pp. 32ff.

The list of markets of *generi alimentari* as of 1658 is given by Martinelli, *Roma ricercata*, 3rd ed. published that year; it is found identically already in the first edition in 1644 and still in that of 1677. There were twenty-three markets on streets and squares, including a number that have survived to this day, though none on major squares, except the one on Campo dei Fiori. There were, moreover, listed *ibid.*, 475ff., twenty streets and squares where other vendors congregated, from the cattle dealers on Piazza delle Terme to the oil sellers on Piazza Capranica and the needle-makers at the Madonna dei Monti, not to mention the incongruous gathering on Piazza Navona as enumerated in the text.

The removal of the vendors from Piazza del Pantheon to Piazza di Pietra, short term as it turned out to be, is discussed below, pp. 104ff., and note. The much broader project to remove market stalls, especially of edibles, from all public squares was proposed in the *Congregazione delle Strade*'s last meeting of 1662 (ASV, Misc. Arm., VII 50, c. 117r): "ordinare la demolitione di tutti li casini di tavole fatti ed esistenti nelle piazze, siti e strade in qualsiasi luogo di Roma et specialmente quelli della Rotonda, ... di Campo di Fiore, della Piazza avanti alla Cancelleria, ... piazza Giudia, ... piazza di Ponte...." *Ibid.*, 117v, "... sopra lo sgombero di Piazza Navona, si proibisce la scarica dei frutti, erbaggi ... eccezione il giorno di mercato...."

Alexander's *chirografo*, undated but in all likelihood issued 1662, commanding the transfer of all vendors from Piazza del Pantheon to a shopping center to be set up along what is now Via Giovanna d'Arco "in meditullio urbis" has been published by Bösel-Garms, 341; it also contains the phrase about public squares staying unencumbered, quoted above, p. 29.

The permanent shopping center planned for Piazza di Pietra is known from a drawing, possibly Felice della Greca's, BAV, Chig., P VII 13, f. 44r. Regarding the complementary proposal of installing *botteghe* inside the nunnery built into the colonnade of Hadrian's Temple, see ASV, Misc. Arm., VII 50, c. 103r and our figs. 23, 24.

The shopping centers planned for Piazza del Popolo appear on all projects prepared for the square, see below, pp. 122ff., and figs. 97, 98. The one to the left at the entrance to Via del Babuino had been built by 1666, as witness Agnelli's map of that year and the Small Map of Falda's (Frutaz, *Piante*, pls. 344, 345), transformed from the original "palatial" project into a series of rowhouses, each with its *bottega* at ground floor level.

The *manica lunga* of the Quirinal Palace, planned by the spring of 1657 (Diary, 84, May 10), was under construction by the summer and winter of the following year (Diary, 230, August 21; 254, November 26; 276, February 9, 1659). Its original length as completed by Bernini apparently during 1659 (Diary, 362, November 14, accounting?) can be gathered from the Large Falda Map. Under Innocent XIII (1721-1724) and Clement XIII (1758-1769) it was extended to its present length.

THE ARCHITECTS

pp. 37ff.

The bibliography on Bernini is endless, starting, aside from contemporary guidebooks, with F. Baldinucci, *Vita del Cavaliere Gio. Lorenzo Bernini*, Florence, 1682, and D. Bernino, *Vita del cavalier Gio. Lorenzo Bernino . . .*, Rome, 1713. Regarding his architectural work, suffice it to mention among recent major publications: Br-W, *passim*; Wittkower, *Pelican*, esp. 114ff.; H. Hibbard, *Bernini*, Harmondsworth, 1965, *passim*; Fagiolo dell'Arco, *Bernini*, a handy survey; not to forget good old Fraschetti, *Bernini*. I. Lavin, *Bernini and the Unity of the Visual Arts*, New York and London, 1980, has brought out the importance of the *bel composto* as the *leitmotif* of Bernini's art.

The quotation about the pope's inquiring during Bernini's illness comes from BAV, Barb. lat., 6367, c. 695, October 2, 1655.

The "classical" features in Bernini's architectural design have been stressed frequently, for instance Wittkower, *Pelican*, 116ff., and Fagiolo dell'Arco, *Bernini*, 113ff. However, his preference for Renaissance rather than antique prototypes has not always been sufficiently brought out; see, however, C. L. Frommel, "S. Andrea al Quirinale: Genesi e struttura," in *Gian Lorenzo Bernini architetto*, ed. A. Spagnesi and M. Fagiolo, Rome, 1983, whence I have borrowed the term "Cinquecentismo." The two Bernini quotations in the text are reported, the first by Chantelou, 213, October 8, the second, regarding deviations from the established orders used, by D. Bernino, *op cit.*, 33. The remark regarding the colossal order goes back to Mattia De Rossi, Bernini's chief draughtsman at the Louvre; see Chantelou, 108, August 20, the one on rustication, *ibid.*, 41, July 1.

On the hidden subtleties in the seemingly plain layout of a Bernini building, see J. Connors, "Bernini's S. Andrea al Quirinale," *JSAH* 41 (1982), 15ff.

For Alexander's having been brought up in the "classical" tradition as represented by Vitruvius and his sixteenth century codifiers, see Pallavicino, I, 36 and Alexander's autobiographical notes as quoted above p. 156, note to pp. 8f., as well as a few autograph Vitruvius excerpts from his student days, BAV, Chig., a I 17, cc. 56 and 63ff.

The bibliography on Bernini's individual works as far as they concern us will appear in the appropriate places.

A monographic study on Pietro da Cortona, long needed, had been prepared by Anthony Blunt. At the time of his death the manuscript was to my knowledge nearly finished, and it is hoped that it will be published in the near future. So far a handy summary of Cortona's work is provided by G. Briganti's article in *Diz. biogr.*, IX (1965), 398ff.; the best available treatment of the architectural work is found in Noehles, *SS. Luca e Martina, passim*.

The quote in our text concerning the jealousy between Cortona and Bernini comes from Diary, 37, August 20, 1656.

The best study of Carlo Rainaldi's work is still R. Wittkower, "Carlo Rainaldi and the Roman Architecture of the Full Baroque," *Art Bull.* 19 (1937), 242ff. (reprinted Wittkower, *Studies*, 9ff.), to be supplemented by F. Fasolo, *L'opera di Hieronimo e Carlo Rainaldi*, Rome, 1961, by Hager, "Zwillingskirchen," and by Eimer, *S. Agnese, passim*.

The characterization of Rainaldi's style as overloaded and confused comes from Chantelou, 313, October 20.

On Giovanni Antonio De Rossi, aside from Pascoli, *Vite*, I, 316ff., see G. F. Spagnesi, *Giovanni Antonio De Rossi*, Rome, 1964, and A. Blunt, "Roman Baroque Architecture: The Other Side of the Medal," *Art History* 3 (1980), 61ff.

pp. 43ff.

Along with the early standard work, E. Hempel, *Francesco Borromini*, Vienna, 1924, and revising it on many points, stand A. Blunt, *Borromini*, London, 1979, and Connors, *Borromini*. Of the planned catalogue raisoné of the drawings, a first part covering the years up to 1632 has been published: H. Thelen, *Francesco Borromini: Die Handzeichnungen*, I, Graz, 1967. The basic documentary material, as far as preserved in the ASR, has been brought out in *Ragguagli Borrominiani*.

Alexander's remarks on Borromini's work at the Lateran are from: Diary, 51, September 24, 1656, "ordinato al . . . Borromini la speditione" and 396, April 2, 1660, on cutting off the funds with a final "finisca a S. Giovanni Laterano . . ." three days later. *Ibid.*, 130, September 2, 1657, on having to pull from Borromini his drawings "per via degli sbirri" and "Borromini vuol morire di dolore," *ibid.*, 123, August 22, 1657.

Alexander's criticism of Borromini's architecture is recorded by Cartari, reporting on an audience, March 16, 1660; see *Ragguagli Borrominiani*, 136f., and Eimer, *S. Agnese*, 445f., where part of the report omitted from *Ragguagli* is published. Alexander censures Borromini's "Gothic" manner ". . . nè esser maraviglia per esser nato in Milano dove era il Duomo di architettura gotica," and in particular his memorial for Alexander III at the Lateran (*Ragguagli, loc. cit.*); he also repudiates his inclination towards "needless ornaments," instead of proceeding "francamente," plainly, concentrating on a design of his for steps to ascend to S. Agostino "with diverse angles and projections, *risalti*"; he adds that he had ordered him "to remove all that" and to make the stairs oval like those at S. Maria del Popolo (Eimer, *loc. cit.*). For Borromini's dismissal from S. Agnese, see L. Montalto, "Il drammatico licenziamento di Francesco Borromini della fabbrica di S. Agnese . . . ," *Palladio*, n.s. 8 (1958), 139ff., whence also the quotes regarding his lack of cooperation; see also Diary, 4, October 1655, ". . . Borromini che si porta bene a sbrattar piazza navona." Eimer, *S.*

Agnese, 436ff. and 448ff., views Don Camillo's accusations as one-sided and largely unjustified. But the label of obstreperous incompatibility stuck.

For Borromini's work at S. Agostino aside from Hempel, *Borromini*, 171ff., Bösel-Garms, as above, 341f. and Diary, 342, 345, 360, 365, from August 31 to November 23, 1659.

The nasty affair of the planned Banco di S. Spirito (Palazzetto Spada) is discussed at length by M. Heimbürger-Ravalli, *Architettura, Scultura e Arti Minori*, Florence, 1977, 275ff., whence also Alexander's complaint about Borromini's (and Spada's) always underestimating the cost. For Borromini's drawings for the building, aside from Hempel, *op. cit.*, 176ff., and Blunt, *Borromini*, 175, see M. Heimbürger-Ravalli, "Disegni sconosciuti del Borromini per il Banco di Santo Spirito . . . ," *Paragone* 24 (1973), no. 275, 57ff.; for Alexander's apparent hesitation to approve the drawings, Diary, 450, 454, 457, 460, 467, January 30 to April 10, 1661.

Borromini's project for completing the rear façade of the Sapienza flanked by the Chigi *monti* has been published by M. Fagiolo, "La Sapienza di Borromini," *Storia dell'Arte* 38-40 (1980), 343ff.

PIAZZE AND CHURCHES

pp. 47ff.

H. Ost, "Studien zu Pietro da Cortona's Umbau von S. Maria della Pace," *Röm Jbch* 13 (1971), 231ff., has clarified the chronology of both planning and construction; a recent study by M. L. Riccardi, "La Chiesa e il convento di S. Maria della Pace" (*Quaderni* 26 [1981], fasc. 163-168, 5ff.), traces the history of the complex from its beginnings based on a new architectural survey.

Here is a survey of the major evidence. The restoration of the Chigi chapel in 1628 has been documented by G. Cugnoni, "Agostino Chigi il Magnifico," *ASRStP* 4 (1881), 65ff., esp. 72ff., based on BAV, Chig., R V c, 210ff. The restoration of the church by Alexander must have been decided on shortly after his election, in the winter of 1655, since by February 17, 1656 the *scarpellini* were at work (Ost, *op. cit.*, 234 and 255, n. 79, based on BAV, Chig., H II 40, f. 371); one asks oneself what part of the church they were working on, since the major problems of the design rose but later. Indeed, only on July 6, 1656 were the difficulties of the approaches to the church pointed out in an anonymous memo, BAV, Chig., P VII 9, f. 73f. The plan to break through the houses at the left is attested to by the memo just quoted and the drawings, ibid., ff. 65 and 71, on which latter appears the pencil sketch of the five-sided piazza (fig. 35); a comment by Virgilio Spada on breaking through the houses, Güthlein I, 190, while Alexander's qualms—". . . se nel vicolo passaran carrozze . . . se si fa la volta per lo spazio . . ."—are recorded Diary, 34, August 19, 1656. The final plan and elevations are found in BAV, Chig., P VII 9, f. 74 and in Vienna, Albertina, call numbers Rom, AZ 618, 619; the proposal for widening the approach through Via della Pace, BAV, Chig., P VII 9, f. 80. Copies done by Domenico Martinelli of three versions of Cortona's for the façades of the church and the buildings enclosing the piazza (Milan, Castello Sforzesco, Collezione Bertarelli, Domenico Martinelli, *Disegni d'edifici in Roma ed altrove*, vol. I, f. 41, 43v-44r, 61v-62r) have been published by P. Portoghesi, *Roma barocca*, Rome, 1968, figs. 190ff. The concealment of the apse of S. Maria dell'Anima by the right-hand anchor of the façade of the Pace has been

pointed out by G. Severati, "La chiesa della Pace e S. Maria dell'Anima," *Architettura* 16 (1970), 259.

A few entries in Diary, most of them known to Ost, complement his study. On October 5, 1656, Diary, 54, Alexander is shown a "modello dell'alzato del Portico e Teatro della Pace," suggesting that even then the square and the church had been conceived as an architectural entity; on December 2, *ibid.*, 64, he sees the "disegno finito." Providing funds, pressure for speed and acquisition of travertine went on through the spring and continued into the summer of 1657, see Diary, 84, 93, 115, 116, 120, May 10, June 2, August 5, 6, and 19, respectively. But work on the church must have preceeded rapidly, since ASV, *avvisi stampati* 27, c. 390, on September 1, 1657, records a visit of Alexander's to the "nuova fabrica che stà per finirsi"; see Rossi, 1939, 268 and Ost, *op. cit.*, 246, n. 8; another visit is recorded November 10, 1657 (ASV, *avvisi* 105, c. 190).

Work on the piazza progresses more slowly. The *gettito*, needed to clear the piazza, "... acciò si copri ben la facciata ..." (ASV, *avvisi* 105(?), c. (?); see J. Schmidlin, *Geschichte der deutschen Nationalkirche in Rom ...*, Freiburg and Vienna, 1905, 463, n. 3; no pagination is quoted and despite numerous checks we have not been able to locate the quotation) was ordered March 10, 1657; but it does not start before the summer when two *chirografi*, dated June 24 and July 4 respectively, are issued regarding estimates, purchase and demolition of houses; see C. Fea, *Promemoria ... S. Maria della Pace*, Rome, 1809, 44ff., 47ff. The final *chirografo* forbidding any changes on the square and the accompanying drawing showing the enveloping façades as of today and as planned presumably since October 1656 (see above) was issued June 27, 1659, when, one supposes, work on them was finished; see C. Fea, *op. cit.*, 54ff. and engraving.

The Thanksgiving Service for the Peace of the Pyrenees is recorded by Cartari, ASR, Cartari Febei, busta 78, c. 222, February 25, 1660. Cartari on that day, *ibid.*, c. 235, records the celebration of a *Capella Pontificia* at S. Maria della Pace, sumptuously decorated for the occasion. By the end of 1659, in any event, work was finished.

pp. 53ff.

Full documentation for Piazza Colonna is found in R. Krautheimer, "Alexander VII and Piazza Colonna," *Röm Jbch* 20 (1982), 213ff. I am summing up the principal evidence. The rumours in February 1658 as to a transfer of the Trevi waters to Piazza Colonna and a move by the Chigi are recorded BAV, Barb. lat., 6367, c. 801v, whence Rossi, 1939, 272. The acquisition of Palazzo Aldobrandini by the Chigi is amply documented by R. Lefevre, *Palazzo Chigi*, Rome, 1973, in particular 119 and 127, n. 14; see also for the long, drawn-out negotiations Diary, 199, 228, 229, 270, June 5, August 13 and 16, 1658 and January 27, 1659, and for the purchase, *ibid.*, 346, September 23, 1659. Felice della Greca's view of the square (fig. 38) is in BAV, Arch. Chig., 24958, the two *chirografi* with plans showing the progressive demolitions proposed for the "Barnabite block" are contained in ASR, Disegni e Mappe, cart, 81, 252 (fig. 39); the detailed plan of the block with the pencil outline sketched in is found BAV, Chig., P VII 10, f. 6r.

Monsignor Neri Corsini's (see the article prepared for *Diz. biogr.*; the proofs were made accessible to me through the kindness of Mrs. Ornella Francisci)

diary, of which a fragment survives (Corsiniana, cod. 216) was unknown to me at the time I wrote the paper mentioned above. It records cc. 156r-160r, February 12-March 5, 1659, his suggestion to deepen the cut of the "Barnabite block," thus regularizing the square, as well as the various solutions apparently discussed to overcome the resulting problems: attaching the Trevi Fountain to the column so as to conceal its off-center position, c. 156r; placing the fountain against the front of the "Barnabite block" remaining after the deep cut, c. 159r and v; and, possibly, as witness Alexander's request for a survey of the exits from the square, opening the approach to Montecitorio, c. 158v. The *chirografo* with plan and elevation, December 31, 1659, approving the construction of and establishing the façade design for the *parvum palatium* to house the Ludovisi *famiglia* is preserved ASR, Notai di Acque e Strade, vol. 88 (98), 1659, c. 375.

The Cortona drawings, P VII 10, fol. 10-13, have been published frequently, e.g., K. Noehles, "Die Louvre Projekte des Pietro da Cortona," *ZKG* 24 (1961), 40ff., esp. 50, but dated 1667; the *terminus ante* is given by the *chirografo* of December 31, 1659, which shortens the building site in favor of widening the Montecitorio approach. The ship fountain project is sketched in a plan, BAV, Arch. Chig., cart III, 1, 25058, datable around 1662 because of the street corrections executed and planned along the Corso; Alexander's and Bernini's discussion about a fountain to be set up on Piazza Colonna is recorded Diary, 634, November 26, 1662. Bernini's story about moving the Column of Trajan as well to Piazza Colonna is reported Chantelou, 15, June 25 and repeated 249, October 19. Alexander's deathbed note to himself ". . . move the show façade (*mostra*) of the Trevi Fountain to Piazza Colonna . . . ," see below, p. 79 and note to pp. 77ff.

The groundplan of Cortona's "fountain palace," BAV, Chig., P VII 10, f. 10, bears a scale hardly visible in fig. 40; from it the length of the building results to have measured 225 *palmi*, corresponding to that of the "Barnabite block."

p. 59

The history of planning and construction of S. Andrea al Quirinale has been clarified and the building analyzed in two recent papers: C. L. Frommel, "S. Andrea al Quirinale: Genesi e Struttura," in *Gian Lorenzo Bernini architetto*, ed. G. Spagnesi and M. Fagiolo, Rome, 1983, 211ff. and J. Connors, "Bernini's S. Andrea al Quirinale," *JSAH* 14 (1982), 15ff. Both are based in part on new documentation; in particular a contemporary *racconto*, written by one of the Jesuits (Frommel, *op. cit.*, 247ff. and *appendice*) proves invaluable to that end. Diary, 226, 235, 238 and 241, dating from August 9 to September 29, 1658, and the terminating *chirografo* with plan and section, issued October 26 (BAV, Chig., P VII 13, cc. 40v, 41r) bespeak both Bernini's rapidity of planning and Alexander's impatience—his remark about having moved back the church, Diary, 235, dates September 2. The *racconto*, on the other hand, clarifies Don Camillo's role, the slow progress of and changes in the construction, while underway; the first major changes being attested to by the *chirografo* project preserved ASR, Disegni e Mappe, cart. 84, R. 476, undated, but probably 1659-1660. Alexander's note regarding the planning of the lantern, as late as October 1, 1661, overlooked in Diary (and I apologize), is published by G. Morello, in *Bernini in Vaticano*, 330.

The plan presented to Alexander on September 2, 1658, Diary, 235, was

probably the five-sided project, a crude sketch of which survives in the Pamphili archives (Eimer, *S. Agnese*, 528, p. 271); the *invenzione* is by now generally accepted as Bernini's.

The differences between the two *chirografi* projects of 1658 and 1660, respectively, have been brought out Br-W, 110ff., Frommel, *op. cit.* and in particular Connors, *op. cit., passim*. The contrast between the first and second planning of the façade is discussed T. Kitao, "Bernini's Church Façades," *JSAH* 24 (1965), 263ff., where also a convincing reconstruction is presented of the façade as planned in 1658. For the date of the curved "forecourt" wings adjoining the façade, perhaps as late as 1667, and of the colonnaded porch, 1670, see Frommel, *op cit.*, 241, and Connors, 26f.; for the revetting of the interior with precious marbles, Connors, *op. cit.*, 20ff., where also the change during construction from private to public has been stressed.

pp. 63ff.

For the history and the aspect of Piazza S. Pietro before 1656, see Chr. Thoenes, "Studien zur Geschichte des Petersplatzes," *ZKG* 26 (1963), 97f., supplemented by H. A. Millon, "An Early Seventeenth Century Drawing of the Piazza S. Pietro," *Art Quarterly* 25 (1962), 229ff. Regarding the genesis of Bernini's piazza and the successive stages of his design, the twenty-odd pages, Br-W, 69ff., are essentially unsurpassed, based as they are on the visual evidence, the piazza as it presents itself and Bernini's and his workshop's drawings supplemented by such items as the medals showing Piazza S. Pietro issued over the years by Alexander. On the other hand, the documentary evidence available fifty-odd years ago has been vastly complemented by newly dug up material: the archives of the Reverenda Fabrica di S. Pietro (ARF), explored and used by Kitao, *Square of St. Peter's* and Haus; by Spada's papers, Güthlein I, II; by Alexander's Diary; by further documentation and by a series of letters addressed by his agent in Rome to Cardinal Leopoldo of Tuscany and including two drawings, one by Bernini, the other from his workshop, in the Archivio di Stato, Florence, Carteggio Artisti 17 (M. Mercantini, *Due disegni inediti Berniniani per Piazza S. Pietro*, Città di Castello, 1981). Some of this new evidence thoroughly changes the sequence of events in the planning stage of the square; suffice it to point to the date of Bernini's final design of the colonnade with the present powerful single columns as early as September 2, 1657, rather than 1659 as previously assumed. Hence I thought it useful to list the digests of the documentation as now available as it refers to the planning phase and to sketch the major milestones in the construction stage.

Since I have not checked the documents from the ARF, I refer only to Kitao, *Square of St. Peter's*, and/or Haus, where the exact location in the archives is given.

1656 July 31: The *Congregazione della Fabrica* is informed by Virgilio Spada of Alexander's having commissioned from Bernini a plan for porticoes to envelop Piazza S. Pietro (ARF; Kitao, *Square of St. Peter's*, 80, n. 10; Haus, 8; also Ehrle, 34, n. 155).

August 9: Flavio Chigi to talk to Bernini "del portico esterior di S. Pietro" (Diary, 30, Haus, 8).

August 13: Alexander orders the square to be trapezoidal, as close to a square as possible, the porticoes to be one-storied, not two-storied as

apparently discussed, and surmounted by a balustrade and a statue over each pier (*pilastrino*); Diary, 32, Haus, 9, with corrections of my reading.

August 19: *Congregazione* approves plan, would prefer longer and rectangular shape and, if an *avviso* of that same day is correctly informed, with apartments for the canons surmounting the porticoes (BAV, Chig., H II 22, cc. 95f.; Br-W, 69). Also ARF; Kitao, *Square of St. Peter's*, 80, n. 11; Haus, 9; the *avviso* ASV, *avvisi*, 103, c. 212; Pastor, XXXI, 291, n. 4; Haus, 10, who doubts its validity. Objections Pallotta in the *Congregazione* (BAV, Chig., H II 22, c. 97; Fraschetti, *Bernini*, 314, n. 1; Br-W, 69).

August 20: Bernini presents Alexander with "the plan" of Piazza S. Pietro (overlooked in Diary, see Morello in *Bernini in Vaticano*, 322).

September 8: Porticoes to be arcaded and one-storied, two arches drawn on house wall for pope's inspection (BAV, Chig., H II 22, c. 108v; Br-W, 70, n. 1; ASV, *avvisi*, 103, c. 388; ASR, Cartari Febei, busta 77, c. 234r; Kitao, *Square of St. Peter's*, 81, n. 13; Haus, 12). Difficulties "... perchè il disegno non era del Bernini ..." (ASV, *avvisi*, 103, c. 388; Pastor, XXXI, 292, n. 2).

September 29: Digging to sound terrain southwest part of piazza (ASV, *avvisi*, 103, c. 366; Pastor, XXXI, 291, n. 2; Kitao, *Square of St. Peter's*, 81, n. 13).

October 15: Bernini brings Alexander a drawing of "portici doppi" for Piazza S. Pietro (Diary, 56), meaning presumably for the two sides, north and south.

November 8: Life-size model started by Carcani (BAV, Chig., H II 22, c. 142) where on November 23 payments for several *modelli*, Carcani's among them, are recorded (Kitao, *Square of St. Peter's*, 99, n. 81; Haus, 14). For description of completed life-size model, see below, October 29, 1657; however, that final design need not have been envisaged at the start. See also BAV, Chig., H II 22, c. 142, where many "modelli" are recorded under that date.

November 23: *Chirografo* referred to re demolition of buildings in the area of the piazza (ASV, *avvisi*, 103, c. 272).

December 15: Alexander inspects a model of the "archi" in St. Peter's, "che si pensa di fare in questa piazza" (ASR, Cartari Febei, busta 77, c. 286r).

December 23: *Chirografo* issued to purchase houses for demolition (ASV, *avvisi* 103, c. 272; Pastor, XXXI, 292, n. 3; Kitao, *Square of St. Peter's*, 81, n. 14. See also ASR, Cartari Febei, busta 77, c. 287v).

1657 Presumably early in 1657, length of obviously rectangular piazza being demonstrated by setting up wooden uprights and traverses; the pope, so Bernini maintains, decides on oval piazza (BAV, Chig., H II 22, c. 108v-109r; Br-W, 70, n. 1).

March 17: Bernini presents the *Congregazione* with the plans of an oval piazza, arcaded, single-naved and single-storied (Br-W, 72f., pl. 161a). Commission submits to the will of the pope "... et Emm.i Domini se rimiserunt voluntati Sanct.i ..." (ARF; Kitao, *Square of St. Peter's*, 81,

n. 15; Haus, 12; Fraschetti, *Bernini*, 315, n. 5, erroneously dated 1659); the same minutes in Italian, BAV, Chig., H II 22, c. 136. See also Bernini's memorandum summing up the events of 1656-57 (BAV, Chig., H II 22, cc. 107vff.; Br-W, 71f., n. 1, *Bericht* II; also Kitao, *Square of St. Peter's*, 89f., n. 40) and two memoes: one by Spada (Güthlein I, 189f.) dated March 17, written obviously right after the meeting, suggests strengthening "i pilastri"—piers or pilasters?—by doubling them and pleads for twin-naved porticoes; the other memo, anonymous and presumably written also shortly after the meeting (BAV, Chig., H II 22, cc. 105v and ff.; Br-W, 71, n. 6) proposes a Serliana design for the arcades "... non sarà difficile trovar modo che il Cav. Bernino ne divenisse l'autore ...," perhaps, like the drawing BAV, Chig., H II 22, c. 94v (fig. 94).

Whether or not this was the "split-semicircular" plan, BAV, Chig., H II 22, c. 155v (Kitao *Square of St. Peter's*, 12 and n. 48) or the true oval of the foundation medal remains open.

Prior to April 14: Wood and canvas life-size model of three arches set up on piazza, crowned by balustrade and four models of statues (ARF; Kitao *Square of St. Peter's*, 12f.); see above, November 8, 1656, and below, October 9, 1657. Linked to it perhaps Bernini's sketch, BAV, Chig., a I 19, c. 13v.

Possibly at that time also a counter project, inscribed P. Chircan (Kircher?; Carcani?) BAV, Chig., P VII 9, f. 25r, oval, with *terzo braccio* and buildings (canonry and barracks) behind single-naved portico, supported by single piers.

May 20: Alexander firmly approves Bernini's plan and elevation "... e concludiamo così" (Diary, 90); presumably freestanding twin Tuscan columns, as foundation medal I (below, August 3, 1657), colonnaded gate to palace corridor replacing Ferrabosco's clock tower (BAV, Chig., a I 19, c. 26r; Br-W, 74f., pl. 57).

June 9: Work to be started that coming week (Pastor, XXXI, 292, n. 6, as coming from ASV, *avvisi*, 105; we have been unable to locate the quotation under June 9 or elsewhere in that volume, or for that matter, among *avvisi stampati*).

June 17: Bernini to be told of "medal of Portico of St. Peter's" (Diary, 100).

July 23: More manpower to quarry travertine, houses speedily to be bought up "to start the portico" (Diary, 111).

August 3: Medal commissioned "pel portico ovato" (Diary, 113), inscriptions composed (*ibid.*, 114). See *Bernini in Vaticano*, no. 289, also Pallavicino, II, 182: oval plan, porticoes twin-naved, on paired freestanding columns carrying entablature; *terzo braccio*; drawing of latter, BAV, Arch. Chig., 24916 (Br-W, 75, n. 2; Fagiolo dell'Arco, *Bernini*, scheda 166).

August 5: Quarrying for porticoes sped up (Diary, 115).

August 25: Alexander receives medals of piazza (Diary, 126).

August 28: Cornerstone laid (Diary, 128; ASV, *avvisi*, 105, c. 148; Pastor, XXXI, 293, n. 2).

September 2: Bernini presents Alexander with his "disegno ultimo con colonne più grosse e non doppie" (Diary, 130), that is, with single strong columns as of today. Also, by that time, as reported by Spada, September 15 (Mercantini, *op. cit.*, 29f.), a plan had been evolved and was under discussion for colonnades composed of a vaulted nave and two flat-ceilinged aisles, as at present; but it was still debated whether the columns would be double or single.

Jointly the two items change the chronology of planning in that the final project for the colonnades was evolved, if not in all details, not much more than a year after the beginning of planning.

In any event, the life-size model (see next item) is already obsolete.

Prior to October 29: Life-size wooden and canvas model underway since November 8, 1656 is nearing completion: twin columns, slightly lower than those later built, trabeated cornice, balustrade, Chigi arms (ARF; Kitao, *Square of St. Peter's*, 99, n. 81, referring also to BAV, Chig., H II 22, c. 142; Haus, 14).

November 6 and 10: Final accounting for model (Haus, n. 64).

November 10: Alexander inspects model on piazza, "Teatro di Colonnate" (ASV, *avvisi*, 105, c. 190; Haus, 14 and n. 68), is supposedly dissatisfied on grounds of criticism levelled against its "eccetioni et errori di buona architettura" and its contrast to the façade of St. Peter's (BAV, Barb. lat., 6763, c. 777v).

1658 January 3: Edict by *Congregazione della Fabrica* preparatory to shipping travertine for colonnades (*Regesti*, 6, no. 249).

January 4: "Colonne del modello" removed (ARF; Haus, 14 and n. 69).

January 10: Work to be sped (Diary, 166).

January 28-March 31: Work on travertine columns started (ARF; Haus, 14 and n. 70).

March: Four column bases set in place on north portico (ASR, Cartari Febei, busta 191, c. 13; Haus, 14 and n. 71).

March 9: Work on columns to be hastened "per una mostra" (Diary, 179).

May 1: More stonemasons to be hired (Diary, 193).

August 4: Bernini shows Alexander clay model of Chigi arms for porticoes (Diary, 224).

August 5: Bernini presents new model for arms (Diary, 224).

September 17: Alexander views setting up one column (Diary, 240).

September 20: Twenty-four columns are in place (ASR, Cartari Febei, busta 191, c. 13v; Haus, 14, n. 72).

1659 March 28: "Al colonnato si lavori più in furia" (Diary, 292).

Prior to April 1: Alexander has commissioned from L. Morelli a model in wax and wood, 25 *palmi* high, of the porticoes (ARF; Br-W, 81, n. 6; Kitao *Square of St. Peter's*, 99, n. 81).

April 17: Work to be sped up (Diary, 297).

May 18: Bernini brings Alexander "the drawings of the Portico" (Diary, 307), possibly elevations.

May 30: Alexander wants four *arcus* (intercolumniations) to be finished in all details, meaning entablature and balustrade (ARF; Haus, 14).

June 20: Bernini to send hurriedly the drawing of the portico (Diary, 319).

June 22: Second fountain for piazza planned; *Congregazione* complains about Bernini (Diary, 320).

June 26: Drawing of "vestibulo del portico di S. Pietro e del grande portico," perhaps *terzo braccio* (Diary, 322).

July: Bonacina works on engraving of piazza (ARF; Haus, 15 and n. 76).

July 10: Work on entablatures and balustrade not yet started (BAV, Chig., H II 22, c. 158r; Br-W, 82, n. 1).

July 23: Bernini to finish entablature (ARF; Haus, 15 and n. 75).

July 30: Forty-seven columns of north portico in place, among them thirty-two of inner colonnades and eight of three entrance porches (BAV, Chig., H II 22, cc. 162f.; Br-W, 81, n. 8; Haus, 14f. and n. 73).

August 10: Bernini shows Alexander (model of?) first statue for balustrade (Diary, 334).

August 25: Bernini with corrections(?) (*richiami al disegnio*) of portico (Diary, 339).

August 26: Bernini shows Alexander copperplate of Bonacina engraving (Diary, 340).

August 27: About twenty prints made of plate (Diary, 341).

September 23: Wooden model of balustrade placed above cornice to judge effect (ARF; Haus, 16).

Work on the north portico continues through the end of 1659 into the spring of 1662. Progress of construction need not be followed in detail. Alexander comes several times, for instance on September 1, 1660 and June 18, 1662, to inspect "... quel gran teatro attorno la piazza che riesce di gran bellezza ..." (ASV, *avvisi*, 109, c. 226; 110, c. 136; Pastor, XXXI, 293, n. 6 and 294, n. 1 and n. 4). On April 18, 1662, construction is nearly completed (Diary, 469); by November 18, portico completed and being paved (ASV, *avvisi*, 111, c. 180; Pastor, XXXI, 294, n. 7; Diary, 629).

Meanwhile attention turns to laying out and building the north corridor (*braccio*) to link the colonnade to palace entrance and Scala Regia. On February 19, 1660, Bernini determines the axis of the portico "... per sfilar quello corridore" (Diary, 387). On March 10, he shows a first model (Diary, 391). Discussion continues through the summer about clearing the site and work on the foundations starts September 7 (Diary, 424); by June 8, 1662 it seems to be in use (Diary, 565).

At the same time construction continues on the south portico. The foundations are started on April 23, 1661, as the north colonnade and its corridor near completion; on August 20 Alexander inspects the foundations (ASV, *avvisi*, 110, c. 172; Pastor, XXXI, 294, n. 4). But construction is slow: not before

June 12, 1664 can Alexander walk "per tutto il portico" (Diary, 757) and only in November 1665 can he really use it (Diary, 897). However, the site for the adjoining south corridor, today's Braccio di Carlomagno, was not yet cleared, the old Penitentiary being still in the way (Diary, 913, March 14, 1666); but by April 17, that too was being removed (ASV, *avvisi*, 113, c. 272r and v; Pastor, XXXI, 295, n. 2), ". . . essendo hormai perfettionato il teatro di S. Pietro. . . ." In June no contractor has yet been awarded construction (Diary, 931). Nonetheless, on March 19, 1667, that *braccio*, too, is about to be finished (ASV, *avvisi*, 114, c. 48; Pastor, XXXI, 295, n. 4).

In January 1667, Bernini presents the design for paving the piazza to Alexander, "lo scompartimento della piazza del Teatro di S. Pietro" (Diary, 949); see also BAV, Chig., H II 22, c. 223, the note made by the pope to himself about work yet unfinished; and on February 19, 1667, the decision of the *Congregazione della Fabrica* to have the piazza paved (BAV, Chig., H II 22, c. 238; see below, note to pp. 70f.

pp. 70f.

The objections against Alexander's command to lay out Piazza S. Pietro as listed in the text are those raised by Cardinal Pallotta at the meeting of August 19, 1656; see previous note. Spada's qualms, laid down on March 17, 1657, are directed against the specific solution proposed at that point by Bernini (Güthlein I, 189f.; also Br-W, 71f., n. 6, *Bericht* II). The sharp critique of the final solution, in a set of drawings now BAV, Vat. lat. 14620 (R. Wittkower, "A Counterproject to Bernini's Piazza S. Pietro," *JWCI* 3 [1939], 88ff., also *Studies*, 61ff.) cannot date prior to September 2, 1657, since it takes into account Bernini's final solution.

Bernini in his long memorandum of 1657-58 presents (BAV, Chig., H II 22, cc. 107v-109v; Br-W, 70, n. 1, *Bericht* III) the justifying counterarguments as summed up by us. These arguments crop up in the records of other contemporaries as well, in particular the one about combatting unemployment; see Pallavicino, II, 177ff.; Cartari (ASR, Cartari Febei, busta 77, c. 234r, September 8, 1656); and the anonymous memo (BAV, Chig., H II 22, cc. 102r ff.) ". . . di tener occupata tanta quantità di poveri artisti. . . ."

For the usefulness of the piazza as parking space and of the porticoes as shelter from sun and rain, Pallavicino, II, 181f., as quoted in the text; as early as March 17, 1657, Spada (Güthlein as above). The confirming inscription in the porticoes, Forcella, *Iscrizioni delle chiese e d'altri edifici di Roma . . .* , Rome, 1869ff., 6, 538, nos. 1707f. and with variations, BAV, Chig., J VI 205, cc. 270ff.

The justification of the piazza's shape by the *concetto* of the porticoes' representing the arms of the Mother Church, is used in Bernini's memo (as above, 109v), whether his own or an advisor's. Speaking in Paris he again uses the image of the open arms, this time without symbolical meaning but to stress the porticoes' function to raise by contrast the façade of St. Peter's (Chantelou, 42, July 1).

As to the porticoes' competing with antiquity, see a memo BAV, Chig., H II 22, c. 121ff.; also Spada (Güthlein I, 190).

On the uselessness of the square and the ruinous expense, aside from Cardinal Pallotta, the Venetian ambassadors, *Relazioni*, II, 245, 320, whence our quotations in that sequence; see also the critique of Angelo Correr in 1660,

Relazioni, II, 218f., "Il benefizio poi che da sì gran mole si caverà non è chi sappi specularlo. . . ." Benedetti's little malice comes from a letter to Mazarin, December 20, 1660; see M. Laurain-Portemer, "Mazarin, Benedetti et l'Escalier de la Trinité-des-Monts," *GBA* 102 (1968), 273ff., esp. 293, and Lotz, "Spanische Treppe," *Röm Jbch* 12 (1969), 77f.

Could the *eccetioni ed errori di buona architettura* (BAV, Barb. lat., c. 777f., *avviso*, November 10, 1657) refer to the combination of Ionic frieze and Doric columns? That deviation of Bernini's in Piazza S. Pietro from the codified system of orders had been pointed out, though without disapproval, by Carlo Fontana, *Templum Vaticanum*, Rome, 1694, 193 (and indeed compounded by his calling the bases Tuscan instead of Roman-Doric as indeed they are); Th. Thieme, "La geometria di Piazza San Pietro," *Palladio* 33 (1973), 129ff.

OVERALL PLANNING AND OPPOSITION

p. 74

For the start of the first projects of the Cathedra Petri, see R. Battaglia, *La Cattedra Berniniana di San Pietro*, Rome, 1943, 11f.; also, Fagiolo dell'Arco, *Bernini*, 224ff. and scheda 167; for the delivery of the marble blocks for the Constantine—where was it to be set up?—inside St. Peter's as planned by Innocent X? or did Bernini even then envisage a landing, level with the narthex of St. Peter's?—now Güthlein II, 219f. For the Quirinal gate, R. Krautheimer, " 'Il porton di questo giardino,' " *JASH* 42 (1983), 135ff. and above, p. 97.

For the architecture painted on the wall of a nunnery opposite the Quirinal Palace—there were two, one Benedictine, the other Dominican (Nolli, 175, 176)—ASR, Cartari Febei, busta 81, c. 27, May 24, 1667, shortly after Alexander's death.

pp. 75f.

On Camillo Pamphili as a patron of the arts, Haskell, *Patrons and Painters*, *passim*, who considers him, *op. cit.*, 48, a discerning connoisseur of real taste. On the formation of the collection at Palazzo Doria-Pamphili from 1647, the year of his marriage to Olimpia Aldobrandini, E. A. Safarik and G. Torselli, *La Galleria Doria Pamphilj a Roma*, Rome, 1982, *passim*, esp. 10f.; on his building activities, primarily Eimer, *S. Agnese, passim*, and esp. 519ff., S. Nicola da Tolentino, and 527ff., S. Andrea al Quirinale. Regarding the difficulties at S. Agnese, L. Montalto, *Palladio*, as above, note to pp. 43ff.

The comparison between Don Camillo Pamphili and his wife, so uncomplementary to the prince, is Pallavicino's, I, 169, written and published (!) while Don Camillo was still alive.

For the building of S. Andrea al Quirinale and Alexander's initiative in starting and his supervision of planning and construction, above notes to pp. 37ff. and 59; for his interfering with the construction of S. Agnese, Diary, 41-43 (end of August to September 3, 1656) and his agreeing to Borromini's dismissal, Montalto, *op. cit.*, 166. Don Camillo's remark about following Bernini's orders regardless of cost is quoted Haskell, *Patrons and Painters*, 27. The building of the Pamphili palace wings along Piazza del Collegio Romano and Vicolo della Gatta is documented in O. Pollak, "Antonio del Grande," *Kunstgeschichtliches Jahrbuch der K. und K. Zentralkommission* 3 (1909), 133ff.; Jacovacci shows Alexander the plans, Diary, 453, February 15, 1661. Similarly, when in 1661 Don

Camillo has the chapel of S. Tommaso da Villanova built at S. Agostino, the wooden model was carried for approval to Alexander (Eimer, *S. Agnese*, 531 and n. 47).

For S. Giovanni in Oleo and S. Rita da Cascia, see Blunt, *Guide*, 58 and 141, suggesting that the elegant façade (but not the interior) of the latter was designed prior to 1665 by young Carlo Fontana. The small church was dismantled around 1930 and transplanted to the southeast corner of Piazza S. Maria in Campitelli.

For the Chigi arms with tiara on the presentation drawings of Casa Moretti and Palazzo d'Aste respectively, see BAV, Chig., P VII 13, f. 29r; also ASR, Notai di Acque e Strade, vol. 91 (101), 1664, at c. 376, and *ibid.*, vol. 85 (95), 1658, c. 219 (304), our fig. 49.

pp. 77ff.

For Buti's malicious "maximus in minimis," see Chantelou, 124, August 28, for Bernini's acknowledging Alexander's understanding matters of architecture, *ibid.*, 33, June 14; for the hapless florist at the Pantheon, Diary 265, January 9, 1659. Alexander's sketches are scattered through the sketchbook BAV, Chig., a I 19, among those of Bernini's and through BAV, Chig., J VI 205, his remarks about his having participated in planning through Diary. For his never-flagging interest in watching over the construction of "his" buildings, see Diary, *passim*, and the *avvisi* reporting his frequent visits to the building sites—S. Maria della Pace, Piazza S. Pietro, S. Maria del Popolo; or also his watching from his windows at the Quirinal the progress of construction at S. Maria in Via Lata, as Diary, 628, 631, November 11 and 20, 1662, and *passim*. The well-known reminder to himself written shortly before his death about building enterprises to be finished or newly started, BAV, Chig., H II 22, c. 223, has been quoted often, first Pastor, XXXI, 312f., n. 3. For his "switching about" monuments, as in that note, see also Diary, 939, September 9, 1666, for the wooden model of Rome kept in his bedchamber as he lay dying, A. Neri, "Saggio della corrispondenza di Ferdinando Raggi," *Rivista europea—Rivista internazionale* 5 (1878), 657ff., esp. 676.

Alexander redesigning purgatory comes from *Sindicato*, 15. The quote from the Venetian ambassadors' reports are from *Relazioni* in the following sequence: 219, Angelo Correr, 1660; 321, Giacomo Quirini, 1668; 245, Nicolò Sagredo, 1661—see also Haskell, *Patrons and Painters*, 152. The sally on Piazza S. Pietro as a *pisciatoio di cani* is quoted by Pastor XXXI, 25, n. 3 as from BAV, Barb. lat., LI, 1 (now 4627), but that pamphlet, a pro-French attack on Alexander following the Créqui affair, contains no such invective.

As to Alexander's arms appearing on the presentation drawings of Casa Moretti and Palazzo D'Aste it should be noted that engravings of the Propaganda Fide and of S. Andrea delle Fratte done at his time also show his coat of arms affixed to the buildings. Presumably it was just protocol to attribute to the reigning pope anything projected or underway during his pontificate.

pp. 82ff.

Construction of the façade, remodelling of the building and interior decoration of the palace at Piazza SS. Apostoli, bought for the Cardinal Nepote in 1662, starts in 1664, under Bernini's direction and Carlo Fontana's supervision, and continues for nearly twenty years; see the documentation in Golzio, *Do-*

cumenti, 3ff., supplemented by Bernini's sketches, e.g. BAV, Chig., a I 19, c. 64r, and Fontana's presentation drawings, BAV, Chig., P VII 10, f. 60ff.

The evidence for the history of the planning and building of S. Maria in Campitelli has been assembled and interpreted first by R. Wittkower, "Carlo Rainaldi and the Roman Architecture of the Full Baroque," *Art Bull* 19 (1937), 242ff., esp. 284ff. (reprinted *id., Studies*, 9ff., esp 32ff.): the drawings in BAV, Chig., P VII 10, ff. 105v-109; those in the archives of the church; the two foundation medals (G. Incisa della Rocchetta in *Il Messagero*, February 18, 1926, p. 5.; L. Maracci's contemporary *Memorie di S. Maria in Porticu*, Rome, 1667; C. E. Erra, *Historia di S. Maria in Portico*, Rome, 1750; and some further documents, such as BAV Chig., G III 78, cc. 214ff.

However, some modification is needed regarding the chronology and sequence of planning proposed by Wittkower: enlargement of the old church by means of a trefoil chancel, 1658; an entirely new building wanted by the pope, 1660; high domed oval façade, convex, one-storied, articulated by colossal pairs of columns and piers, as medal of 1662; low domed oval with double-storied narthex façade and domed chancel as project in church archives, after 1662 medal; present plan with cross-shaped nave and square, domed chancel, early 1663, with present façade as 1662-63 medal. All this wants modification. Hager, "Zwillingskirchen," 297f., has convincingly established that the plan and section of the low-domed oval with twin-storied convex façade are dated 1658, and hence presumably antedate the high domed oval project as the 1662 medal has it. Moreover, Diary, 282, March 2, 1659 notes that "Rinaldi si fermi col disegno fatto a Croce e che la spesa non passi da 15 a 20 mila." In the context of the subsequent Diary notes 285-288, dating March 6-13, all referring to a drawing of S. Maria in Campitelli and to the sum of 15,000 *scudi* donated for the building by Alexander three months before on January 28, 1659, that note about the cross-shaped plan too should refer to S. Maria in Campitelli. Hence, the cross-shaped plan postdates at least the first of the oval projects; and since there is only one cross-shaped plan known for S. Maria in Campitelli, namely the one executed, that plan or a similar one was ready and given preference by Alexander three years before the cornerstone was laid on September 26, 1662. The project of an oval church reduced from the first project and less expensive, may still have been considered as an alternative, as on the medal of 1662, used at the ceremony for the laying of the cornerstone. But when the chips were down, the simpler and less costly plan won out in the winter 1662-63.

The latest issue of *JSAH* 43 (1984) to reach me as these pages are about to go to press, brings, 65ff., a study by D. M. Habel centered on a project, heretofore unknown, submitted by Carlo Rainaldi and aimed at remodelling and accentuating the longish south front of Piazza in Lucina (ASR, Notai di Acque e Strade, vol. 90 [100], c. 389). The solution proposed, as pointed out by the author, closely resembles those projected and in part carried out on Piazza S. Maria in Campitelli and Piazza del Collegio Romano. Approved by papal *chirografo* June 30, 1662 accompanying the drawing, the project envisaged setting a strong center accent by masking the medieval façade of S. Lorenzo in Lucina by a twin-towered High Baroque prospect of rather conservative design. Flanking it to the right is a huge structure extending to the southwest corner of the square, divided into ground floor and three upper stories; the

177

former was marked by a grand portal left followed by *botteghe*, each adjoined by a stairway door (both shown also in plan) and above it an oval window, while the upper floors showed eighteen windows each, suggesting very small rooms, perhaps monastic cells. It would have served, it seems to me, as a combination of convent and rent-producing shopping center with apartments above the shops. In fact the *chirografo* mentions, aside from the convent (*quarto*), also *habitationi*.

Somewhat altered, that structure, though of course not the church façade, was actually built: the great portal opens to the left and is followed by seven (rather than eight) *botteghe*, each flanked by a stairway door surmounted by an oval bull's eye, and with only twelve windows on the three upper floors. It thus provides more space both for the shops and upstairs rooms than the project brought to light by Mrs. Habel. The building has been correctly attributed to Carlo Rainaldi by F. Fasolo, *L'opera di Hieronimo e Carlo Rainaldi*, Rome, 1961, 314. Terminated by an (original?) attic, it now houses the barracks of the *carabinieri*. However, as pointed out by Mrs. Habel, both the newly discovered project and its simplified execution were preceded by a first project (BAV, Chig., P VII 10, f. 18r) which envisaged only replacing the preexisting small convent-cum-garden and an adjoining group of small houses by a structure much like that built, though missing the entrance portal and with only eight windows per upper floor over the eight *botteghe*—the whole design much simpler than that proposed in the final project or that executed. Did then Alexander, starting from a purely utilitarian project, demand or was he to be lured into demanding a grand solution for the entire piazza; a solution which, like so many great schemes of his, had to be abandoned because of lack of funds?

Whether or not, as suggested by Mrs. Habel, the site of Palazzo Peretti, left-hand of the church, was ever seriously contemplated for a Chigi Palace had best be left open.

pp. 85ff.

The *chirografo* commanding purchase and demolition of Palazzo Salviati, whence our quotation, dates May 26, 1659 and is accompanied by plan and west elevation of the palace (ASR, Notai di Acque e Strade, vol. 86 [96], c. 738 [fig. 64]; also E. Rinaldi, *La Fondazione del Collegio Romano*, Arezzo, 1914, 122f.). Rinaldi, *loc. cit.*, cites also the expense to the Jesuits, small after the sale of the remaining site to Camillo Pamphili. For the construction of the Pamphili wings, as early as September 9, 1659 and completed 1663, see above, pp. 75f. and note. A plan, BAV, Chig., P VII 13, f. 38v, 39r, marks the sight lines into the nunnery from the Collegio and from some (inaccessible) windows of the Pamphili *galleria* along Vicolo della Gatta. See also Diary, 308, May 21, 1659 about redrafting the *chirografo*; *ibid.*, 343, 356, September 9 and October 30, 1659, respectively, demolition of Palazzo Salviati underway (while construction by Pamphili simultaneously started); and *ibid.*, 442 and *passim*, winter and spring 1660-61, regarding the sewer system of the piazza, for which see also BAV, Chig., P VII 9, f. 133r.

For the remark about S. Maria della Pace, see above p. 167, note to pp. 47ff.

For the convent building of S. Carlo ai Catinari, see the *chirografo* accompanied by plan and section, ASR, Disegni e Mappe, cart. 85, no. 494, April 17, 1660, whence our quotation; a second copy in BAV, Chig., P. VII 10, ff. 110,

111. Negotiations as to the transfer of the congregation from Piazza Colonna to S. Carlo ai Catinari had been underway since February 12, 1659, when Alexander promised to push work on the Barnabite convent there, as reported by Monsignor Corsini, *presidente delle strade*, Corsiniana, cod. 2116, cc. 157r ff.; see also Diary, 288, March 13, 1659, when Corsini brought Alexander a plan of S. Carlo ai Catinari, presumably the convent. The *chirografo* for continuing construction and settling the objections raised by the nuns of S. Anna was apparently drafted by January 27, 1660, Diary, 384. On April 4, 1662 the pope inspected the building under construction, *ibid.*, 547; on June 10 he listed among his achievements "la piazza avanti S. Carlo ai Catinari," and two weeks later discussed (*ibid.*, 575) the *fabbrica* with Monsignor Gastaldi. The original small piazza and the blocks of houses opposite the convent gave way ninety-odd years ago to the vast Piazza Benedetto Cairoli.

pp. 87ff.

The vicissitudes of the fountain at S. Maria in Trastevere have been traced and documented amply by C. D'Onofrio, *Acque e Fontane di Roma*, Rome, 1977, 334ff. First recorded on a map of 1471 (Frutaz, *Piante*, pl. 158), and remodelled under Alexander VI, the original water supply down the Gianicolo having dried up (A. Nibby, *Roma nel MDCCCXXXVIII*, II, 2, Rome, 1841, 36ff.). An attempt to feed it from the Acqua Felice across the river, conceived in 1592 and completed in 1604, failed—that water supply too having dried up by 1638. Alexander in 1659 finally linked it to the Acqua Paola, thus providing an abundant water supply (Nibby, *loc. cit.*) and relocated it to its present position. His autograph note, BAV, Chig., P VIII 17, c. 194, "La detta fontana si deve collocare nel mezo di detta Piazza" (D'Onofrio, *op. cit.*, 348) refers also to the house occupying the south side of the square as the "casa nova" and from its appearance in Falda's engraving of 1665 that building (fig. 68) might well date from Alexander's early years. Diary, 258, December 8, 1658, reports a discussion with Bernini about the fountain; *ibid.*, 264, January 3, 1659 and *ibid.*, 368, December 8, 1659 deal with inscriptions to be composed for the fountain. The Corsini diary, Corsiniana, cod. 2116, c. 155, on January 22, 1659, refers to the relocation of the fountain "in mezo alla Piazza" and to the square having been paved—this being commanded also by the *chirografo*, November 21, 1658 (D'Onofrio, *op. cit.*, 348); the diary, c. 160r, February 19, 1659, also refers to the speedy completion of the fountain, the arms of Alexander to be modelled after those at S. Maria del Popolo. Finally, c. 160r and v, March 5, 1659 (erroneously February 5), Alexander and Monsignor Corsini discuss the water supply for the fountain still under construction "alla nuova fontana che si fà. . . ."

A *chirografo*, dated July 14, 1660 (ASR, Camerale I, Chirografi, t. XIII, no. 314), grants the canons of S. Maria in Trastevere permission to build their house adjoining the narthex of the basilica.

Alexander's fountain in 1659 was altered, the most incisive change being the substitution for Bernini's double shells of large coats of arms, designed by Carlo Fontana. The present fountain is a clumsy copy dated 1873 of the original as remodelled by Fontana in 1692, raised much too high from the ground, overloaded and using grey marble instead of travertine (Blunt, *Guide*, 237).

Linked to the reorganization of Piazza S. Maria in Trastevere was another project, a piazza to be laid out at the Ripa Grande set with a fountain to be

fed by the surplus water of the fountain at S. Maria in Trastevere. Plans were ambitious: a piazza to be cleared "opposite the buildings to be erected for the Dogana and the granaries"—so Monsignor Corsini with Alexander on March 5, 1659 (Corsiniana, cod. 2116, c. 160r); Corsini urged delaying a decision until Giovanni Antonio De Rossi had submitted the plan. In any case a *chirografo* was prepared—the text is in Corsini's diary, c. 164—ordering the demolition of the old church of S. Maria di Porto Salute (presumably S. Maria del Buon Viaggio, Armellini-Cecchelli, *Chiese*, 822) and promising the construction of a new one, higher up above the high-water level (*ibid.*, c. 164f.). It is unclear whether anything came of the project; for, the new constructions (*nuove fabriche*) at S. Francesco a Ripa which Alexander inspected on February 27, 1666, need not be the ones at the Ripa Grande (ASV, *avvisi*, 113, c. 244v).

PROSPECTS

p. 90

The two alternatives for placing the obelisk dug up late in 1665 in the garden of the Dominican convent adjoining the church on the square of S. Maria sopra Minerva are demonstrated BAV, Chig., P VII 9, c. 77, obviously before it had been decided to have it carried by the elephant or any of Bernini's alternative proposals (fig. 69). The sources on the discovery of the obelisk, Bernini's several projects for setting it up (see also Br-W, 143ff., pls. 109ff.) and his use of the *concetto* of the elephant as carrier, developed thirty-odd years before for a monument to be erected in the Barberini Gardens, are best found in C. D'Onofrio, *Gli obelischi di Roma*, Rome, 1967, 230ff. For the iconography of elephant and obelisk combined as a symbol of Divine against human wisdom as alluded to also in the inscription on the socle, the authority remains W. Heckscher, "Bernini's Elephant and Obelisk," *Art Bull* 29 (1947), 155ff. BAV, Chig., J VI 205, cc. 337ff. contains a number of variants tried out for the inscriptions, but all referring to the elephant design. Diary, 919, April 4, 1666, records Alexander's choice of the elephant project, and *ibid.*, 920 his having spent time with Bernini over the drawings.

The project of modernized oval steps ascending to the church is laid down in an undated drawing, BAV, Chig., P VII 10, f. 27, together with the steps executed for S. Maria del Popolo.

pp. 90f.

The siting of the *terzo braccio* as envisaged by Bernini between 1665 and 1667 is decisive regarding the controversial question of whether Bernini planned an avenue leading from the river to Piazza S. Pietro. The data for the *terzo braccio* have been summed up by R. Wittkower, "Il terzo braccio del Bernini in Piazza S. Pietro," *Bd'A* 34 (1949), 129ff.; also *id.*, *Studies*, 53ff., in English translation. Here is the evidence as I see it.

Planned from the very outset to close the piazza the *terzo braccio* was to stand on the curve of the oval still when Falda did his drawing preparatory for the engraving in the *Nuovo Teatro*, pl. 3; a drawing Alexander would seem to have seen January 13, 1665, perhaps together with one for Cruyl's or Agnelli's map: "vediamo i disegni de' Portici de la Piazza di S. Pietro e gli altri dell'Intaglio grande" (Diary, 798). In the spring of 1666, when presented by Bernini with a drawing of the *vestibulo*, Alexander worried about the expense (Diary, 913) of both construction and buildings to be bought up for demolition.

In any event the *terzo braccio* was by then to be moved east: as far as the Priorato di Malta, the last, westernmost building on the *spina*—as suggested by the workshop drawing BAV, Chig., P VII 9, f. 15 (Br-W, 86, n. 2; 87, n. 3), by G. B. Falda's Small Map, showing the clocktower (Frutaz, *Piante*, pl. 347), by M. G. De Rossi's Map (*ibid.*, pl. 355) and still in 1667 by Cruyl's large drawing at Oxford (Th. Ashby, "Lieven Cruyl e le sue vedute di Roma," *MemPontAcc.* I, 1 [1923], 221ff.); or indeed east of that building as proposed by Bernini's sketch plan BAV, Chig., a I 19, c. 68r (Br-W, pl. 63a), presumably to go with his clocktower sketch (*ibid.*, c. 63v and Br-W, pl. 64) for the *terzo braccio.* On February 19, 1667, the demolition of the Priorato di Malta is approved by the *Congregazione*; a project for the *terzo braccio* with clock or clocktower (*orologio*) is presented but discussion is postponed. Instead, paving the piazza is to be given priority, as proposed by Alexander (BAV, Chig., H II 22, c. 238).

Wittkower, *op. cit.*, concluded that Bernini did not think of an avenue and, indeed, there is no documentary evidence. Kitao, *Square of Saint Peter's*, 56ff., has already countered this view and claimed on stylistic grounds that Bernini's project envisaged an avenue closed off by the *terzo braccio* located forward as planned in 1667. (I had overlooked this passage and the pertinent reconstruction proposal, *op. cit.*, p. 82, and I am most grateful to Kaori Kitao for enabling me to correct the oversight.) Indeed, it seems to me that placing the *terzo braccio* with its clocktower so close to the westernmost buildings of the *spina*, which would have remained after the demolition of the Priorato di Malta, would have deprived the *terzo braccio* of its raison d'être of being visible from afar. The *spina* simply had to go. Moreover, there was the long tradition of the avenue project; see Thoenes, "Petersplatz," *ZKG* 26 (1963) for both the 1586 and 1651 projects and for this latter, now the minutes of the *Congregazione* meeting, February 6, 1651 and the estimates for the demolition of the *spina* and for an avenue flanked by arcaded porticoes, each eighty-one arches long (Güthlein II, 228ff.). Finally, there was talk indeed in Rome of such an avenue around 1667. A French traveller who arrived in Rome in 1669 was told that the colonnades of Piazza S. Pietro were "to be continued to Ponte S. Angelo by the demolition of . . . the houses in between; that is, that the façade of St. Peter's and the Papal Palace would show themselves from the bridge on straight ahead" (Robias d'Estoublon, *Lettres de Monsieur le Marquis* +++ *écrites pendant son Voyage d'Italie en 1669*, Paris, 1676, 245; the book is apparently not to be found in Rome, but the passage is summed up by L. Schudt, *Italienreisen*, as above, p. 162, and Mrs. Charlotte Lacaze was good enough to copy it for me at the Bibliothèque Nationale in Paris. I am greatly indebted to her).

For the eighteenth century projects of such an avenue, H. Hager, "Progetti del Tardo Barocco Romano per il Terzo Braccio del Colonnato della Piazza S. Pietro," *Commentari* 19 (1968), 299ff.

p. 90

For the history of the façade of S. Andrea della Valle and its final completion in 1661-62, see H. Hibbard, *Carlo Maderno*, London, 1971, 146, 154 and Diary, 864, July 5, 1665, superseding Wittkower, "Rainaldi," *Art Bull* 19 (1937), 258ff.; for the design of the "modern" steps being ordered, Diary, 246, 249 and 266, November 12, 18, 1658 and January 10, 1659, thus correcting by one year Hibbard's date 1657-58. The tiny piazza to be laid out in front is shown BAV, Chig., P VII 9, f. 90r and v. The ambitious project of an avenue leading from

the Collegium Germanicum, the Apollinare, adjoining the south flank of the homonymous church, right down to S. Andrea della Valle, was considered seriously enough to call for estimates, see the document (undated but probably 1662) Bösel-Garms, 342, note ". . . con slargar la strada dritta dall'Apollinare a drittura a S. Andrea della Valle importa sc. [figure missing]" and "slargar la detta strada per contro della nuova fabrica dell'Apollinare importa scudi 1600. . . ." The explanatory drawing mentioned in the document has so far not turned up.

p. 93

Since I have published the detailed evidence for the projected gate of the Quirinal gardens and the approach from Piazza del Popolo (R. Krautheimer, "Il porton di questo giardino," *JSAH* 42 [1983], 35ff.) I need only list the sources. Alexander's note is in Diary, 102; the confirming *avviso*, undated, ASV, *avvisi*, 105, c. 315f. The planned continuation of Via Babuino-Due Macelli running dead against the bastion of Urban VIII is documented by the drawing BAV, Chig., P VII 10, f. 32v-33r (fig. 75); the description of the flight of steps ascending to the "majestic portal," is recorded in [L. Pascoli], *Testamento di un Accademico Fiorentino*, Cologne, 1733, published anonymously with fictitious place and date; the drawing of the gate is preserved in Berlin, Kupferstichkabinett, KdZ 15904; see Br-W, 134f. and pl. 171 B and *Zeichner sehen die Antike*, ed. M. Winner, Berlin (1967), 90ff., no. 57. The identification of the horse-tamers as Alexander the Great and his horse Bucephalus was corrected first by A. Donati, *Roma vetus ac nova*, Rome, 1638. But the older identification survives both in F. Nardini, *Roma antica*, Rome, 1665 (but written before 1661—I am quoting the edition of 1771, p. 497) and in an encomium addressed to Queen Christina by A. L. Gentili (ASR, Cartari Febei, busta 77, inserted after c. 123): "Alexandri Magni statuas marmoreas Bucephalum edomantis quae iam dudum in Quirinali extant."

p. 99

Authorship, history and political context of the approach to the Trinità dei Monti planned in Alexander's time have been discussed most recently by M. Laurain-Portemer, "Mazarin, Benedetti et l'escalier de la Trinité des Monts," *GBA*, ser. 6, 82 (1968), 1, 273ff. and independently by Lotz, "Spanische Treppe," *Röm Jbch* 12 (1969), 39ff., the latter supplemented by Tod A. Marder, "Bernini and Benedetti at Trinità dei Monti," *Art Bull* 62 (1980), 286ff. The evidence is provided on the one hand by the correspondence between Mazarin and Benedetti from January 1660 to February 1661; see both Laurain-Portemer and Lotz, *op. cit.*, supplemented by an entry in Alexander's diary on December 13, 1661, overlooked by me, but published by Marder, *op. cit.*, 288, n. 11. The graphic evidence, on the other hand, is represented in the first place by two large drawings: one, attributable to Bernini's workshop, is in Stockholm (National Museum, Collection Cronstedt), the other is in the Vatican Library (BAV, Chig., P VII 10, f. 30v, 31r). This latter (fig. 80) appears to be a copy after the Stockholm drawing or a nearly identical drawing, perhaps Bernini's original, and is inscribed, "dall'Abbate Benedetti." A groundplan "of Bernini's model," as expressly stated, and corresponding to the project surviving in the two large drawings, was sketched and described in his travel journal by the Swedish architect Nicodemus Tessin the Younger when visiting Benedetti's villa in Rome in 1687.

The history of the abortive project becomes reasonably clear from the Mazarin-Benedetti exchange of letters. Likewise, the reasons for its failure in the framework of the tense relations between France and Alexander have been convincingly suggested by Lotz, *op. cit.* The authorship of the project as it survives in the Stockholm and Vatican drawings is still being debated. Laurain-Portemer accepts Benedetti's claims in his letters to Mazarin and the inscription on the BAV drawing and believes him capable of the *invenzione*. Lotz, on the contrary, based on Tessin's inequivocable statement and still more on the originality and superb quality of the project, voted for Bernini. So does Marder, *op. cit.*, who suggests that the BAV copy was done by Benedetti from Bernini's original and presented as his own so as not to embarrass the latter. This seems to me to be the most convincing explanation; I even wonder whether it is by chance that Alexander in his diary note fails to mention the author of the drawing he was shown on December 13, 1660.

For the interpretation of Mazarin's project as a political ploy to humiliate Alexander, see, convincingly to me, T. A. Marder, "The Decision to Build the Spanish Steps: From Project to Monument," in *Studies on Roman Baroque Architecture*, ed. H. Hager, University Park and London, 1984. Mr. Marder has been good enough to let me have the galleys of his paper.

ROMA ANTICA E MODERNA

p. 102

The use of spoils on the Arco di Portogallo was observed and in consequence a late antique date proposed already in *Ritratto di Roma antica*, Rome, 1645, 176f. ". . . ed a mio parere . . . secondo la sua maniera di Imperatore posteriore (*scil.* to Hadrian). . . ." Recent research has confirmed its having been composed of spoils in late antiquity, see S. Stucchi, "L'Arco detto di Portogallo sulla Via Flaminia," *Bull Comm* 73 (1949-50), 101ff., as quoted Helbig-Speier, II, no. 1447, and C. Pietrangeli, in *Via del Corso*, Rome, 1961, 34ff.

Learned opinions on the monument requested by Alexander and some drawings are assembled in BAV, Chig., M VIII LX, where, c. 16r, the statement quoted as to the arch's being "neither antique nor triumphal"; another opinion, *ibid.*, c. 55v, maintains even "che la struttura d'esso arco . . . nè habbia piu di trecento anni." BAV, Chig., G III 78, contains two more learned dissertations by Cesare Magalotti, cc. 301ff., and *ibid.*, cc. 317f., a survey of the arch before and after demolition accompanied by a statement identical with that quoted from BAV, Chig., M VIII LX and signed by Carlo Fontana, della Greca and the master masons. See Rossi, 1939, 375, note 1 for the text, and for another copy of that survey, BAV, Chig., P VII 13, f. 32, published by G. Matthiae, "La demolizione dell'Arco di Portogallo," *Roma* 20 (1943), 508ff.

The *chirografo* commanding the demolition, dated August 2, 1662, is printed in Fea, *Diritti*, Appendice, 66f.; the demolition started five days later, Diary, 598, and was still underway August 31, *ibid.*, 607. The *avviso* depicting Alexander among the ruins, September 9, 1662 (ASV, *avvisi*, 111, c. 142) is published Rossi, 1939, 375; see also an *avviso*, August 22, ASV, *avvisi*, 111, c. 124.

pp. 102ff.

Alexander's early interest in the Pyramid of Cestius is attested to by Diary, 25, June 20, 1656, a first attempt at seeing it restored, *ibid.*, 282-284, March 2 and 3, 1659; drawings were submitted on March 27, Diary, 291 and exca-

vations to establish the original level take place in April when bases with inscriptions are found, *ibid.*, 297, 299, April 17 and 18; drawings in BAV, Chig., P VII 13, ff. 56-63. The *chirografo* commanding the restoration and addressed to Jacovacci dates July 21, 1659, whence our quotation regarding the *virtuosi forestieri*; see Fea, *Diritti*, 62ff. Work proceeds slowly; Diary, 492, July 19, 1661, Alexander waxes impatient. In the summer of 1662 work was underway. See also the estimate and accounting, M IV L, cc. 150ff., as published J. Serra, "Sul restauro della Piramide di Cestio," *Bull. Ist. Centr. di Restauro* 31-32 (1957), 173ff.

BAV, Chig., M IV L, cc. 157ff. contains also the plea addressed to Alexander by Martinelli to install a chapel dedicated to Peter and Paul inside the pyramid, thus purging it "da ogni superstizione gentile." It is accompanied by the Borromini drawing *ibid.*, c. 160r, see Serra, *op. cit.*, and again M. Fagiolo dell'Arco, "La religiosa trasmutazione della Piramide di Cestio," *Arte illustrata* 5 (1972), 210ff.

The inscriptions drafted by Alexander to link the repair of the pyramid with the burial ground of the plague victims, thus providing an *interpretati Christiana*, are in BAV, Chig., J VI 205, cc. 384ff.

pp. 104ff.

A study, due to S. Bordini, "Bernini e il Pantheon," *Quaderni*, 79-84 (1967), 53ff., sums up Alexander's program for the Pantheon: clearing Piazza della Rotonda, freeing the building from both the surrounding ground and the houses attached, regularizing and lowering the square and adjoining streets, restoring the structure and redecorating the interior. Bernini's sketches within that program (BAV, Chig., a I 19, cc. 29v, 30r, 31r, 31v, 66r, this last being Bernini's ideal reconstruction of the Pantheon as of old; fig. 83), first assembled and convincingly interpreted Br-W, 120ff., pls. 89f. are reproduced and discussed Bordini, *op. cit., passim*.

The quotation about rescuing the building from squalor and meanness caused by the market is taken from Alexander's *breve*, June 20, 1662, BAV, cod. Pantheon, II 1, no. 22, cc. 117ff. The removal of the *tavola* from the porphyry tub is recorded Diary, 25, June 20, 1656; an edict of the *presidente delle strade*, March 27, 1657, confines the vendors to marked sites (G. Eroli, *Raccolta . . . delle Iscrizioni . . . nel Pantheon*, Narni, 1895, 274; Bordini, *op. cit.*, 70ff. misrepresents the text as referring to the complete removal of the vendors); finally, the rumours regarding a planned removal of the houses are reported in an *avviso*, June 6, 1657 (ASV, *avvisi*, 105, c. 247).

The campaign of 1662-63 was preceded by numerous discussions from the fall of 1659 on, Diary, 352, 363, 370, 376, 384, 447, 448, the last two, January 1661 showing Alexander's impatience "spedir il negoziato della Rotunda." Action gets underway on June 15, 1662 at a meeting of the *Congregazione delle Strade*, which decides to clear Piazza del Pantheon and to find out about the rents from the houses attached to both flanks of the portico (BAV, Chig., M VIII LX, cc. 157r-158v).

Clearing the square: all butchers, fishmongers and the like are to be moved to Piazza di Pietra (*ibid.*, c. 157r and v); a meeting on June 23 (*ibid.*, 131r) lays down preparatory measures to be taken for that move, including a fountain to be set up on Piazza di Pietra. The transfer occurs July 24 (Diary, 587, 588). The empowering *chirografo* is issued belatedly on August 5 (Fea, *Diritti*, 68f.),

stating the pope's intention to give back "il suo Prospetto decoro al Portico della Rotonda."

The settling of the vendors on Piazza di Pietra (which entailed the demolition of S. Giuliano, see BAV, Chig., G III 78, cc. 291ff.) is depicted in the plans BAV, Chig., P VII 13, f. 47r with flap, in the view *ibid.*, f. 43r, and in the discussions of the *Congregazione delle Strade*, ASV, Misc. Arm., VII 50, *passim*, esp. c. 115v. See also Diary, *passim*, from July 19 to August 23, 1662.

For the return of the vendors to Piazza della Rotonda, see Felice della Greca's drawing, signed and dated April 25, 1663 (ASR, Disegni e Mappe, cart. 81, no. 284), antedating incidentally the lowering of the piazza as evident from the steps descending to the portico. A *breve* issued by Alexander, April 27, 1663 (Casan., Editti, t. 10, c. 56; *Regesti*, 6 1297) confirms the canons' title to the piazza.

Freeing the Pantheon, regularizing and grading the piazza: While the *Congregazione delle Strade* on June 15, 1662 (as above, BAV, Chig., M VIII LX, cc. 157r-158v) envisaged demolishing the buildings attached to either flank of the portico, a *chirografo* of July 24 more modestly focuses on the houses attached to the left, the east flank, with the aim of enlarging the street leading to the Minerva (Fea, *Diritti*, Appendice, 65f.). An undated meeting of the *Congregazione* considers details and proposes to build arcaded houses, thus enlarging the width of the street from 18 to 50 *palmi* and more ". . . si dilaterà con logge e dilaterà il transito della larghezza di 50 e più palmi . . ." (ASV, Misc. Arm., VII 50, cc. 104r, 105v, 106r). The *chirografo* of August 5 (Fea, *Diritti*, 68f.) empowers the *presidente* and the *maestri di strade* to proceed; for a sketch of the site, see BAV, Chig., M VIII LX, cc. 166v, 167r; for another studying the situation opposite Piazza della Minerva and of the street leading there, *ibid.*, c. 172r. Demolition starts August 7 and still goes on September 5, Diary, 598, 608. However, as early as March 20, 1663, a *chirografo* permits the canons to build a house attached to the rotunda, thus blocking the planned widening of the street (BAV, cod. Pantheon, II, 1, no. 23, c. 12v). The projected removal of the block of houses between Piazza del Pantheon and Piazza della Maddalena, and Alexander's withdrawal, is reported by Cartari, September 5, 1661 (ASR, Cartari Febei, busta 79, c. 101). A proposal to regularize the right-hand, the east side of Piazza del Pantheon, appears BAV, Chig., M VIII LX, c. 164r; another survey BAV, Chig., P VII 10, c. 4, envisages regularizing the north side as well.

Studies on lowering the level of the piazza and on overcoming the resulting difficulties are discussed BAV, Chig., M VIII LX, cc. 127ff., and illustrated BAV, Chig., P VII 13, f. 42, with regard to the sewer system, a major problem. The study proposing the present north-south slope was accompanied by a clay model (BAV, Chig., M VIII LX, c. 129).

Implementation, however, took time. Not before March 20, 1666 did a *chirografo* order the grading of the square and the approaching streets "con declivio proporzionato" (Fea, *Diritti*, Appendice, 114; also ASV, *avvisi*, 113, cc. 272r and v, April 17, 1666: [the Pantheon] ". . . viene . . . sollevato alquanto sopra la Piazza la qual a tal effetto si va spianandosi . . ."). Work started in the spring of 1666; it was completed in two phases by the end of July (P VII 9, c. 104r; also *ibid.*, 101, *ristretto* of expenses). The supervisor of work was P. Giuseppe Paglia, the Dominican architect from S. Maria sopra Minerva (*ibid.*, 104r).

Restoring the Pantheon to its ancient dignity was from the outset the *agens*

movens of Alexander; see as early as November 23, 1659 "abbelimento di Roma per la Rotunda" (Diary, 363). In September 1662 Alexander sees a "modello fatto della Rotonda," perhaps an ideal reconstruction like Bernini's, BAV, Chig., a I 19, c. 66r, and distinct from it a clay model, Diary, 609, 618, September 5 and 28. In the fall of 1662, the *Congregazione delle Strade* suggests placing the porphyry sarcophagus of Helena and the Bacchic sarcophagus from S. Costanza in the portico (ASV, Misc. Arm., VII, 50, c. 116v). Replacing the two columns missing on the east flank of the portico was the first practical task: two roughly corresponding ones found near S. Luigi dei Francesi were transferred, *chirografo*, November 4, 1662. An earlier suggestion had been to reuse two columns from the Concordia Temple on the Forum (ASV, Misc. Arm., VII 50, c. 116v). Payments for moving the columns from S. Luigi to the Pantheon, undated but presumably spring 1663, are recorded BAV, Chig., M VIII LX, cc. 117v, 120r. Setting them in place, however, like grading the square, was delayed. It started in August 1666 (BAV, Chig., P VII 9, c. 104r; also ASV, *avvisi*, 113, cc 272r and v, April 17, 1666) ". . . dovendosi erigere a lato del Portico le due grandi colonne che mancano e farsici altri risarcimenti e ornamenti . . ."; by September 30 the columns were in place, but not yet the capitals and entablatures bearing Chigi emblems on the soffits of the cornice (BAV, Chig., P VII 9, *loc. cit.*, and f. 109r). By March 19, 1667, work on the portico was completed (ASV, *avvisi*, 114, c. 48).

Meanwhile Alexander turned to restoring and redecorating the interior. On December 4 and 5, 1663, he studied a drawing of the opaion, life-size it seems (Diary, 637, 638). Nine months later, on August 20, 1663, a wooden model was paid for "da chiudere l'occhio . . . della Rotunda" (BAV, Chig., P VII 9, c. 104). But again there was delay. Not before September 1666, dated through the preceding estimate on completing work on the portico, an estimate was submitted to restore inside the revetment, polish the columns and repair the porphyry cornices (*ibid.*, c. 101III, 101v) and the stucco covering of the dome and its coffers. The restorations both inside and on the portico are illustrated in a group of watercoloured "modelli" by Carlo Fontana (BAV, Chig., P VII 9, 108r-114r): like the cornice of the portico on its soffits the coffers of the dome were to carry Chigi emblems, and the opaion on its rim was to be inscribed in colossal letters ALEXANDRO VII. The plan to "take over" the Pantheon thus seems to go back to 1662 when the estimates were submitted including those "per ornare li stucchi della Cupola" (BAV, Chig., P VII 9, c. 101III) or by the latest in 1663 when Alexander approved the "dessegno" of the "stucchi per la Rotonda" and the price agreed on "col placet di N.S." (*ibid.*, c. 103). The story regarding Bernini's refusal to participate in refurbishing the Pantheon (Fraschetti, *Bernini*, 299, n. 3) comes from a source (BAV, Vat. lat., 8235, c. 4v-5r; old 8v-9r) dating a century later and hence of doubtful reliability.

Like the repairs on the exterior and the grading of the square, that project, too, lay dormant until 1666, when work on the interior got underway: on March 16, Alexander made a contribution to the Rotunda—the figure is missing (Diary, 914); on September 4, he studied a *modello* (*ibid.*, 937). The day before, Negrelli, the *senatore di Roma*, submitted a progress report on work inside the Pantheon (BAV, Chig., P VII 9, c. 103): a trial cleaning of columns, pilasters and revetment was underway, an estimate had been prepared for glazing the opaion; as to remodelling the fountain in the piazza, the pope's commands were being expected; and "no one would be told of Your Holiness' wishes, except the supervisor Fr. Paglia . . . I shall present everything as if the ideas

were mine . . ."—why the secrecy? can it be anything but the projected Chigi emblems and the inscription in the dome?

In December 1666 Alexander worries about the cost of the restoration and sets aside 3,000 *scudi* (Diary, 945, 946) and on February 20, 1667 he reminds himself to send more funds for the Rotunda (Diary, 954). The *stucchi* planned for the coffers and the projected glazing of the opaion are mentioned still on March 19, 1667 (ASV, *avvisi*, 114, c. 48).

There is no evidence to support Bordini's contention (*op. cit.*, 70ff.) that Alexander intended the Pantheon to serve as his and the Chigis' mausoleum.

pp. 109f.

The transfer of the cattle market for three years from the Forum Romanum to Piazza S. Giorgio in Velabro to protect the young trees planted on the Forum is commanded April 11, 1656, by edict of the *presidente* and the *maestri delle strade* (*Regesti*, 6, no. 201); the prohibition to hold the market on the Forum was prolonged for two more years, November 6, 1658 (*ibid*, no. 766). However, it is doubtful that the market went to S. Giorgio in Velabro. F. Martinelli, *Roma ricercata*, Rome, 1658, 170, locates it on Piazza Termini in front of the Thermae of Diocletian. In any case, the market was back on the Forum by January 21, 1659 (*Regesti*, 6, no. 799); presumably by then the trees had grown sufficiently so as not to be exposed to damage by the cattle.

For details of Alexander's program of planting trees all over Rome, see my paper, *Roma verde nel seicento*, in *Studi in onore di Giulio Carlo Argan*, Rome, 1984, II, 39ff. The project started in the spring of 1656 when the avenue across the Forum either had been or was about to be planted (*Regesti*, 6, no. 191); hence the presentation drawing BAV, Chig., P VII 10, ff. 94r (fig. 86), must date from that time; the same edict provides for the planting of trees at S. Maria Maggiore, the Ripa Grande and the road to S. Croce in Gerusalemme and "altri luoghi." The order given to Don Mario on September 24, 1656, Diary, 51, "donde cavarsi il denaro," and the draft estimate, BAV, Chig., R VIII c, f. 13r, obviously antedating that order, seem to represent a second, enlarged phase of the project which can be followed in successive edicts issued by the *maestri di strade* such as *Regesti*, 6, nos. 640 and 1611, December 17, 1657 and May 9, 1666; see also the *chirografo* of January 30, 1666 and the accompanying presentation drawing commanding a tree-lined avenue at S. Giorgio in Velabro, BAV, Chig., P VII 10, f. 97; two more plans showing at least the beginning of that avenue are found ASR, Notai di Acque e Strade, vol. 93 (103), cc. 381 and 567, dated by *chirografi* June 16, 1666, and July 9 of that year, concerning public property to be ceded to private owners, one of them being the architect Antonio del Grande (c. 381). The city maps reflecting the implementation of the program are Giovanni Giacomo De Rossi's adjusted Tempesta map, 1661-62; Cruyl's map, 1665; Agnelli's, 1666; Falda's Little Map, 1667; Matteo Gregorio De Rossi's map, 1668; finally Falda's Large Map, 1676 (Frutaz, *Piante*, 338ff., 343, 344, 345ff., 350ff.

PIAZZA DEL POPOLO

pp. 114ff.

For the links between stage design and city planning at an early moment see R. Krautheimer, "The Tragic and the Comic Scene," *GBA* 33 (1948), 327ff. (also, *id., Studies*, 345ff., with postscript). The interlocking of stage design and

festival decoration has been noted often. See for the Italian Seicento in particular, M. Fagiolo dell'Arco, *La scenografia*, Rome, 1973 and *id.*, *L'effimero Barocco*, Rome, 1977, *passim*.

The quotation on "Sacred and Prophane Showes" he saw in Rome in 1668-69 comes from R. Lassels, *The Voyage to Italy*, Paris, 1670, II, 250f. Contemporary accounts on the entry into Rome of the "ambassadors of obedience" from Lucca, for example, November 4, 1655 (ASR, Cartari Febei, busta 77, c. 71r f.) or of Queen Christina on December 22 (*ibid.*, c. 104r ff.; among many descriptions of her entry, G. Gigli, *Diario Romano*, ed. G. Riccioni, Rome, 1958, 475 and G. Gualdo Priorato, *Historia della Sacra Real Maèstà di Cristina Alessandra Regina di Svetia*, Rome, 1656, 249f.), to mention just two of many such "shows," convey a detailed picture of colourful garments, horse trappings, coaches, silver trumpets, soldiery and liveries. An edict by the *presidente delle strade*, December 20, 1655 (Casan., Editti, t. 8, p. 74; *Regesti*, 6, no. 141) on the occasion of Christina's entry orders everybody along the route "deba parare avanti le loro case con panni darazzi et adornino le finestre con portiere."

For the fictitious architectures designed for celebrating the *Quarant'ore* throughout the seventeenth century, see M. S. Weil, "The Devotion of the Forty Hours and Roman Baroque Illusion," *JWCI* 37 (1974), 218ff. The *theatrum sacrum* and the role of the Jesuits has been summed up in the abstract of a paper by P. Bjurstrøm, "The Roman Baroque Stage and Teatrum [sic!] Sacrum," *JSAH* 27 (1968), 212, and at greater length, *id.*, "Baroque Theater and the Jesuits," in *Baroque Art: The Jesuit Contribution*, ed. R. Wittkower and I. B. Jaffé, New York, 1972, 99ff.

False prospects masking church façades, as customary for funeral services, are plentifully recorded in engravings, see M. Fagiolo, *L'effimero Barocco, passim*. The fictitious façade applied to Palazzo Farnese on the occasion of Queen Christina's temporary residence after her official entry survives in the preparatory drawing by Carlo Rainaldi and a copy thereof, both in Berlin, see *Italienische Zeichnungen der Kunstbibliothek Berlin*, ed. S. Jacob, Berlin, 1973, nos. 374, 375, Hdz. 1144, 1145; also W. Vitzhum, *Il barocco a Roma (I disegni dei maestri 14)*, Milan, n.d., fig. 24.

The stage set from Pietro da Cortona's circle (Milan, Castello Sforzesco, Coll. Bertarelli, Martinelli, *Disegni d'edifici in Roma ed altrove*, I, 40) was published first by P. Portoghesi, *Roma barocca*, Rome, 1966, 247, and fig. 201, misinterpreted as a project for remodelling Piazza del Gesù. Other drawings from the same source are stage props or table decorations, for instance, Martinelli, *Disegni*, I, 37 (Portoghesi, *op. cit.*, fig. 200) and I, 38. The stage set showing Castel S. Angelo and S. Pietro as seen from Palazzo Borghese is illustrated in P. Bjurstrøm, *Feast and Theatre in Queen Christina's Rome (Analecta Reginensia, 3)*, Stockholm, 1966, 31, the one showing Banco di Santo Spirito and the diverging streets is recorded in BAV, Chig., P VII 13, f. 54 (fig. 90).

pp. 122ff.

Basic for discussing the history of Piazza del Popolo under Alexander VII and in the following decades until the end of the century are R. Wittkower, "Carlo Rainaldi," esp. 245ff., and H. Hager, "Zwillingskirchen." G. Ciucci, *La Piazza del Popolo*, Rome, 1974, provides a useful summary of the appearance of the square prior to 1655 and of the planning under Alexander and of its later history.

Alexander's interest in the wedges separating the trident of streets at the south end of the piazza becomes evident first in Diary, 55, October 6(?), 1656, when he orders Monsignor Fagnani to inquire about the property-owners on the wedges. Apparently nothing was done and on February 4, 1657, Diary, 70, he ordered Bernini to find out "in ordine a farci questi portici per ornamento del Popolo." Hager's assertion ("Zwillingskirchen," 195) that the aim in building the churches was not primarily one of city planning, and that the initiative came from the Carmelites, must thus be corrected. The project of a funnel-shaped piazza, clearly articulated in successive stages and terminated by complementary concave fronts on the two wedges, marked in pencil on the plan BAV, Vat. lat., 13442, f. 34, fits best in my opinion that portico scheme. There is no trace whatever on it suggestive of churches to be placed on the wedges (fig. 95); nor does, incidentally, the survey plan drawn by Rainaldi, BAV, Chig., P VII 10, f. 26r, leave room for churches on these wedges, roughly enlarged in frontage and length. However, in my opinion, neither plan dates as early as 1655, as proposed for BAV, Vat. lat., 13442, f. 43 by Wittkower, "Rainaldi," 250, and Hager, *op. cit.*, fig. 138, since Alexander's interest in reshaping the wedges manifests itself not before October 1656. As I see it, both plans date from the winter 1656-57 and the survey plan precedes the funnel-shaped project. The *terminus ante* of the former is obviously given by the purchase of a house on December 22, 1657 on the left-hand wedge by the Carmelites, with an eye to eventually building their church, S. Maria di Monte Santo; a house not yet marked on the plan (Hager, *op. cit.*, 195). But that late *terminus ante* is of little use. Nor can I agree with attributing to Rainaldi the sophisticated funnel plan. It just is not his style.

In fact, a rumour about twin churches to be sited on the wedges crops up first in April 1657 (ASR, Cartari Febei, busta 191, c. 10v; Eimer, *S. Agnese*, 537ff.). But there is no concrete evidence regarding their planning at that early time. Whether or not the site plan presented to Alexander on February 24, 1658 (Diary, 173) provided for them ". . . le cantonate tagliate al principio del Corso," remains open. The first dated evidence is provided by another note of Cartari's (ASR, Cartari Febei, busta 191, c. 21v; Eimer, *S. Agnese*, 539, n. 11) stating that in September 1661 he saw drawings for the two churches planned; and, two months later, the plan of the square accompanied by plan and elevation of one of the twin churches, presumably the one attached to the *chirografo* of November 16, 1661, was submitted by Rainaldi, ASR, Disegni e Mappe, cart. 84, no. 279 (fig. 96). (Our quotations as to widening and opening the Corso come from the *chirografo*, printed Hager, *op. cit.*, 299.) The piazza, on that plan, has become a continuous funnel, unarticulated except for the short stretch behind the city gate; the church cross-shaped, its façade broken in what I believe to be Rainaldi's customary style. Whether or not the project of the churches submitted in 1661 dates already from 1658 (Hager, *op. cit.*, 212) may be left open.

The large *veduta*, BAV, Chig., P VII 13, ff. 26v-27r (fig. 97), likewise has been dated 1658, interpreted as preparatory for the plan attached to the *chirografo* and attributed to a collaboration between Rainaldi and Carlo Fontana (Hager, *op. cit.*, 200ff.). But I wonder whether Rainaldi had much part in it and whether it need be dated that early. Contrary to Hager, *op. cit.*, 201, I cannot see the façade as markedly Rainaldesque ("eine ausgesprochen rainaldeske Fassade"). Rather the *veduta*, clearly a presentation drawing, seems to me a counterproject

to Rainaldi's proposal; a project submitted by Fontana in 1660 or 1661 and close to Bernini's architectural style at that time.

However, Rainaldi remained in charge and the cornerstone of S. Maria dei Miracoli, the right-hand, westward church was laid on December 9, 1661, long before the houses on the site had been purchased for clearing (Hager, "Zwillingskirchen," 207f.). When on July 6, 1662 (Diary, 562) Alexander "saw the two churches at the beginning of the Corso," he could not have seen more than the excavations and on July 15 when the cornerstone was laid for the left-hand church, S. Maria di Monte Santo, and the fountain medal was issued, Rainaldi was specifically named as the architect.

Bernini's (or Alexander's) qualms about Piazza del Popolo are hinted at on January 17, 1662, Diary, 536, and it seems to me that the succession of projects for the twin churches from 1661 to 1665 had best be explained as a tug-of-war between Fontana, backed by Bernini, and Rainaldi, in which the latter was forced into ever more "classical" solutions: the churches both planned circular rather than cross-shaped; the colonnaded portico front as it appears on the foundation medal in July 1662 (Hager, *op. cit.*, 212ff.); the project as transmitted late in 1665 by Lieven Cruyl both in sketches (Rome, Istituto di Archeologia e Storia dell'Arte, Racc. Lanciani, Roma XI, 11, 1, f. 115r) and in the finished drawing in Cleveland, prepared for the engraver and hence reversed (fig. 98)— a cylindrical circular space surrounded by niches, a Pantheon-type, but surmounted by a tall, slender drum and provided with three colonnaded and gabled porticoes; all features which are best understood as due to Fontana's and indirectly to Bernini's impact (Hager, *op. cit.*, 215ff., 219).

For the subsequent planning- and building history of the twin churches which falls after Alexander's pontificate, see Hager, "Zwillingskirchen," 220ff.

Valadier's project for Piazza del Popolo based on extending it sideways in huge hemicycles and thus countering the effect intended by Alexander is discussed G. Ciucci, *La Piazza del Popolo*, Rome, 1974, 93ff.

The sketch for a theater (?) curtain based on what may have been an early project of Alexander's time for Piazza del Popolo (fig. 99) became known to me through an advertisement of Sotheby's, *Burlington Magazine* 111 (1969), xiii. It was sold October 19, 1969, as a letter from the firm accompanied by a photograph kindly informed me on December 6, 1972. I am most grateful to Sotheby's for their prompt reply to my inquiry.

T. A. Marder, "La chiesa del Bernini ad Ariccia," in *Gian Lorenzo Bernini architetto*, ed. G. Spagnesi and M. Fagiolo, Rome, 1983, 255ff. has linked, *ibid.*, 271, the porticoes envisaged originally for the wedges on Piazza del Popolo to a comparable project of Alexander's and Bernini's to terminate by porticoes the piazza "incontro la porta del Quirinale," Diary 202, June 9, 1658.

THE REVERSE OF THE MEDAL

pp. 125f.

The decrees issued by the *presidente* and the *maestri di strade*, jointly or respectively, concerning sanitary conditions and the general state of the streets are summarized *Regesti*, 6, *passim*: see in particular the one of January 30, 1658 (no. 664) banning hogs from the streets; that of July 20 of the same year (no. 730) forbidding cattle to be driven unleashed through the city; those of May 23 and June 28, 1658 (nos. 712, 725) concerning street paving; those of

January 7, 1659 (no. 792) and January 19, 1660 (no. 926), the first forbidding the slaughter or display of meat in the open, the second prohibiting the frying of pasta or fish on the squares and streets "per il decoro e igiene della città"; finally, the ever-repeated commands to deposit garbage on assigned sites on the river bank, such as the decrees of January 5, 1657, May 7, 1659, February 4, 1662 and April 3, 1663 respectively (nos. 461, 843, 1180, 1296) and the numerous prohibitions to dump the refuse elsewhere, repeated from 1657 through May 1667.

pp. 126ff.

Lorenzo Pizzati's memorandum survives in a number of copies in the Vatican Library: BAV, Chig., C III 71; Barb. lat., 2471; Reg., 1507; Vat. lat., 13550; and Vat. lat., 13551. I have not checked whether further copies are held elsewhere. The differences between the single versions are minor, the most outstanding being the omission in Barb. lat., 2471 of the introductory paragraphs addressed to Alexander. Otherwise the text is nearly identical in all copies, including the grotesque Latin misspellings and bowdlerizations; this notwithstanding the interval of more than a decade which separates BAV, Chig., C III 71 and Reg., 1507 on one hand from Vat. lat., 13550 and 13551; the former two being dated chapter by chapter and in that sequence February 1, 1656; June 24, 1656; May 28, 1658 and May 20, 1659; while Vat. lat. 13550 and 13551 were submitted to Clement IX Rospigliosi and his *nipoti*, early in his pontificate. I have used primarily BAV, Chig., C III 71 and have transcribed with the help of Enrico Bassan the chapters I (*contra immunditiam*) and IV (*pro ornatu urbis*) but have checked the other Vatican copies, especially Vat. lat. 13550, which latter on some loose, unpaginated leaves contains Pizzati's supplication to Clement IX and his nephews.

What little is to be known about Lorenzo Pizzati must be gathered from these supplications and from the introductory paragraphs of his memorandum. Upon the *raccomandazione* of an uncle, the Cavaliere Annibale Pizzati, "antico Offitiale del Palazzo Apostolico," he was at the very beginning of Alexander's pontificate appointed *cameriere extra*, a semi-clerical post—they wore violet cassocks—of ill-defined duties, but which carried a small stipend, 4.50 *scudi* and a number of "perks" in kind, such as free wine, oil and so forth. He held the position for four years and in fact his name appears among the *camerieri extra* in the *Ruolo di famiglia di Alessandro VII* of 1656 (BAV, Chig., B I 12, c. 5v), but is no longer listed in the *Ruolo* of 1659 (BAV, Chig., B I 13, c. 18v). From then on he was always on the look-out for a job, the more so since he intended to or indeed in 1656 did marry (BAV, Chig., C III 17, c. 2r)— any job: superintendent of sanitation first (*ibid.*, c. 6); later, when petitioning Clement IX, subquartermaster (*sottoforriere di palazzo*) or a place in the guards, or supervisor of the papal bakery; or else, when approaching the Rospigliosi *nipoti*, headwaiter, carver or no less than custodian of the armory at Castel S. Angelo, or else overseer of the Roman beaches. At that time (Vat. lat. 13550) he lived opposite S. Urbano in Via Alessandrina in the Pantani quarter.

Regarding high rents in Rome ever since the fifteenth century, P. Picca, "Editti di papi e principi contro il rincaro dei pigioni," *Nuova Antologia* 1909, VI, 488ff., where incidentally I have found the only reference to Lorenzo Pizzati's *memoriale* known to me.

The formation of a hard core of unemployables, the excessive numbers of

beggars and the appalling condition of the poor in Alexander's Rome become apparent from the records of the *visite apostoliche*, see L. Fioriani, "Le visite apostoliche del Cinque-Seicento e la società religiosa Romana," *Ricerche per la storia religiosa di Roma* 4 (1980), 53ff., esp. 127ff.

CITY PLANNING AND POLITICS

pp. 131ff.

The dedication of Cruyl's map, dated June 4, 1665, stresses that Rome which Alexander aspires to raise to the glories of the time of the Roman emperors is emphatically his city, *la sua città*, twice repeated.

The guidebook quotations citing the prospect of Piazza del Popolo as the introduction to Rome of the illustrious foreigner from the *nazioni forestiere* are taken the first from (F. Franzoni), *Roma antica e moderna*, Rome, 1668, 37f., written and printed still under Alexander, the second from F. Titi, *Ammaestramento . . . di Pittura, Scoltura et Architettura . . .*, Rome, 1686, 355; it was not yet included in the first edition of 1674, entitled *Studio di Pittura*.

The route laid down for Queen Christina's official entry is described in two edicts issued on December 20, 1655 by the *Governatore di Roma* and reported in Cartari's diary, ASR, Cartari Febei, busta 77, c. 102: "... per tutto il Corso, cominciando dalla Piazza del Popolo, per la via del Gesù, Cesarini, Pontem, Borgo Nuovo ..."; and (all streets which from) "... Porta del Popolo conducono al Palazzo Vaticano, cioè il Corso avanti al Palazzo di S. Marco, la Piazza del Monte Giordano, Banchi, Ponte S. Angelo, Borgo Nuovo ..."; see also *Regesti*, 6, no. 141; and *ibid.*, no. 142, a corresponding decree by the *Conservatori* ordering decoration with tapestries and illumination along that route as well as along the return route to Palazzo Farnese, where the queen was going to take up residence.

For the *teatri* along that route of entry, finished and under construction by 1667 or those planned but never even begun, see above, *passim*, and of course Blunt, *Guide, passim*. As to Ponte S. Angelo, the link between the showpieces in the old town and Piazza S. Pietro, Cartari (ASR, Cartari Febei, vol. 92, c. 85; Hager, "Zwillingskirchen," n. 229) refers in passing to a project of Alexander's to build two chapels flanking the entrance on Piazza del Ponte, the east bank. Bernini's angels with the instruments of the Passion forming a *Via Crucis* leading into the sacred precinct of the Borgo were commissioned six months after Alexander's death by Clement IX, the Rospigliosi Pope; inscriptions, contracts and contemporary reports leave no doubt (M. S. Weil, *The History and Decoration of the Ponte S. Angelo*, University Park and London, 1974). Given the short interval between the first payment made to Bernini and Alexander's death and the lack of a contract commissioning the angels, one is tempted to suggest with C. D'Onofrio, *Gian Lorenzo Bernini e gli angeli di ponte S. Angelo*, Rome, 1981, 82 (also Mark Weil, orally), that an agreement regarding them already existed between Alexander and Bernini. But there is no proof whatever. For the avenue planned to replace the *borghi* and to lead from Castel S. Angelo to Piazza S. Pietro, above, pp. 90ff.

p. 138

The praise of Alexander as outshining Romulus comes from a lengthy encomium placing him and his deed above those of all the legendary heroes of

Rome; preserved in BAV, Chig., J VI 205, c. 335, it was prepared to be set up at the Capitol.

pp. 140f.

On Alexander's activity as nuncio at Cologne and his refusal to sign the Treaty of Münster, see Pastor, XXX, 94f.

The tense relations between France and Alexander from the very outset and climaxing in the affair of the Duc de Créqui, the resulting humiliation of the pope in the Treaty of Pisa and the enforced apologies tendered in 1664 personally in Paris by the Cardinal Nepote are discussed at length by Pastor, XXXI, 111f. They have been sketched by Haskell, *Painters and Patrons*, 153, as the context within which to understand also Bernini's stay in France the following year, convincingly it seems to me—not so much in order to further humiliate Alexander (Hibbard, *Bernini*, 168), but as a kind of reparation meant to seal a reconciliation between Rome and Paris (C. Gould, *Bernini in France*, Princeton, 1982, 9).

Stalin's question is anticipated in a clever piece of French propaganda, a pamphlet purporting to be a report rendered by the Venetian ambassador Basadona which was widely spread by Alexander's time (H. von Ranke, *Die römischen Päpste*, III, Leipzig, 1889, Anhang: 187*, who took it to be genuine; *Relazioni*, II, 295ff. and 259, where it is unmasked as a forgery: "... che il trescare con chi ha dei grilli in capo, eserciti a fianchi e milioni sotto i piedi non sia buon giuoco per i pontifici che hanno solamente le due dita alzate."

pp. 142f.

Bernini's remark, "princes ought to build splendidly and grandly or not at all since this reflects their character," is reported by Chantelou, 213, October 8.

Alexander's admonition to the cardinals is quoted, in part *verbatim*, Pallavicino, I, 369f. Regarding his giving a good example during the *Cappelle Pontificie* to the cardinals and other clergy so that "... anche essi legarono e composero le lingue ... in quel teatro ...," see *ibid.*, I, 335.

The guidebook quotation about the entry into Rome of the *nazioni forestiere* having been heaped with beauty by Alexander, is taken from [G. B. Molo], *Roma sacra antica e moderna*, Rome, 1687, 38f.; the one about the Corso being straightened "acciochè i forestieri a quella prima vista che si presenta Loro nell'Ingresso non vedano alcuna di detta difformità ..." from an *avviso*, Barb. lat. 6367, c. 795v, 796r, February 2, 1658. The particular attention paid to the distinguished foreigner is confirmed by Pallavicino, I, 336, reporting the exclusion during the *Cappelle Pontificie* from the chancel of everybody, "salvo qualche forestiere che meritasse questo special godimento. ..."

p. 143

The late appearance of engraved *vedute* of "modern" Rome—as distinguished from those of *Roma antica*—twenty and thirty years after such *vedute* of Paris or The Hague, waits for explanation; see now H. Keller, *Das alte Europa, die hohe Kunst der Stadtvedute*, Stuttgart, 1983.

On Lieven Cruyl's Roman *vedute*, Th. Ashby, "Lieven Cruyl e le sue vedute di Roma," *Memorie ... Pontificia Accademia*, I (1923-1924), 221ff., H. Egger, "Lieven Cruyl's Römische Veduten," *Mededeelingen van het Nederlandsch Historisch Instituut te Rome* 7 (1927), 183ff.; and *id., Römische Veduten,*

Vienna, 1931, I, 13, 55, 66 and II, 69, 70, 77, 78, 80; all formerly Vienna, Albertina, now Cleveland Museum of Fine Arts.

Falda, see above pp. 3ff.

pp. 144f.

For travellers to Rome in Alexander's time as well as before and after, basic L. Schudt, *Italienreisen im 17. und 18. Jahrhundert* (Römische Forschungen der Bibliotheca Hertziana, 15), Vienna-Munich, 1969, *passim*.

For Catholic travellers see R. Lassels, *The Voyage to Italy, II*, Paris and London, 1670, 4ff.; or Grangier de Liverdis, *Journal d'un Voyage de France et d'Italie . . . 1660 . . . 1661*, Paris, 1667, 251ff.; for an observant Protestant traveller, G. Burnet, *Travels . . . 1685 and 1686*, London, 1737, 148ff., 183ff.

For the reception by Cardinal Francesco Barberini of John Milton, see the latter's letter to Holstenius as quoted by J. Arthos, *Milton and the Italian Cities*, London, 1968, 55; for the attentions paid to minor Protestant royalty by Alexander and his court, S. von Birken, *Hochfürstlicher Brandenburgischer Ulysses . . .* , Bayreuth, 1669, 120 and *passim*; and Ferdinand Albrecht, Herzog zu Braunschweig-Bevern, *Wunderliche Begebnüssen und wunderlicher Zustand dieser wunderlichen verkehrten Welt . . . Erster Teil begreiffund des Wunderlichen Lebens und Reisebeschreibungen . . .* , Bevern, 1678 (known to me only through Schudt, *op. cit.*, 408).

G. Christ, "Fürst, Dynastie, Territorium, und Konversion," *Saeculum* 24 (1973), 367ff., as quoted E. and J. Garms, "Mito e realtà di Roma," in *Storia d'Italia, Annali*, 5, Turin, 1982, 610, accounts for thirty-odd conversions from German princely houses. The outstanding cases in Alexander's time are listed already by Pastor, XXXI, 149f.

pp. 146f.

Falda's Small Map, while published perhaps after Alexander's death, May 22, 1667, but still within that year, was being prepared during the pope's last years and is dedicated to him (fig. 110; Frutaz, *Piante*, I, 216 and III, pls. 345-49; see also the allusions in the dedicatory encomium to the Chigi star and *monti*). The drawing (fig. 111), on which Falda's group of allegorical figures is based is in a private collection, at present deposited at the Metropolitan Museum of Art, New York: brownish paper, brown ink and wash, 250 by 180mm. Its free and forceful style differs vastly from and is far superior in quality to Falda's manner, as it appears both in the engravings and in autograph drawings of his (R. Kristeller, "Zeichungen von Giovanni Battista Falda," *Amtliche Berichte aus den Berliner Museen* 36 [1914-15], 109ff.). Hugh McAndrew and Nicholas Turner both suggest that the drawing is close to Bernini. The name of Carlo Maratta has been suggested independently by Dr. Dieter Graf and Dr. Ursula Pace-Fischer; he works in a similar vein in drawings dated albeit from the eighties (A. Nesselrath, "Carlo Maratta's Designs for the Piatti di S. Giovanni," *Master Drawings* 17 [1979], 417ff.; kindly pointed out to me by Dieter Graf). Also it was Maratta who furnished Falda with the *modello* (Chatsworth, *Catalogue*, no. 528; identified by Dr. Graf) of the group for the dedicatory inscription on the latter's Large Map of Rome, 1676 (Frutaz, *Piante*, pl. 358).

Malcolm Campbell in a letter to Irving Lavin, June 7, 1982, in accepting our identification of the allegorical figures, suggested the sketch might well be designed "for some panegyric celebrating Alexander VII's architectural patronage" or perhaps for "a map like Falda's of Rome." My thanks go to him.

Index of Names

The name of Alexander VII, because of its frequent occurrence, has not been indexed.

Index of Places

199

Library of Congress Cataloging in Publication Data

Krautheimer, Richard, 1897-
The Rome of Alexander VII, 1655-1667.

Bibliography: p.
Includes index.
1. Rome (Italy)—City planning. 2. City planning—Italy. 3. Rome (Italy)—Buildings. 4. Architecture,
Baroque—Italy—Rome. 5. Architecture and state—Italy—Rome. 6. Alexander VII, 1599-1667. I.
Title.

NA9204.R7K7 1985 945'.63207 84-26553
ISBN 0-691-04032-X